STRONGER TOGETHER

KAMMANATUT ATAUSIGUN *Bering Strait Inupiaq*

IKNAQATAGHAGHLUTA QERNGAAMTA *St. Lawrence Island Yupik*

STRONGER TOGETHER

KAMMANATUT ATAUSIGUN

IKNAQATAGHAGHLUTA QERNGAAMTA

BERING STRAIT COMMUNITIES RESPOND TO THE COVID-19 PANDEMIC

Edited by **Amy Phillips-Chan**
with **RB Smith and Carol Gales**

UNIVERSITY OF ALASKA PRESS
Fairbanks

Published by University of Alaska Press
An imprint of University Press of Colorado
1580 North Logan Street, Suite 660
PMB 39883
Denver, Colorado 80202-1559

 The University Press of Colorado is a proud member of Association of University Presses.

The University Press of Colorado is a cooperative publishing enterprise supported, in part, by Adams State University, Colorado State University, Fort Lewis College, Metropolitan State University of Denver, University of Alaska Fairbanks, University of Colorado, University of Denver, University of Northern Colorado, University of Wyoming, Utah State University, and Western Colorado University.

∞ This paper meets the requirements of the ANSI/NISO Z39.48-1992 (Permanence of Paper).

ISBN: 978-1-64642-551-8 (hardcover)
ISBN: 978-1-64642-552-5 (paperback)
ISBN: 978-1-64642-553-2 (ebook)
https://doi.org/10.5876/9781646425532

Library of Congress Cataloging-in-Publication Data

Names: Phillips-Chan, Amy, editor.
Title: Stronger together = kammanatut atausigun bering strait inupiaq = iknaqataghaghluta qerngaamta St. Lawrence Island yupik : Bering Strait communities respond to the COVID-19 pandemic / edited by Amy Phillips-Chan; with RB Smith, Carol Gales.
Other titles: Bering Strait communities respond to the COVID-19 pandemic
Description: Fairbanks : University of Alaska Press, [2023] | Includes bibliographical references and index.
Identifiers: LCCN 2023033378 (print) | LCCN 2023033379 (ebook) | ISBN 9781646425518 (hardcover) | ISBN 9781646425525 (paperback) | ISBN 9781646425532 (ebook)
Subjects: LCSH: COVID-19 Pandemic, 2020——Social aspects—Bering Strait Region. | COVID-19 Pandemic, 2020——Social aspects—Alaska—St. Lawrence Island.
Classification: LCC RA644.C67 S775 2023 (print) | LCC RA644.C67 (ebook) | DDC 614.5924144—dc23/eng/20220715
LC record available at https://lccn.loc.gov/2023033378
LC ebook record available at https://lccn.loc.gov/2023033379

The University Press of Colorado gratefully acknowledges the support, in part, of the Carrie M. McLain Memorial Museum for this publication.

Front cover image credits (*clockwise from top left*): break time on the way to the reindeer fair at Mary's Igloo in 1915 or 1916: from left to right are (*seated*) Marcus, Charlie, and Dr. Daniel Neuman, (*standing*) Toutuk, Walter Shields, Alfred, and Henry (Carrie M. McLain Memorial Museum, 2017.5); dwarf dogwood in bloom on the Nome tundra (photograph by Amy Phillips-Chan); Karen Olanna, Pandemic Response III (*detail*) (Carrie M. McLain Memorial Museum, 2021.2.2); Josephine Tatauq Bourdon, Four Seasons Mandala (*detail*) (Carrie M. McLain Memorial Museum, 2021.7.3); Elaine Kingeekuk tries on her in-process Protector Mask in 2020 (photograph courtesy of Elaine Kingeekuk); Delia Irrigoo Iyapana waits to be tested for COVID-19 outside the Nome Airport in 2020 (photograph by John Handeland); Marjorie Kunaq Tahbone, Family Protection and Ceremonial Healing (Carrie M. McLain Memorial Museum, 2020.20.2, 2020.20.1). Back cover image: mist settles over the Kigluaik Mountains as seen from the Grand Central River Bridge on the Kougarok Road northeast of Nome (photograph by Amy Phillips-Chan).

CONTENTS

ACKNOWLEDGMENTS

Launching this collaborative initiative during the COVID-19 pandemic carried unique challenges and could not have been achieved without our partners, who believed in the importance of this project and gave of their time and resources at a most transformational period in history. The City of Nome provided generous financial support for the oral history interviews, artwork commissions, and manuscript preparation. The Museums Alaska Art Acquisition Fund supported by the Rasmuson Foundation aided the purchase of pandemic-themed artwork. The Bering Strait region demonstrated an exemplary level of unity during the pandemic with region-wide teleconferences, distribution of medical supplies, and respect for each community's unique quarantine and travel restrictions. The title *Stronger Together* speaks to this collective defense against the coronavirus. The title has been beautifully translated into Bering Strait Inupiaq by Josephine Tatuaq Bourdon and St. Lawrence Island Yupik by Vera Metcalf. Photographer Michael Burnett helped to capture the essence of each piece of artwork, while James Mason, John Handeland, Leon Boardway, KNOM, and the *Nome Nugget* offered local images of community members and activities. Photographs of contributors were taken by RB Smith, Carol Gales, and Amy Phillips-Chan. Participants selected and submitted additional photographs to illustrate their stories with credits in the image captions. Rachel Fudge contributed her sharp copyediting skills to the first draft of the manuscript. Nate Bauer and Darrin Pratt with the University of Alaska Press and University Press of Colorado championed the book for publication. Press team members carefully polished the text and prepared it for print, with special thanks to Laura Furney, Sonya Manes, and Tina Kachele. This book would not have been possible without the fifty-two community contributors who made space while juggling remote work, distance learning, illness, loss, and major life changes to share their stories, artwork, and poetry for ourselves and future generations to listen to and consider what it was like when the pandemic forever shifted our lives.

STRONGER TOGETHER

KAMMANATUT ATAUSIGUN *Bering Strait Inupiaq*

IKNAQATAGHAGHLUTA QERNGAAMTA *St. Lawrence Island Yupik*

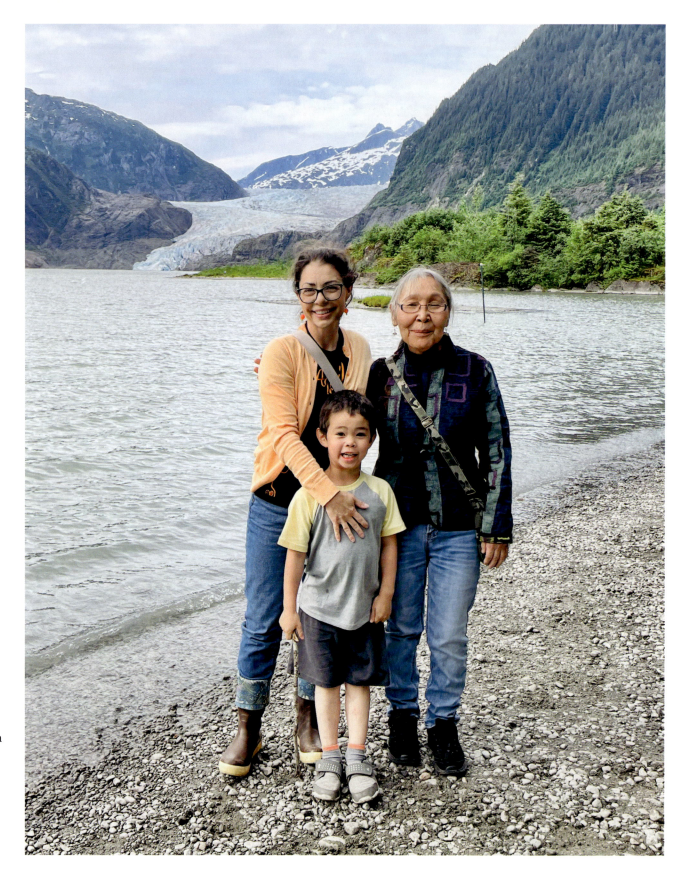

FIGURE 0.1.
Amy Phillips-Chan
and son David Winston
enjoy Mendenhall
Glacier with artist
Elaine Kingeekuk
in the summer of
2023. Juneau, AK.
Photograph courtesy
of Amy Phillips-Chan.

INTRODUCTION

Living and Remembering Pandemics in the Bering Strait Region

AMY PHILLIPS-CHAN

Amy Phillips-Chan, PhD, served as director of the Carrie M. McLain Memorial Museum in Nome, Alaska, on the traditional homeland of the Bering Strait Inupiat from 2015 to 2022. She now serves as director of the Alaska State Libraries, Archives & Museums in Juneau, Alaska, on the homelands of the Áak'w Kwáan Tlingit. Phillips-Chan is honored to partner with communities and organizations on projects that foster coproduction of knowledge about the rich history and cultural heritage of Alaska (figure 0.1).

Sounds of shuffling boots and rustling coats punctuated the silence inside Nome City Hall on March 12, 2020. The normally sparse room used as council chambers now had guests spilling out into the hallway and standing on chairs to catch a glimpse of City Council members assembled on either side of the mayor of Nome (figure 0.2). An open container of cookies sat untouched on a table next to a package of cleaning wipes. One person wore a face mask. Nome residents had gathered for a special emergency meeting to discuss potential cancellation of activities related to the 48th Iditarod Trail Sled Dog Race, due to the COVID-19 coronavirus that had just arrived in Alaska. Over the next three hours, council members listened to families, business owners, and medical staff who expressed varying levels of caution for continued operation and access to city facilities, stores, and air travel (Haecker 2020a). A cloud of intense fear hung over the room as residents envisioned mass arrival of the coronavirus with visitors flying into Nome for the Iditarod and the Lonnie O'Connor Iditarod Basketball Tournament. Council Member Meghan Sigvanna Topkok urged the audience to remember the devastating effects of the 1918

Spanish Influenza on Alaska Native families and remarked that she "was only a few generations removed from family that had died in the Spanish Flu" (City of Nome 2020a). The meeting ended with an approved motion to close public facilities frequented by visitors for the next two weeks, including Old St. Joe's Hall, the Nome Visitor Center, and the Nome Recreation Center. The doors of the Richard Foster Building—home of the Kegoayah Kozga Public Library, Katirvik Cultural Center, and Carrie M. McLain Memorial Museum (Carrie McLain Museum)—were also to close to the public.

Like other Alaska museums at the start of the COVID-19 pandemic, the Carrie McLain Museum did not know how long we would remain closed to visitors or how exactly the pandemic was going to unfold in our rural community. The museum spent the first few months of the pandemic striving to remain a community resource in small ways, such as responding to research inquiries, accepting (and quarantining) new donations, and increasing social media posts about materials in the collection. Staff organized our collection of historical newspapers and completed a few writing projects. Willow leaves on the tundra began to display their

FIGURE 0.2.
Nome residents
crowd into City
Hall on March 12,
2020, to share
their concerns
about the arrival
of COVID-19 in
Alaska. Photograph
courtesy of John
Handeland.

brilliant hues of red and gold, and the pandemic appeared here to stay. By the fall of 2020, museums across the country were pivoting to online experiences, and many were launching initiatives to acquire objects and stories related to the pandemic (Chambers 2021; Cooper Hewitt, Smithsonian Design Museum 2021; Errico 2020).

Nome residents had been expressing their thoughts on the pandemic through social media, but there was very little COVID-19 related signage, artwork, or other ephemera for our museum to collect. What our community did have was a glaring absence of firsthand accounts from the 1918 Spanish Influenza, particularly stories from Indigenous community members (Smith 2020b). So, with our past before us, in September 2020 the Carrie McLain Museum decided to focus our efforts on launching an oral history project that documented local narra-

tives and promoted collaborative history of the pandemic in the Bering Strait region.

As 2020 stumbled forward into 2021, the country experienced an intense period of racial and social unrest; an unprecedented era of isolation; the development, distribution, and ultimate politicization of vaccines; and a gradual, cautious reentry into a post-COVID reality. In Nome, the museum's oral history project expanded to welcome addi-

tional community narrators, artists, and poets who came onboard to share stories, create artwork, and contribute written material for a project that came to be known as *Stronger Together: Bering Strait Communities Respond to the COVID-19 Pandemic*.

This introductory chapter to *Stronger Together* situates the COVID-19 pandemic within the scope of historical pandemics in the Bering Strait region with emphasis on the 1918 influenza and a compar-

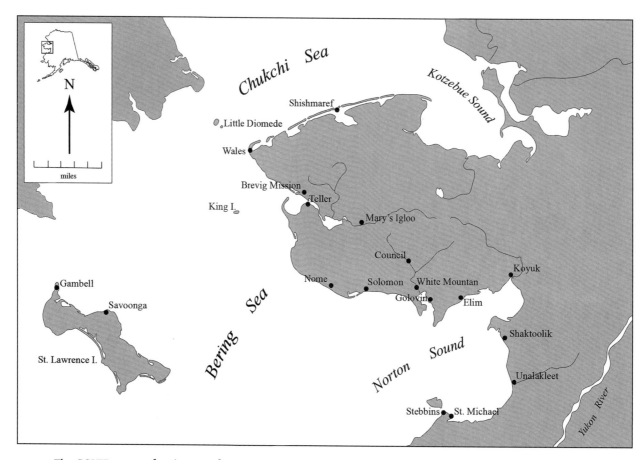

MAP 1. The COVID-19 pandemic spread across 23,000 square miles of the Bering Strait and impacted community members connected to all twenty Alaska villages in the region shown here. Map by Dale C. Slaughter.

ative model of community impact and response. An overview of museological responses to the pandemic is offered with consideration of historical documentation practices in Nome that gave rise to the current oral history and artwork initiative. Community member stories afford insight into personal experiences and challenges encountered during the pandemic, from cancellation of the Iditarod Trail Sled Dog Race and loss of tourism, to the celebrated arrival of air freight and vaccines. Artist narratives speak to the work they created for the project as well as shifts in the art world during the

past three years. The text prioritizes first-person narratives and strives to offer a nuanced look into the lived experiences of Bering Strait community members in the era of COVID-19.

BERING STRAIT COMMUNITIES

Tumultuous waves carry marine mammals, fish, and people through the ice-laden channel of the Bering Strait between Eastern Chukotka and Northwest Alaska (map 1). In Alaska, the Bering Strait region lies just below the Arctic Circle and

features sloping mountains with rocky outcrops, windswept tundra speckled with berries, and lush riverine valleys that feed into the sea. The area encompasses approximately 23,000 square miles on the Seward Peninsula and the shores of Norton Sound as well as Little Diomede Island, King Island, and St. Lawrence Island. Many of the region's twenty communities are strategically located along the coast or next to river systems with access to marine mammals, fish, berries, and plants. Sixteen communities are permanently inhabited, while four communities are used as fish camps or for other subsistence activities. Over 9,000 people currently live in the region, of which approximately 7,000 are Alaska Native people (McDowell Group 2020:6). Indigenous people of Alaska have made this region home for 4,000 to 6,000 years, and three distinct cultural and linguistic groups live here today: Inupiat, who reside on the Seward Peninsula as well as Little Diomede; Central Yup'ik, who live in villages primarily south of Unalakleet; and St. Lawrence Island Yupik, who make their homes in Gambell and Savoonga on St. Lawrence Island.

Subsistence activities structure the lives of many families in the Bering Strait region (Sutton and Steinacher 2012:10–11). Melanie Bahnke, president, Kawerak, Inc. explains that subsistence means more than hunting or gathering but, rather, maintaining a relationship with the environment: "Our Tribes are stewards of our oceans, and we are not merely users of resources, but intimately connected and part of the ecosystem in the Bering Sea" (Bahnke 2021). Winter brings opportunity to catch king crab through the ice and trap furbearers like fox and wolf. Breakup of the sea ice in spring takes boats out after seals, walrus, beluga and bowhead whales, and excursions along the coast to hunt seabirds and gather eggs. Summer entices fam-

ilies to fish camps along the coast and long days netting and drying salmon; picking salmonberries, blueberries, and crowberries; and gathering beach greens and sour dock. First frost in autumn sweetens tundra cranberries and signals the time to hunt moose, harvest reindeer, and jig for tomcod through lagoon and harbor ice. Local foods hunted and gathered throughout the year are carefully dried, frozen, or canned to be brought out and shared with family members and friends on special occasions. Bering Strait Native artists carefully save, gather, or purchase the walrus ivory, whalebone, baleen, and animal skins from harvested animals to use in a wide range of artwork (Kawerak, Inc. 2021; McDowell Group 2020).

At the heart of the Bering Strait region lies Nome, or Sitŋasuaq in Inupiaq, located on the southern coast of the Seward Peninsula.[1] Indigenous peoples first lived in this area over 300 years ago, where they netted fish, scraped sealskins, and ate their dinner from earthenware vessels next to the Snake River (Bockstoce 1979; Eldridge 2014). The town of Nome originated during the 1898 gold rush that brought Euro-Americans, Alaska Natives, and Chukchi villagers together on the remote six-mile stretch of smooth coastline laden with golden sand (Cole 1984; Phillips-Chan 2019). The town soon developed into a bustling center of trade and commerce, as well as a supply depot for travelers venturing farther north or inland across the Seward Peninsula (Bockstoce 2018:60–66). Today, Nome serves as a transportation hub for the Bering Strait region. Alaska Airlines and Bering Air shuttle passengers year-round while Alaska Marine Lines and Alaska Logistics barge mountains of freight to the Port of Nome in the summer and fall. About 3,200 longterm residents call Nome home, with around half of the community identifying as Alaska Native and the

other half as Non-Native. Altogether, Nome encompasses a diverse and rich range of blended families, languages, and cultures that speak to the complex social history of the community and region.

PANDEMICS ACROSS THE BERING STRAIT

Smallpox, influenza, measles, diphtheria, and tuberculosis have swept through the Bering Strait over the past 120 years and left families and communities devastated (Haycox 2020; Jarvis et al. 1900; G. Salisbury and L. Salisbury 2005; Wolfe 1982). Nineteenth-century exploration and Western settlement in the region brought diseases for which Alaska Native communities held little natural immunity. In 1838–1839, Russian-American activity at St. Michael set off a smallpox epidemic that stretched to the Yukon River and along the southern coast of Norton Sound. The disease decimated several villages, including Taciq and Atrivik at St. Michael (Pratt et al. 2013:42–43; Zagoskin 1967:95–100). Spread of respiratory infections across the Seward Peninsula in the late 1800s was further exacerbated by a decline of walrus and caribou herds upon which Native peoples relied as a primary source of nutrition (Burch 2012:70–74; Krupnik 2020; Pratt et al. 2013:43–44). Over the following generations, Native communities demonstrated an incredible resilience to social and ecological adversities and an enduring capacity to pivot to alternative resources.

THE GREAT SICKNESS OF 1900

One of the first major epidemics to strike Nome occurred in the summer of 1900, when an influenza virus arrived aboard steamships to the burgeoning city of 20,000 residents (Wolfe 1982:95–98). Local officials at the time considered the viral disease to be smallpox, which carries initial symptoms similar to influenza, including headache, fatigue, and nausea. Vessels found to have the disease onboard were swiftly put under quarantine and forced to retire to Egg Island near St. Michael. In Nome, Captain D. H. Jarvis ordered "a hospital to be erected, and immediately isolated all persons known to be afflicted with the disease, and all suspects were carefully watched. Within a few weeks all danger of contagion had been destroyed, and with the recovery of the last of the patients in the hospital the building and all of its furnishings were burned" (Harrison 1905:59–60).

Outside Nome, Siberian Yupik traders from Chukotka made their annual summer visit to St. Lawrence Island and Wales and inadvertently carried a measles virus along with their reindeer skins, tea, and other goods. As measles and influenza raced across the Seward Peninsula over the fall, the respiratory diseases merged into concurrent infections, causing severe symptoms and high mortality rates among Alaska Native peoples. One victim was the mother of Emma Willoya, who was traveling down the coast from North Alaska in the fall of 1900 with her mother and father, Captain William Hegarty, on his whaling ship the *Mary D. Hume*. Willoya's mother contracted measles around Port Clarence and soon passed away. Left on her own, Emma spent the remainder of her childhood at the orphanage in Brevig Mission (Bockstoce 1986:327; Willoya 1979:64–65). The influenza-measles epidemic became known as the "Great Sickness" due to its spread throughout Western Alaska from Point Hope to Atka. In Nome, several Alaska Native people are known to have perished during the first month of the epidemic and in Gambell, seventy-

four people, approximately 22 percent of the population, succumbed to the disease by the summer of 1901 (Wolfe 1982:105–107).[2]

1925 DIPHTHERIA EPIDEMIC AND THE SERUM RUN

Arguably the most well-known epidemic to strike Nome occurred during the winter of 1925, when diphtheria broke out and set off a breathtaking relay of dogs and men to bring serum to the isolated town. In 1925, Nome's population had declined to fewer than 1,500 and townsfolk relied on a single physician, Dr. Curtis Welch, and a handful of nurses at Maynard-Columbus Hospital for health care (Coppock 2006). On January 21, Dr. Welsh diagnosed the first case of diphtheria in six-year-old Richard Stanley, an Alaska Native boy, who passed away the next day.[3] With only expired serum at the doctor's disposal, the Nome Board of Health announced a quarantine over the town, and a coordinated effort began to bring fresh antitoxin from Anchorage to Nenana via railroad and from Nenana to Nome via dogsled.

FIGURE 0.3. Museum visitors capture a photograph of "Fritz," one of the lead dogs of Leonhard Seppala during the 1925 Serum Run. March 2022. Photograph by Amy Phillips-Chan.

The resulting Serum Run, or "Great Race of Mercy," involved a relay of twenty mushers and almost 150 sled dogs who crossed 647 miles of snow and ice to bring vials of antitoxin bundled in canvas and furs from Nenana to Nome in five and a half days (B. Thomas and P. Thomas 2015:66–73). Administration of the fresh serum curbed the epidemic and prompted Dr. Welch to remark that "the situation is more favorable at this time than I expected it to be."[4] By the time the disease had run its course, dozens had been diagnosed with diphtheria and five people had perished, a number that without treatment might have reached into the hundreds.[5] Mushers and the lead sled dogs Balto and Togo quickly captured the media's attention and became heroes memorialized in films, cartoons, and books (Phillips-Chan 2019:107–108; Ricker 1928).[6]

The Serum Run continues to elicit fascination from sled dog enthusiasts all over the country. The Carrie McLain Museum fields research requests about the Serum Run every year, and one of the most popular displays at the museum is the stuffed Siberian husky "Fritz," lead dog of Serum Run musher Leonhard Seppala (figure 0.3).

On February 22, 2020, a team of six mushers accompanied by snowmachines, a veterinarian, and a medical doctor set out on a commemorative Serum Run Expedition from Nenana to Nome. The team encountered severe cold, overflow, and a sled dog–snowmachine collision before mushing into Nome on March 12, 2020, the same day as the arrival of the COVID-19 pandemic in Alaska (Haecker 2020a; Johnson 2020). KNOM reporter Emily Hofstaedter (this volume, p. 70) remarked, "I'm following this reenactment of the Serum Run, which is tracing a serious illness in Nome's history, right as we're starting to hear rumbles around the world of coronavirus . . . I'm thinking of those other reporters whose accounts of the diphtheria outbreak I was reading and I thought, 'I'm one of those reporters now.'"

SPANISH INFLUENZA, 1918–1919

The most devastating epidemic to ever hit the Seward Peninsula occurred during the winter of 1918–1919, when the Spanish Influenza took the lives of over 800 Alaska Native and Non-Native adults and children (appendix A; table 0.1). Steamer ships carrying passengers and mail to Nome in the summer of 1918 brought news of an unfolding worldwide epidemic caused by the Spanish Influenza. Nome health officer Dr. Daniel S. Neuman decided to take precautionary measures against the virus. In early fall he began to advise all mail on the *S.S. Victoria*, one of the most frequented passenger ships to Nome, to be fumigated before distribution (figure 0.4).[7] As news from the outside became more alarming, Dr. Neuman sent an urgent telegram to health officials in Seattle on October 9, 1918, with an appeal to carefully inspect all passengers and crew of the *Victoria* before embarking on that year's final voyage to Nome. Neuman warned, "Only two physicians here and they are insufficient for epidemic. Soldiers, Eskimo, and white population must be protected in this isolated section."[8] Three passengers showing signs of influenza were refused passage. The *Victoria* arrived in the Nome roadstead on October 20, after a slight delay due to returning to Port Townsend to let off a sick crewman who had doubtless contracted the virus. Dr. Neuman met the incoming passengers at the lighterage dock in Nome and personally escorted the travelers to Holy Cross Hospital in a solemn procession that made "some of the more timid observers" start to run "when the line of passengers approached on their

journey."[9] *Victoria* passengers were placed under strict quarantine at the hospital while around town, public gatherings were banned, the Dream Theater locked its doors, and schools closed for two weeks. The military base at Fort Davis, located a few miles east of Nome, was also placed under quarantine and social visits to town prohibited. No signs of influenza developed among the *Victoria* passengers over the next few days, and on October 25 residents were allowed to return to their homes.[10]

On October 28, 1918, close to 700 passengers crowded aboard the *Victoria* for the fourteen-day return trip from Nome to Seattle. The departure of Dr. W. d'Arcy Chace, assistant commissioner of health, left only Dr. Neuman to oversee the 450 Non-Native residents and 250 Alaska Natives in Nome and Dr. Henry Burson at Fort Davis to oversee the military staff (Harrison 1905:367–368).[11] The following day, October 29, Dr. Burson made the first diagnosis of influenza in William Bailey, an enlisted man at Fort Davis. Bailey tended to the heating plant at the hospital when *Victoria* passengers were under quarantine, which is where he is thought to have contracted the disease.[12] Nome officials raced to reinstate a city-wide quarantine, suspend church services, and prohibit pub-

FIGURE 0.4. Hundreds of passengers line the deck of the *SS Victoria* upon arrival in the Nome roadstead on June 25, 1918. Carrie M. McLain Memorial Museum, *McLain-833*.

MAP 2. The Spanish Influenza raced along the coast of the Seward Peninsula during the winter of 1918–1919. The disease left mortalities in the villages identified here and led to the desertion of many Alaska Native villages. Map by Dale C. Slaughter.

lic gatherings. Despite efforts to curb the spread, by November 4 active cases of influenza in Nome and Fort Davis had soared to 200.[13] Tending to the infected soon caught up with Dr. Neuman, who fell ill, leaving only Dr. Burson at Fort Davis to oversee the growing epidemic.

Over the next few weeks, outbreaks of influenza flared up across the Seward Peninsula, unknow-

ingly carried by individuals who were in Nome during late October 1918. On November 12, *The Nome Tri-Weekly Nugget* reported that influenza had been confirmed at Candle, Council, Cape Nome, Sinrock, and Cape Woolley (map 2). Eleven-year-old Jerry "Ahsuk" Kaloke was living with his parents and six other families at Cape Woolley when an Alaska Native man named Atunguk from Teller

stopped at Woolley on his way back from Nome. Kaloke (1979:10) recalls people soon began to get headaches, and then "the whole village was nearly wiped out in five days except for my father."[14]

As November 1918 dragged mercilessly on, influenza broke out at Solomon, Bluff, St. Michael, Mary's Igloo, settlements along the Penny and Cripple Rivers, Chinik, and Golovin. By the end of the month, twenty-six white residents in Nome and five at Fort Davis had perished.[15] Even more devastating, influenza had swept through Alaska Native families living close to Nome and taken 175 men, women, and children. The number was so great that Father Bellarmine LaFortune reported that the Pioneer Mining Company was digging a trench 200 feet long for a mass burial of Alaska Natives who had succumbed to the disease.[16]

Other communities were more fortunate than Nome and escaped the epidemic. At Shishmaref, a messenger from Deering arrived in late November with news of superintendent of education Walter C. Shield's death and warned influenza was sweeping across the peninsula and wiping out Native villages including nearby Wales (figure 0.5) (Jones 1919:1). Shishmaref officials and teacher John P. Jones immediately instituted a strict quarantine, discontinued school, halted trapping, and established a guarded outpost eight miles down the coast (Jones 1919:2). Nome resident Sherri Anderson (chapter 36 in this volume, p. 161) remembers her grandmother Katherine Olanna recounting the tale of her grandfather in Shishmaref, who was "one of those people that would have to go stand at a post." The *Nome Tri-Weekly Nugget* on March 24, 1919, detailed one encounter at such an outpost: "Nick Christianson of York is said to have attempted to reach Shishmaref sometime after the influenza had abated in the Wales section but was stopped by a native with a gun a short dis-

FIGURE 0.5. Nome residents Walter and Julia Shields (left) and Wales herder Louis Tungwenuk (right) pose with reindeer horns in February 1910. Walter Shields was the first recorded Nome resident to perish in the 1918 influenza. He left behind his wife, Julia, and seven-year-old twins, Sarah and Tom. Louis Tungwenuk survived the pandemic and carried news to Nome on April 15, 1919, that influenza was finally gone from Wales. Carrie M. McLain Memorial Museum, *Accession 2017.5.*

tance from Shishmaref." Christianson continued to proceed, but the guard fired a shot in warning. When Christianson brought his dog team to a standstill, he saw that the guard had his gun fixed upon him. He stopped and retraced his steps and later stated "he was convinced that the Eskimo would have shot him dead if he had not halted."

At Council, alarming reports from Nome prompted local physician Dr. William Ramsey to post flyers across town on November 8 announcing a strict quarantine over Council and its 150 res-

idents (Ramsey 1919:1). Over the next few months, all social calls were prohibited, residents were advised to wear gauze face masks, and none were allowed to enter or leave the town except by permit from the Health Committee. Similar actions were taken at White Mountain by quarantine officer and teacher J. V. Geary, who visited families every morning to check on their health. Dr. Ramsey stated, "As a result of the most rigid quarantine neither White Mountain or Council ever became the vast field of infection, sickness, and death, as did Nome" (Ramsey 1919:2).

Below-freezing temps, blistering winds, and scant snowfall in December 1918 made sled travel difficult as relief parties from Nome fanned out across the Seward Peninsula to check on neighboring communities. On December 2, news first reached Nome of a dire situation at Teller, where influenza had already taken 60 Alaska Natives and 1 Non-Native from a community of fewer than 80 residents.[17] Sam "Paukingnauk" Ailak was eleven years old when a mail carrier arrived with his dog team at Teller on November 3 and inadvertently brought the influenza virus. Ailak (1979:3) recollected, "I remember one of the last church services we had before the flu. It was the first part of November 1918 and we were crowded in the school room for service. This was one of the last Sundays the Eskimos were together and had communion. By the next Sunday many of them had gone to a more beautiful service to be with their Lord." Additional assistance for Teller was hurriedly sought, and volunteers quickly set off from Nome with medical supplies and clothing. Volunteer Thomas Jensen left directly from Teller to Wales, where "the gravest fears" were entertained for the large Alaska Native settlement from which there had as yet been no report.[18]

The first relief party to Wales arrived on December 4, 1918, and found the community in the grimmest of circumstances. An Alaska Native mail carrier and his two companions had unknowingly carried the influenza virus into Wales, an Inupiaq community of 312 people, on November 9, where it swept through the north and south villages, striking entire families down, and causing orphaned children to freeze to death due to their inability to secure fuel (Nagozruk 1919:2).[19] A total of 170 people perished in Wales, 55 percent of the whole community (Nagozruk 1919:5–14). One of those carried away by the epidemic was Nowadluk/Nowadlook (Nora) Ootenna, who was living with her husband, George Ootenna, and their nine-year-old daughter, Isabel Tayokenna, in the north village (figure 0.6) (Nagozruk 1919:13). News of her death was one of the few Alaska Native obituaries that ran in the *Nome Tri-Weekly Nugget*: "Reports from Wales say Norah [sic], the Eskimo beauty, whose face is well known to the majority of Nomeites through the medium of the portrait studies made of her some years ago by Lomen Brothers, was a victim of the influenza epidemic."[20]

Of the 142 survivors at Wales, almost 100 were children left without parents.[21] Willie Senungetuk was nine years old and living with his family in the north village at Wales when influenza struck. Sixty years later, Senungetuk (1979:12–13) still remembered the trauma of that winter:

> The people were told a bad flu would come
> and by interpreter were made to understand
> how it would be best to take care if it came.
> Then the mail carrier came, and half or more
> of the people of Wales were dead. The territory governors sent help by dog team, food and
> labor. The people who were left were taken

to the schoolhouse until everyone was well. Many children were taken in by their closest relatives. Some children survived staying with the dead until they were located. All of us who were left will never forget that year. It's tough to go through [life] without parents, especially when you are small.

Influenza symptoms first manifested in Wales on November 15, but without a telegraph system the snowbound community was unable to send word of their plight (Nagozruk 1919:2). Community members waited over two weeks for someone, anyone, to come while sickness ravaged their community. Arthur "Angazuq" Nagozruk, US government teacher at Wales in 1918, implored, "If we could communicate through wire or wireless to Teller and Nome this terrible epidemic would have been avoided and a strict quarantine would have been done like other villages who had heard about it before any spread toward them" (Nagozruk 1919:3).

By the end of February 1919, the influenza virus had receded from the Seward Peninsula and left behind a region in mourning. The death toll was bleak: sixty-nine Non-Natives had perished, including those who had become infected during *Victoria's* last sailing of 1918 from Nome to Seattle (table 0.1).[22] The number of Alaska Native deaths was even more staggering: over 720 men, women, and children had died from eighteen known communities.[23] Emma Willoya, who had survived the Great Sickness of 1900, was herding reindeer with her husband in the fall of 1918 when she observed that "villages came to be very small, even the small village close to where we had moved [in the area of Penny River], there had been thirteen families, but there were only three women left . . . They died just like feathers falling down, that's all" (Willoya 1979:66).

FIGURE 0.6. Nowadluk/Nowadlook (Nora) Ootenna and her husband, George Ootenna, were successful Inupiaq reindeer herders from Wales. Nowadluk was a favorite subject of Nome photographers, and her passing in the 1918 influenza was one of the few Alaska Native obituaries that ran in the *Nome Tri-Weekly Nugget*. Photograph by Wilfred McDaniel, Nome, c. 1905. Carrie M. McLain Memorial Museum, *MCD-197*.

Departure of the sea ice in the spring of 1919 brought a difficult choice for those who had survived. Non-Native families weighed the decision to remain in Nome or book passage to places with less-painful memories. There was no question of remaining for Julia Shields, whose husband, Walter C. Shields, had been one of the first victims of influenza in Nome.[24] Julia carefully packed her husband's handwritten journals, photograph albums, and collection of walrus ivory carvings; took the hands of her seven-year-old twins, Tom and Sarah; and swiftly boarded a southbound ship.[25] Fifty years after leaving Nome, memories of 1918 remained so raw that Julia would not speak of her time on the Seward Peninsula, even to her grandchildren (Shields 2017). A similar decision to leave was made by Elizabeth "Lizzie" Mielke, who lost her husband, prominent businessman Frank J. Mielke, during the height of influenza in November 1918.[26] Lizzie and her fifteen-year-old daughter, Clara Mielke, moved to Seattle in the summer of 1919 (figure 0.7). Despite the heartbreak of 1918, Clara stayed in touch with friends in Nome and upon her passing gifted the Mielke family's extensive collection of walrus ivory carvings, grass baskets, and photographs to the Carrie McLain Museum.[27]

For the almost 250 Alaska Native children left without parents, a choice to decide on what would happen next was almost nonexistent.[28] Over the course of the epidemic, the US Bureau of Education provided care for orphans across the Seward Peninsula. Children from small villages or isolated areas were taken to the mission at Teller or brought to the orphanage established at Holy Cross Hospital in Nome.[29] By January 1919, ninety orphans were living in Nome, and the Bureau of Education turned their care over to the Lavina Wallace Young Native Mission and the Catholic Church. Children deemed of "Catholic persuasion" were placed with the Catholic mission at Pilgrim Hot Springs near Mary's Igloo (figure 0.8).[30] The remaining children were transferred to a Methodist-run boardinghouse and school on Second Avenue in Nome. In Wales, the Alaska Native community resisted government efforts to remove the 100 orphans from their village. Acting superintendent of education Dyfed Evans reported, "The natives were much averse to the orphaned children being transported to other places and he [Evans] was repeatedly importuned to 'tell the government not to take our children away.' The natives insisted that the orphans belonged to their village and that they would be cared for by survivors of the epidemic."[31] As a result, many orphaned children at Wales stayed in the community with their adopted families and remained connected to their language and culture.

One hundred years after the influenza epidemic, Nome community members gathered in the fall of 2018 for dedication of the Sitnasuaŋmiut Quŋuwit memorial, which honors the 175 Sitnasuaŋmiut people who perished during the Spanish Influenza as well as those who died in surrounding communities (Mason 2018) (figure 0.9). Present at the dedication ceremony was eighty-nine-year-old Abunaat Atqaq Esther Bourdon (1929–2021), whose parents, Kimasuk (Josephine) and Kauwailak (Michael) Koweluk, were living with their two oldest children in the north village at Wales when influenza struck in 1918 (Nagozruk 1919:12).[32] In between songs performed by the Inupiaq language choir, Gloria Karmun of Nome Eskimo Community commented, "These people laid to rest here are ancestors, family members to many of us . . . and, in their day, laid their foundation for the City of Nome" (qtd. in Hofstaedter 2018).

FIGURE 0.7. Clara Mielke (back row far left) lines up her Nome Sunday school class for a photograph in June 1919. Clara's father, Frank Mielke, was a prominent Nome businessman who perished during the Spanish Influenza. Clara and her mother, Lizzie, relocated to Seattle soon after this photograph was taken. Carrie M. McLain Memorial Museum, *96.7.19*.

FIGURE 0.8. Inupiaq children and adults pose for a photograph with ptarmigan caught in wood snares at Mary's Igloo around 1920. The 1918 influenza devastated Inupiaq families and left behind almost 250 orphaned children. Nome authorities relocated many children to the Catholic mission at Pilgrim Hot Springs near Mary's Igloo. Carrie M. McLain Memorial Museum, *NMP-4–18*.

COVID-19 PANDEMIC, 2020–2021

Dedication of the Sitnasuaŋmiut Quŋuwit memorial had taken place less than two years before the Nome community faced the threat of another widespread pandemic. During the special emergency meeting on March 12, 2020, Nome residents expressed concern that the coronavirus would be carried into Nome through arriving travelers, similar to the Spanish Influenza of 1918 (City

FIGURE 0.9. Nome community members gather for the dedication of the Sitnasuaŋmiut Quŋuwit on October 1, 2018. The memorial features a twelve-foot cross and viewing platform on the West Beach hillside. It serves to remember and reclaim Indigenous autonomy over a nearby mass grave where 175 Sitnasuaŋmiut Inupiat lie who perished in the 1918 Spanish Influenza. Photograph courtesy of James Mason.

of Nome 2020a). Nome youth pastor James Ventress (this volume, p. 88) recalled, "We were interpreting reports from down south through the lens of the historical context of 1918. New York was a major city, and they were falling behind in keeping up with the virus. We are a tiny town with not so many resources. That fear was what was occupying our minds a lot." Soon after that initial meeting, the City of Nome passed a series of emergency orders that sought to limit air travel and reduce public gatherings of people in indoor spaces (appendix B) (City of Nome 2020b; Haecker 2020b, 2020c). Dr. Mark Peterson (this volume, p. 58) commented that the "really intense travel bans into Nome" were a response to those who "had listened to stories and received wisdom from their ancestors who had survived the 1918 flu epidemic. The history of infectious diseases wiping out areas of Alaska really put fear into people."

Following cancellation of 2020 Iditarod activities in Nome, tensions ran high among the iced-in community. Nome resident Derek McLarty (this volume, p. 82) opined, "The City of Nome's decision to close things down was definitely made in a late fashion. Halfway through the week of events before Iditarod, the city was like 'Well, I guess we're going to shut everything down, even though everybody's already here in Nome.' They tried to have their cake and eat it too." Artist Karen Olanna (this volume, p. 127) had a different opinion: "I had lived long enough in rural Alaska to know many stories of the flu epidemic of 1918 . . . I thought the future would bring mass deaths, so I supported the Nome City Council's decision to shut down most Iditarod activities. Even though I had worked hard all winter preparing for art activities for Iditarod week."

Confirmation on April 14, 2020, of the first positive case of COVID-19 in Nome prompted many local organizations to lock their doors and send employees home (Haecker 2020e). Bering Tea & Coffee owner Kristine McRae (this volume, p. 66) remarked, "Closing took some stress off of us, in terms of the virus danger, but it also added stress because we had ordered a lot of supplies for Iditarod . . . So we took a big hit financially after having made that initial investment and then not selling anything for six weeks." A flurry of public service announcements followed the first case of COVID with health and safety recommendations that suggested setting up virtual playdates for children and sharing snowmachine or four-wheeler rides with only your immediate family.[33] City of Nome manager Glenn Steckman (this volume, p. 78) explained, "It was really about trying to balance the concerns of the Alaska Natives, who remember through generational stories the big sickness of 1918, and those in our community who didn't quite buy into the complete shutdown of the city."

Threat of a potential COVID-19 outbreak in the Bering Strait region seemed to fade over the summer of 2020, when just a handful of cases were identified, and residents took to the tundra to enjoy their usual activities of picking berries and gathering greens, drying fish, and spending time with family at camp. Nome resident Brandon Ahmasuk (this volume, p. 165) remarked, "I was still able to do all my hunting and fishing during the pandemic. Subsistence activities fall right in with social distancing: getting out and getting away from everybody. We could be up at camp for weeks and not see anybody. I think this was a subsistence user's time to shine."

Then on October 8, 2020, the community of Gambell experienced the region's first outbreak, with over thirty positive cases of COVID-19. Village public safety officers delivered food and supplies to

affected households in Gambell, as well as hauled water for those without indoor plumbing. Isolation from friends and family was particularly difficult for the community of 700, as noted by Gambell resident Charlotte Apatiki. "It's especially hard when you have close-knit families that are so used to spending so much time together" (Smith 2020c). Just over a month later, Nome experienced its first outbreak, when a positive case of COVID-19 at a local bar led to a surge of fifty active cases in just a few weeks (Smith 2020d, 2020f). Nome City Council quickly responded to the outbreak with closure of bars and restaurants, local schools returned to distance learning, and public holiday celebrations were canceled, among them, the Nome Volunteer Fire Department's Fireman's Carnival and the City of Nome's Christmas Extravaganza (Smith 2020e).

Most schools in the Bering Strait region returned to in-person classes in January 2021. In March, mushers of the Iditarod Trail Sled Dog Race did not come to Nome for the first time in race history, and residents hosted an alternative Winterfest with outdoors races and contests (Mason 2021). Nome resident Julie Farley (this volume, p. 177) enthused, "I am just amazed at how people came through with their little activities and festivities here in Nome . . . There were snowmachine races and dog races in between the storms . . . It gave you hope for the future." COVID-19 cases ebbed and flowed across the region during the summer, with outbreaks in Stebbins and St. Michael that sent the communities into lockdown mode in August (Lerner 2021a). Then on October 13, 2021, more than a year and a half into the pandemic, the Bering Strait region experienced its first COVID-19–related death (Lerner 2021c). A month later, a pediatric version of the Pfizer COVID-19 vaccine arrived in Nome, and doses were quickly distributed to villages in the

FIGURE 0.10. Gambell Health Aide Marina Koonooka embraces her daughter Lena, the first five-year-old in Gambell to receive a Pfizer vaccination for COVID-19. November 2021. Photograph courtesy of Norton Sound Hospital.

Bering Strait (NSHC 2021a) (figure 0.10). As the year 2021 drew to a close, approximately 75 percent of the Bering Strait region had received a vaccination, and active cases outside of Nome were declining (NSHC 2021b) (figure 0.11). At the start of 2022, the Bering Strait region had experienced three deaths due to COVID-19, and communities were experiencing a resurgence in cases related to the Omicron variant (Loewi 2022; NSHC 2022).

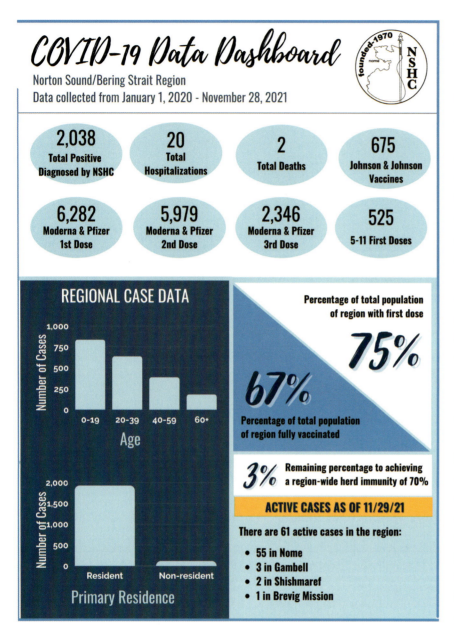

FIGURE 0.11. Norton Sound Health Corporation kept residents in the Bering Strait region apprised of active COVID-19 case counts through a weekly COVID-19 Data Dashboard. The week for November 28, 2021, is shown here. Data Dashboard courtesy of Norton Sound Hospital.

MITIGATING PANDEMICS IN THE BERING STRAIT REGION

Precautionary measures taken by local officials to reduce the spread of the Spanish Influenza and COVID-19 in the Bering Strait region carry remarkable similarities despite the 100-year time difference. Infectious disease experts in 1918 recognized that the influenza virus could be transmitted through contaminated air. The *Victoria* was thoroughly fumigated in October 1918 before passengers boarded the ship for their return trip to Seattle.[34] Similar steps were taken in 2020 by Alaska Airlines, which expanded COVID-19 safety measures onboard their aircraft, including equipping planes with hospital-grade air filtration systems, limiting the number of guests, and using electrostatic sprayers to disinfect surfaces (Alaska Airlines 2020). Twenty-first-century travelers also became accustomed to mandatory use of face masks while inside terminals and airplanes (figure 0.12).

The City of Nome instituted additional precautions against COVID-19 beginning in March 2020, with the introduction of essential air travel permits followed by a quarantine period for all travelers flying into Nome via the Anchorage airport (figure 0.13) (Haecker 2020d). In May 2020, a white testing tent for COVID-19 sprung up outside the Nome Airport and soon expanded to include two heated weather ports for passengers waiting to get tested (Haecker 2020f). Nome implemented air travel requirements to protect both local residents and regional community members who had to fly through town when returning from outside the region. Not everyone agreed with the travel precautions. City manager Glenn Steckman remarked (this volume, p. 78), "People are feeling like they're trapped on the island, and if they get off the island,

FIGURE 0.12. TSA agent Wayne Arrington helps to ensure COVID-19 safety protocols are followed inside the Alaska Airlines terminal in Nome. June 2020. Photograph by John Handeland.

then they have a choice of going through a seven- or a fourteen-day quarantine." Norton Sound Hospital offered free "Quarantine Lodging" for Alaska Native travelers stopping in Nome on their way to other villages in the region and stressed that the hospital honored "the community's leadership travel restrictions" (NSHC 2020a).

Medical personnel in 1918 also realized that the influenza virus could be carried by infected indi-

FIGURE 0.13. Recent arrivals at the Nome Airport stand in line to get tested for COVID-19. From March to December 2020, the City of Nome required incoming travelers from Anchorage to quarantine and complete a travel activity form. June 2020. Photograph by John Handeland.

viduals traveling into surrounding villages. Council was one of the first communities to be infected with influenza and quickly formed a Health Committee to control all movements in and out of town.[35] On December 16, 1918, Nome city health officer Dr. Daniel S. Neuman reiterated that the quarantine over Nome would not be lifted for some time, mail was not allowed to leave or enter the city, all unnecessary travel was discouraged, and no one was allowed to leave town without permission from the local health authorities.[36]

City of Nome officials made comparable efforts to control the spread of disease within town in 1918 and 2020. In October 1918, Nome officials closed the public schools, shuttered the Dream Theater, prohibited church services, and banned public gatherings.[37] Similar action was taken in March

2020, when trips to grocery stores became limited, city facilities closed to the public, and Nome Public Schools transitioned to distance learning (Mason 2020).[38] Nome high school senior Ava Earthman (this volume, p. 54) recalls what it was like to take classes remotely: "My physics class started at eight in the morning, so I would call in and go back to sleep immediately. It was difficult, especially because I didn't have internet at home … everybody else could see each other, and that was sad for me."

In April 2020, the City of Nome began promoting the use of face masks to curb the spread of COVID-19.[39] Local youth embraced face masks as both a business venture and science experiment, including ten-year-old Neva Horton, who spent her summer sewing and selling cloth masks and eleventh grader Bode Leeper, who tested the effectiveness of various face coverings to block airborne droplets (M. Thomas 2020, 2021). Grocery stores in Nome started requiring patrons to wear face masks in July 2020, and directional arrows and social distancing decals soon popped up in grocery store aisles (Smith 2020a). On October 2, 2021, the City of Nome issued its first face mask mandate for all indoor public spaces following a rise of COVID-19 cases in town (Lerner 2021b).

The use of face masks in Nome in 1918 began to appear almost immediately after the arrival of influenza. Face mask users were applauded by local newspaper staff, who claimed their efforts were "aiding themselves and the community in stamping out the influenza germs."[40] Face masks made from gauze or cheesecloth were considered essential safety items and were carried by relief parties alongside medicine and clothing to surrounding Alaska Native communities.[41] The resumption of mail service across the Seward Peninsula in February 1919 included a long list of restrictions for mail carriers who had to exchange their parcels twenty feet apart, isolate their dogs, and, when in close contact, "wear over nose and mouth, masks made of eight folds of cheesecloth—always same side out."[42]

Organizational health efforts to educate the general public about the spread of infectious diseases followed similar promotional strategies in 1918 and 2020. In the fight against the Spanish Influenza, the US Army Corps encouraged individuals to "Remember the three C's—a clean mouth, clean skin, and clean clothes" (figure 0.14).[43] For COVID-19, the Alaska Department of Health and Social Services also relied on a triple-C acronym to motivate individuals to avoid "closed spaces, crowded places, and close contact situations" (Alaska Department of Health and Social Services 2022). Likewise, repetition of the "3 Ws"—"wear a mask, wash your hands, and watch your space"—appeared on everything from street signs to T-shirts in 2020 and 2021 (figure 0.15).

Educational messages on how to remain healthy during the Spanish Influenza were frequently published in the *Nome Tri-Weekly Nugget*. However, messaging was strictly geared to English-speaking residents of the region. During the COVID-19 pandemic, Norton Sound Hospital worked with Alaska Native language speakers on Indigenous-language messaging. Vera Metcalf (this volume, p. 158), originally from Savoonga, remarked, "I worked a lot with Norton Sound Hospital doing public service announcements for them in Yupik. I did the best I could to figure out new terminology and explain all the precautions we have to do, especially during our spring season, when boats are getting ready to go out." The Alaska Native Tribal Health Consortium also worked with Alaska Native language experts to produce a series of videos and culturally relevant infographics about COVID-19 specifically for tribal

HOW TO STRENGHTEN OUR PERSONAL DEFENSE AGAINST SPANISH INFLUENZA

1. Avoid needless crowding—influenza is a crowd disease.

2. Smother your coughs and sneezes—others do not want the germs which you would throw away.

3. Your nose, not your mouth was made to breathe through—get the habit.

4. Remember the three C'c—a clean mouth, clean skin, and clean colthes.

5. Try tc keep cool when you walk and warm when you ride and sleep.

6. Open the window—always at home at night; at the office when practicable.

7. Food will win the war if you give it a chance—help by choosing and chewing your food well.

8. Your fate may be in your own hands—wash your hands before eating.

10. Don't use a napkin, towel spoon, fork, glass or cup which has been used by another person and not washed.

11. Avoid tight clothes, tight shoes, tight gloves—seek to make nature your ally not your prisoner.

12. When the air is pure breathe all of it you can—breathe deeply".

CHAS. RICHARDS
Brigadier Genera, Medical Corps
Acting Surgeon General
U. S. Army.

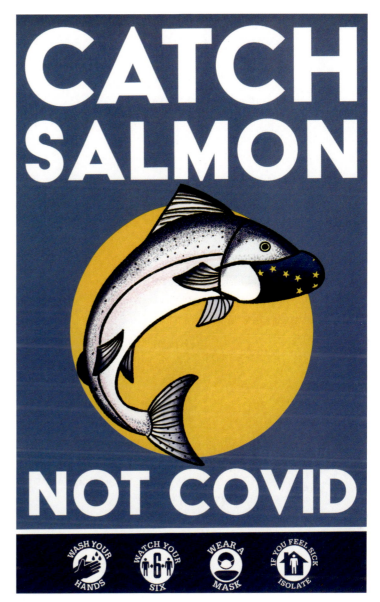

FIGURE 0.14. (*left*) The *Nome Tri-Weekly Nugget* ran local and national recommendations to safeguard residents against the Spanish Influenza. This precautionary list by acting surgeon general of the US army Charles Richards appeared in the *Nugget* on November 4, 1918, and urges, among other advice, "Smother your coughs and sneezes—others do not want the germs which you would throw away."

FIGURE 0.15. (*above*) A promotional flyer distributed in 2021 by the Alaska Department of Health and Social Services encourages individuals to practice the "3 Ws" of safety and "Catch Salmon Not COVID." Collection of the Carrie M. McLain Memorial Museum.

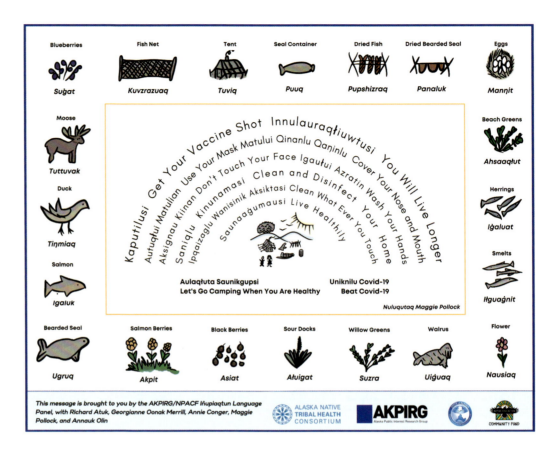

FIGURE 0.16. The Alaska Native Tribal Health Consortium organized a series of Alaska Native Language Panels who convened virtually to create culturally relevant messages about COVID-19 in eight languages. This Inupiaqtun message about COVID-19 prevention and wellness was created by the AKPIRG/NPACF Inupiaqtun Language Panel with Richard Atuk, Georgianne Oonak Merrill, Annie Conger, Maggie Pollock, and Annauk Olin. Courtesy of the Alaska Native Tribal Health Consortium.

communities (Alaska Native Tribal Health Consortium 2021) (figure 0.16).

Despite parallels that can be drawn between safety measures enacted during the Spanish Influenza and COVID-19 pandemics, the diseases resulted in very different outcomes for the Bering Strait region. Over 800 deaths occurred within three months of the Spanish Influenza, while the COVID-19 pandemic lingered in the region for over two years and led to 3 reported deaths at the end of 2021. Perhaps the most significant change between the two epidemics has been improvements in communication with the outside world. Due to its remote location, Nome residents relied on often-outdated reports in the newspaper and word of mouth from arriving ship passengers to glean information about the Spanish Influenza.[44] In contrast, online news sources in 2020 provided residents with almost minute-to-minute coverage of COVID-19 beginning with its outbreak in Wuhan, China, to its spread across international borders and into Alaska. Online meters and data dashboards posted by the Alaska Department of Health and Social Services, Anchorage Daily News, and Norton Sound Health Corporation (NSHC) further allowed Nome residents to track the spread of COVID-19 and make informed decisions about participation in public activities (see figure 0.11).

Communication within the Bering Strait region has also made dramatic strides since the Spanish Influenza. If news of the influenza could have been speedily transferred from Nome to surrounding villages, the death toll could have been much lower, particularly at Solomon, Teller, and Wales. During the COVID-19 pandemic, regional communication efforts included, among others, COVID-19 Tribal Leadership calls hosted by NSHC and a weekly Public Information Coordination Call led by the Department of Health and Human Services. Dr. Mark Peterson (this volume, p. 58) affirmed, "We formed our own incident command team that includes administrators, physicians, and nursing staff, and we met every morning for months. We bonded by leaning on the support of each other." Likewise, the City of Nome activated its Emergency Operation Center (EOC) in April 2020 and over the next two years held regular meetings that brought staff together from organizations across town to share information and work on specific activities related to the COVID-19 emergency plan.[45] The coordinated calls and meetings allowed communities to share information with one another, provide and request support, and actively collaborate to safeguard the region against the virus.

The availability of medical assistance for rural villages in the Bering Strait has increased exponentially over the past few generations. Many communities—including Wales, Golovin, and Shishmaref—did not have a resident physician in 1918. Instead, community members often relied on the basic medical knowledge and supplies of a local schoolteacher or government nurse. When Duncan McLean returned to Nome in mid-November 1918, he reported that influenza was raging at Cape Woolley and that it was likely that the four families residing there would perish. This terrible news prompted newspaper staff to implore, "It is too bad the government has not got more nurses and hospitals for the care of the natives and the fearful mortality would not be so destructive as it has been during this epidemic although the cry for years has been raised for this much needed branch of the public service and no response to the appeal has been made."[46] Even Nome, the largest settlement in the region, had only two doctors, and that number could easily drop to zero as seen in the fall of 1918, when Dr. Chace left for Seattle and Dr. Neuman fell ill.[47]

Transporting medical supplies from Nome to regional villages by boat, horse team, or dogsled posed a logistical challenge in the early twentieth century. During a severe winter storm in January 1919, it took eleven days for a relief party to travel the sixty-five miles from Teller to Wales by dog team.[48] Automobiles in Nome were rare during the early 1900s, as they were prone to get bogged down in the muddy roads and soggy tundra. However, a vehicle owned by William Webb was put to good use on November 22, 1918, when Mrs. Charles Larson rushed to Solomon in the automobile and from there caught a ride on a dogsled to Bluff, where Mrs. Finn Rosvold and her child were very sick with influenza.[49] On return to Nome, the automobile was loaded up with the mail from Solomon and picked up six Alaska Native peoples at Safety Sound.

Today, every village in the Bering Strait region has a local clinic staffed with trained health professionals and medical supplies (e.g., Lean 2021). During the COVID-19 pandemic, free telemedicine and distribution of supplies from Nome to surrounding villages ensured communities received ample quantities of test kits, face masks, vaccinations, and other critical resources (NSHC 2020b,

2021c). In Nome, Dr. Mark Peterson (this volume, p. 59) agreed, "We have been able to continue medical care in the villages through telemedicine . . . There is a benefit to having people receive medical appointments remotely because it limits the spread of viruses and germs . . . It's amazing how much can be done by Zoom or by teleconference or telephone. Thank goodness we have all these key capabilities that we didn't have many years back."

ACTIVATING MUSEUMS DURING A PANDEMIC

The COVID-19 pandemic prompted museums across the country to close to the public. Exhibit surfaces, interactives, and confined viewing areas all seemed to pose a significant threat in transmitting the coronavirus. On March 16, 2020, Alaska governor Mike Dunleavy, in coordination with the Department of Health and Social Services (DHSS), issued a mandate that closed state-operated libraries, archives, and museums to the public for an initial two weeks (Office of Governor Mike Dunleavy 2020a). Alaska libraries and museums did not receive official approval to reopen until two months later, on May 22, 2020, as part of Phase Three of the Reopen Alaska Responsibly Plan (Office of Governor Mike Dunleavy 2020b). While museums grappled with how to shift to remote visitor engagement, "Museum from Home" initiatives sprung up across the country. An online search for #MuseumFromHome takes one to collections, virtual tours, and educational activities designed for families, teachers, and individuals to explore from the comfort and safety of home.

Arrival of COVID-19 in the United States led museums to make creative pivots to online delivery of educational programs, exhibitions, and workshops. A proliferation of oral history projects and collecting initiatives sprung up as organizations raced to preserve the items, memories, and experiences of the pandemic (see Chambers 2021; Errico 2020; New York Public Library 2020). A unique challenge arose as museums like ours in Nome began to amass stories and objects while facilities remained closed to the public. Some organizations quickly launched online exhibits to share new materials, whereas others began to develop physical exhibits to coincide with reopening of their institution (see Arrajj 2021; Cooper Hewitt 2021). Enthusiastic public response to these efforts demonstrated that twenty-first-century museums are strategically positioned to serve as places of meaning making and connection during public health emergencies.

Today's modern museum facilities, trained staff, collecting policies, and online tools offer critical infrastructure to actively participate in the collection, preservation, and sharing of history as events unfold. Active community participation in capturing and co-creating historical narratives can also generate positive social impact during intense periods of anxiety and instability. An invitation in April 2020 from the National Museum of American History (NMAH) to share pandemic-themed objects resulted in hundreds of donations. Benjamin Filene, associate director for curatorial affairs at the NMAH, remarked, "I think our constituents sense that they have been living through a historic moment and they are searching for ways to process what they have experienced" (Filene 2021). For *Stronger Together*, artist Ryder Erickson (this volume, p. 124), from Unalakleet, shared, "I am grateful that *Quality Time* is a part of this initiative because if there is anything good that can come out of these times, I am happy to be a part of it." For artist Elaine

Kingeekuk (this volume, p. 137), of Savoonga, *Stronger Together* provided an opportunity to express her thoughts on the pandemic through symbolic imagery, "I wanted to use the crab design [on the mask] because due to COVID-19, everybody in this whole world, for the first time in a long time, was holding on together like a crab. Scientists were trying to get a vaccine, and religious people were praying for each other. We were all listening to the news and holding on together."

THE ELUSIVE HISTORY OF THE 1918 SPANISH INFLUENZA

In 1918, the Territory of Alaska had around 58,000 residents and three main museums that struggled to find permanent places to store and display their materials.[50] Nome received its first museum in 1967 with the use of centennial funds from the State of Alaska. The museum's initial focus on mementos from the heady gold rush days contributed to an absence of materials from later disheartening events including the Spanish Influenza (Phillips-Chan 2020:26–27).

In addition to the absence of a Nome museum in 1918, the height of the influenza occurred in the middle of a severe winter. Residents would have sought warmth indoors rather than venture out into below-freezing temperatures to try to take photographs around town. Likewise, prevailing sentiment at that time would not have looked favorably on community members snapping macabre photographs of the sick or dead. There was also uncertainty on how the virus could be transmitted, mail and infected households were fumigated, and it is conceivable that everyday items were looked upon with suspicion. Finally, the influenza was an incredibly emotional and devastating event on the Seward Peninsula. I imagine that community members had neither the heart nor strength to think about preserving items for posterity, capturing images, or penning reflective thoughts during those few months that must have stretched on like an eternity.

One of the few objects in the Nome collection from 1918 is a reindeer collar in which Inupiaq herder Samuel Nuipok carefully carved his name and the date "February 8, 1918" into the wood (figures 0.17, 0.18). Nuipok managed to survive the epidemic that winter and ten years later made news for shooting a six-foot-long gray wolf that had been killing reindeer along the Sinrock River.[51] Another museum item from 1918 includes a pair of diminutive leather gloves given to eighteen-month-old Shirley Humber by her father, mail carrier Robert Hart Humber, from Candle (Harrison 1905:277–278) (figure 0.19). Shirley received the gloves to wear on a voyage "Outside" to meet her grandparents in the summer of 1918, a fortuitous trip that took the family far from Nome while influenza swept across the tundra.

Among the few photographs taken around Nome in 1918 are a handful of somber images that show flags fluttering over the newly dug graves of influenza victims at Fort Davis (figure 0.20). The near absence of a visual record of the Spanish Influenza in Nome is in stark contrast to the flood of pandemic-themed images and posts that populated the social media pages of residents and the *Nome Nugget* newspaper in 2020 and 2021. Oral history accounts from 1918, particularly those from Alaska Native peoples, are even scarcer and most were recorded decades after the flu. One poignant oral history was shared by Inupiaq Elder Lela Kiana Oman (Ahyakee) (1915–2018), who recounted the death of two families at Cape Nome for the Nome Communities of Memory Project in 1996.[52]

FIGURE 0.17. Reindeer collar and harness used by Inupiaq herder Samuel Nuipok in 1918. Nuipok survived the epidemic and eventually moved to Nome with his wife and five children. Wood, canvas, sealskin, metal. Length 114 cm (45 in.). CMMM 2007.10.1327.

FIGURE 0.18. A red metal tag stamped with the image of a deer appears above the inscription "Sam Nuipok, C.D. H." on the collar shown in figure 0.17.

FIGURE 0.19. A pair of framed leather gloves worn by eighteen-month-old Shirley Humber on a summer trip in 1918 to the "Outside" that potentially saved her life. Length 20.3 cm (8 in.). CMMM 2021.16.1.

FIGURE 0.20. A boardwalk leads to the fenced-in graveyard at Fort Davis with the graves of five soldiers from the 1918 influenza: George Hadley, Oscar Hendricksen, Morris Pascoff, Tacitus Maheras, and Andy Thompson. University of Alaska Anchorage, Consortium Library, Archives & Special Collections, UAA-HMC-1086-56.

The 1919 Annual Report to the Bureau of Education by Arthur Nagozruk (Nagozruk 1919), US government teacher at Wales, arguably offers the most information on Alaska Natives during the epidemic, with ten pages of names, genders, and ages of those who lived and died in the north and south villages at Wales.

By far, the most detailed information about the Spanish Influenza in the Bering Strait region can be found in the brittle, yellowed pages of the *Nome Tri-Weekly Nugget*. *Nugget* reporters at the time recorded closures of local facilities, relief efforts, the names of those who became ill, and those who perished. And while newspaper accounts include all sixty-nine names of the Non-Natives who died, fewer than ten Alaska Native names were printed out of over 700 Alaska Native peoples who perished. This disparity of recorded information about Alaska Native peoples speaks to colonial perceptions at the time, as well as to differences in languages and cultures, and an overall shortage of communication with Indigenous peoples in the region.

Over 100 years later, the *Nome Nugget* made a commitment to researching and reporting news of COVID-19 with dedicated space on each front page for the pandemic. Unlike 1918, today's newspaper featured first-person voices and perspectives from diverse cultural backgrounds. Anne Marie Ozenna was one of the first residents of Nome to share her experience of COVID-19 with the newspaper: "It's like you have the flu but its heavy on your chest . . . I went to the hospital for a couple days because I got anxiety from it . . . Family members gave me stinkweed juice," a traditional Inupiaq cold remedy.[53] When the Carrie McLain Museum considered what role it could play during COVID-19, we looked to the blank pages of our past and then to documentation of the present by the *Nome Nugget*. The news-

paper was effectively publishing the broad strokes about COVID-19, so our museum decided to pursue a series of oral histories that would focus on diversity and inclusivity to help offer an equitable conversation about the pandemic in our region.

STRONGER TOGETHER: BERING STRAIT COMMUNITIES RESPOND TO THE COVID-19 PANDEMIC

Threat of the COVID-19 pandemic closed the Carrie McLain Museum to the public on March 13, 2020. Departure of staff soon followed, and the museum had to evaluate its core strengths to determine how we could continue to have a positive community impact during a growing period of disconnection. Although we were not positioned for remote delivery of programs and services, we were fortunate to hold longitudinal relationships with local community members. We also had funds in our operating budget that could be shifted to meet emerging needs. This flexibility allowed us to draw on existing relationships to launch "Documenting COVID-19 in Nome, Alaska: An Oral History Project" in September 2020. A month later, our museum began a complementary "COVID-19 Artist Initiative," which invited creative responses to the pandemic through visual works of art. A second series of oral histories was held in March–April 2021, and that fall we worked with poets to contribute written pieces to the project. Like the pandemic, the collective project *Stronger Together* surged forward and slowed down over three years, while the museum and our partners went through a series of transitions in our home and work lives. Through it all, a commitment to co-creation of knowledge about COVID-19 kept the project centered on chronicling an inclusive and insightful narrative for generations to come.

COVID-19 ORAL HISTORY PROJECT

The Carrie McLain Museum began planning our COVID-19 oral history project during a singular sun-dappled summer for Nome in 2020. The project placed collaborative history as our primary aim and drew inspiration from oral history initiatives being undertaken at other museums, among them the Smithsonian National Museum of American History and the Ketchikan Museum. News reporter RB Smith joined the museum early on as an oral historian in 2020, and local historian Carol Gales came onboard to record oral histories in 2021 (figure 0.21). The museum initially announced the COVID-19 oral history project through social media, the *Nome Nugget*, local radio announcements, and a printed flyer that staff posted on announcement boards around town. Similar to previous experience, a general call for participation was not very effective in garnering community interest in the project. The museum subsequently drafted a working list of participants that represented a diversity of ages, genders, cultural backgrounds, and occupations. Direct invitations to participate in 2020 and 2021 received a more positive response, and oral history interviews were held remotely and in person with thirty-six community members. Audio and film recordings from the interviews were transcribed, shared with participants, edited for this project, and placed in the museum archives.

The COVID-19 pandemic highlighted issues of access, equity, and belonging that prompted cultural institutions across the country to take a hard look at whose voices were preserved in the past and whose stories should be included in the present narrative. Nome-Beltz High School teacher Mike Hoyt (this volume, p. 173) emphasized the importance of including diverse voices: "As someone that teaches

FIGURE 0.21.
Oral historian
Carol Gales inter-
views Nome resi-
dents Howard and
Julie Farley inside
the Carrie McLain
Museum. April 15,
2021. Photograph by
Amy Phillips-Chan.

history, and especially Alaska history, I've placed a big emphasis on epidemics in the past. This is definitely going to be in the history books. So then we started asking questions: 'How do we tell that story? Who gets to tell that story? . . .'" For the oral history project in Nome, participants spoke from their unique positions as business owners, fishermen, tribal and city leaders, medical professionals, students, teachers, and community service providers. Open-ended questions invited participants to share personal experiences of the pandemic on their own terms. Some of the questions focused on challenges and coping mechanisms: What has been the toughest part of the pandemic for you? What has given

you comfort and hope during this past year? Other questions spoke to the physical impact of COVID-19: Have you or someone you know had COVID-19? What was that experience like for you? Questions also invited participants to think about the future: If the pandemic ended tomorrow, what is the first thing you would do? What would you like Nome residents to remember about the COVID-19 pandemic 100 years from now?

One of the biggest challenges faced by Nome residents was the closure of schools and the transition to stay-at-home parents and teachers while attempting remote office work. Tiffany Martinson (this volume, p. 52) recalled, "We were all working at

home and my kids were home with me. That was a nightmare! At first, we were all set up at our kitchen table so I could monitor them while I was working. But it got to the point where I found myself doing things for them that they should be doing on their own. I would just have to put my foot down and say, 'I'm not your babysitter. Just pretend I'm not here!'" Melissa Ford (this volume, p. 167) stated the number of take-home worksheets was so daunting that they switched to homeschooling for which they "were able to create classes . . . The boys decided they were interested in gold mining . . . My daughter picked up a paintbrush and became quite the artist." Teachers also struggled with additional precautions when classes resumed to in-person learning. Mike Hoyt (this volume, p. 173) explained, "You make a mental note of whatever the students touch to wipe it down—tables, chairs, pencils. We have five minutes between periods and having to wipe everything down, while trying to make sure you have enough printed material and all of these other things going on, it was a very exhausting teaching year."

Social isolation during the first year of the COVID-19 pandemic also took its toll on residents in the geographically insular town of Nome. Elder Kitty Scott (this volume, p. 74) remarked, "Spontaneous visiting of friends was the first to go, and that's quite popular in smaller isolated locations. Visiting has come to a screeching dead halt, and I miss it." Carol Seppilu (this volume, p. 62) agreed: "I stayed away from family and friends because my parents are both elderly and I didn't want to risk bringing the virus to them. My life before the pandemic was pretty quiet, but it was really lonely not being able to go visit my parents whenever I wanted to." Community members also felt the absence of community gatherings for Alaska Native dancing, arts and crafts fairs, and holiday events. Emily Hof-

staedter (this volume, p. 71) reminisced, "One of the things that I missed so much is the Western Alaska potluck culture, a last-minute call-up of a bunch of people who throw together food. It's a really deep part of culture here."

Despite struggles caused by the pandemic, Nome residents turned to the surrounding tundra and sea for healing and renewal. Long summer days spent fishing, berry picking, and hiking provided plenty of fresh air and boosted personal wellness. "This summer, I spent a lot of time out on the Teller Road, berry picking, or looking for berries. We were fishing, picnicking, and going to Teller. Every weekend. It was good. We realized how much we missed our Eskimo dancing and our Eskimo foods," said Anne Marie Ozenna (this volume, p. 169). Community members also enjoyed crafting, baking, and taking up new hobbies during periods of solitude. "I craft, so I occupy a lot of my time making masks for other people and sewing and knitting for family. That's how I've been occupying my time since COVID hit," said Josie Bourdon (this volume, p. 72). Teenager Ava Earthman (this volume, p. 55) agreed: "I also had a lot of quarantine time to read books that I hadn't read before. I had so much time that I made myself curtains. I attempted to learn how to cook. It was great."

Nome residents shared that they found a renewed sense of purpose for the work that they do. Reporter for KNOM Emily Hofstaedter (this volume, p. 70) remarked, "By the time Iditarod comes, you're already feeling burned out as a reporter up here. Then COVID happened, and it just happened and happened . . . But I think people did appreciate having us running those news stories and those announcements . . . So it was a time when I really felt like my job was part of the public good." Boys & Girls Club director Ryan VandeVere (this volume,

p. 91) expressed a similar view that, despite operational complications during COVID, "the mindset of the mission lives on, and it will always find a way to meet the purpose that it's there for: to provide our youth with opportunities to grow, learn, and have fun as young citizens in this community."

Norton Sound Hospital instituted an aggressive COVID-19 testing strategy for Nome and the Bering Strait region as soon as the coronavirus arrived in Alaska. Residents and nonresidents in Nome could receive free rapid response testing inside tents set up outside the Nome Airport, Norton Sound Hospital, and eventually inside the NSHC Operations Building. Nome resident Adem Boeckmann (this volume, p. 80) opined, "We have tested the heck out of it; we have to have some of the highest testing in the state." Other residents such as Tiffany Martinson (this volume, p. 53) found comfort in the ease of getting tested: "The availability of testing in our area has been tremendous; it was nice to be able to have that opportunity, knowing that it's not available everywhere." Emergency room nurse Mary Ruud-Pomrenke (this volume, p. 174) explained how symptomatic patients were tested: "We had a separate room at the hospital—we called it our COVID room—for patients who had symptoms like coughs, fevers, chills, diarrhea, and loss of smell or taste . . . We would go in wearing full PPE, a gown, a mask, a face shield. That's where we would perform rapid COVID tests. If they had a negative test, we could move them into the ER and continue our routine with patient care."

The first documented case of COVID-19 was confirmed in Nome on April 14, 2020. At the close of the museum's second round of oral histories on April 15, 2021, there had been over 200 cases of COVID in Nome. Four participants in this project shared their different experiences with COVID.

For Bering Air employee John Lane (this volume, p. 162), a positive COVID test caused a minor disruption to home and work life: "I had a cold. I had a runny nose for one day. A day and a half later, and I was 100 percent fine . . . to just sit there for ten days, I started getting really upset . . . She [my girlfriend] would leave a tray of food at my doorway, and then we would wait about two or three minutes. She would walk away, and then she would text me, 'Okay your dinner's on the tray by your door,' and then I would sneak out and get it." Elder Julie Farley (this volume, p. 176) experienced the more severe symptoms of COVID: "It started with a dry cough. Then I started getting cold . . . I couldn't eat anything except ice water. The phlegm in my mouth was always there . . . While I had the virus, I lost fifteen pounds. . . . I don't know if I was scared or not, because I didn't believe in the pandemic . . . I kept telling Howard [my husband], 'It's a hoax, Howard.' Because nobody died in our immediate area. To me, it was a hoax, until I got it."

Anne Marie Ozenna tested positive for COVID in August 2020 following a shopping trip to Anchorage for her kids' school supplies that left her weak and nauseous. "I had a runny nose, headache, and fatigue . . . I felt dizzy, light-headed, and was not eating . . . I became more scared when I realized that my daughter and my grandson had caught COVID too . . . When I couldn't handle my breathing and became more scared from it, I was admitted into the hospital for a couple of days. I just slept and slept" (this volume, p. 168). Three months later in November, Josie Stiles went outside of her "bubble" to join some friends for dinner and started feeling ill a few days later. After several days of chills and sweats, she recalled, "I had no energy. I just stayed in bed. Friends would shop for me and drop off Gatorade and juice and Jell-O . . . I spent Thanksgiv-

ing by myself. My daughter brought me a plate of food with turkey, and a friend brought me a pie... I think the worst part for me was being alone" (this volume, p. 170).

An underlying hope to safely resume travel again is woven through several oral history accounts. "I normally frequent Anchorage about every month to visit my brother and to go shopping and dining. It's strange to have not been on an airplane," said Josie Bourdon (this volume, p. 72). Bob Metcalf (this volume, p. 158) shared that in August 2020, "we finally decided we needed to see our family. We got tested before we went. We were super cautious. Our granddaughter is eleven years old. She was so happy to see us... The most important thing we have had to do is to keep in contact with our family and be a part of their life and her life."

Project participants stressed the significance of caring for your family and community when asked what they would like Nome residents to remember about the pandemic. "What I want to tell people about this time is the importance of connection with the family and how tight it makes a family become. Your family circle's going to be the one that holds you up and keeps you glued together," remarked Josie Bourdon (this volume, p. 73). Kristine McRae (this volume, p. 67) affirmed, "We are a community that supports each other. I think if you were to ask people, 'What's your true goal?' it would be to save lives and to keep people safe." Mayor John Handeland (this volume, p. 77) concurred that Nome's community response had shielded the town from the worst of the pandemic but still cautioned, "We need to continue to be vigilant and diligent in our safeguarding of ourselves and others as we're moving forward. You know the old saying, 'Those that forget history are doomed to repeat it.'"

COVID-19 ARTIST INITIATIVE

Indigenous artists from the Bering Strait region have drawn inspiration from local resources for generations and transformed walrus ivory, bone, baleen, animal skins, grasses, and driftwood into items of function and beauty. The early 1900s gold rush brought Euro-American jewelers, photographers, and needle crafters to Nome while Indigenous artists transitioned to making new decorative objects for sale, among them, small animals and figures of walrus ivory, walrus tusks engraved with Arctic scenes, fur appliqué wall hangings, and woven grass baskets. By the time the Spanish Influenza reached the Bering Strait in 1918, engraving on walrus ivory had reached new heights of popularity and realism led by the Inupiaq carver Angokwazhuk, known as "Happy Jack," and his contemporary Guy Kakarook (Ray 2003) (figure 0.22). Coiled grass baskets woven by Inupiaq women had also flourished and featured decorations that ranged from dyed grasses woven in geometric patterns to small ivory buttons and beaded applique patches (figure 0.23). As influenza spread through Nome in 1918, it took with it many skilled artists, including Happy Jack, who perished in a cabin on the beach alongside his second wife, Assonogy, and their young daughter Sarah (Ray 1984:39, 41). The influenza also took many accomplished basket makers, and grass basketry as an art form almost disappeared from the Seward Peninsula (Phillips-Chan 2019:22; Ray 1996:53–55).

Arrival of the COVID-19 pandemic in Alaska in March 2020 prompted closure of contemporary art galleries and events across the state, including the Iditarod Art Fair in Nome that frequently brought in artists from across the region. To help offset the loss of sales, the City of Nome offered

FIGURE 0.22. This postcard of Angokwazhuk, titled "Happy Jack, Native of Sledge Island, King of Ivory Carvers," shows him wearing a reindeer skin parka and matching boots trimmed in wolverine and polar bear fur. Happy Jack was one of the few Inupiaq artists in gold rush Nome to experience renown during his lifetime. Photographer B. B. Dobbs captured this image of Happy Jack around 1905. Collection of the Carrie McLain Museum.

FIGURE 0.23. An Inupiaq artist on the Seward Peninsula wove this coiled grass basket with a triangular pattern and letters that spell out "SHIELDS." The basket was purchased or gifted to Walter and Julia Shields before the 1918 influenza. Length 30.5 cm (12 in.). CMMM 2017.5.1.

municipal grants of up to $500 to local artists and carvers in 2020 and again in 2021. The Nome Arts Council held their annual art auction virtually in 2020–2021 to support local artists, who submitted works in ceramics, painting, and textiles, including a face mask with a traditional St. Lawrence Island design by Vera Metcalf (figure 0.24). Other pandemic-themed art events included a "Social Distancing Coloring Contest" featuring a coloring page designed by Nasugraq Rainey Hopson that was sponsored by Norton Sound Health Corporation in May 2020 and a "Virtual Traditional Clothing Fashion Show" organized by the Katirvik Cultural Center in August 2020.

In October 2020, the Carrie McLain Museum began working with visual artists on an initiative

FIGURE 0.24.
Nome resident
Vera Metcalf
designed this face
mask with a St.
Lawrence Island
tattoo design and
donated it to an on-
line auction for the
Nome Arts Council
in November 2021.
CMMM 2021.17.1.

to create pandemic-themed artwork. The initiative sought to bring more voices to the *Stronger Together* project, elicit creative reflections on the pandemic, and support artists during a volatile period in the art market. Twelve artists with connections to the Bering Strait region were invited to submit ideas for work that could illustrate their personal thoughts and experiences with COVID-19. Over the next year and a half, artists created work that was purchased by the Carrie McLain Museum for the permanent art collection and for inclusion in the *Stronger Together* publication.

Project budget necessitated a thoughtful approach to selecting artists and creating a visual dialogue representative of diverse heritages, gen-

ders, ages, and artistic mediums. It was also critical that the work be framed from each artist's unique perspective. Because the museum started this project during a pandemic, we had to be flexible in how we communicated with artists. Conversations and informal interviews were held with museum director Amy Phillips-Chan through Facebook messenger, email, in person, over the phone, and via Zoom. Recordings were transcribed, shared with the artists, edited for the project, and archived at the museum. Artists expressed ideas behind their work and offered responses to questions such as: Has the COVID-19 pandemic presented challenges to you as an artist? Have you or your work benefited in unex-

pected ways from the pandemic? What might the future hold for you as an artist?

Artists spoke to difficulties in acquiring materials during the pandemic. "Last year you could order art supplies online, and they would be here in no time flat. Now a lot of cameras and other supplies are all back-ordered," said Michael Burnett (this volume, p. 114). Carver Mark Delutak Tetpon (this volume, p. 133) shared a similar experience: "During the pandemic, it has been harder to get the materials I need, particularly quality ivory and quality baleen, because I can't go and see it."

Loss of tourism to Alaska and subsequent closure of galleries also affected artists. "Tourism, much of the livelihood of carvers and artists in Alaska, all shut down. I spent hours on the phone listening to stories of hardship. Images of boarded-up stores in downtown Anchorage. I worked extra hard growing a vegetable garden in Nome and putting up fish [catching and preserving fish for future use] expecting disruption of food distribution," said Karen Olanna (this volume, p. 128). Some Alaskan artists, including Kunaq Tahbone and Jenny Irene Miller, were able to pivot to virtual artist residencies such as those held at the Anchorage Museum (DuBrock and Mickey 2021). Artist Sonya Kelliher-Combs (this volume, p. 144) explained that her work *From the Body, Land, Sea and Air* "was proposed as an in-person reciprocal residency exchange sponsored by the Inuit Arts Foundation. Due to the COVID-19 pandemic, it was transformed into a distance exchange with Canadian artist Maureen Gruben . . . we still wanted to work together. So our exchange was spent communicating through FaceTime, on the phone, and via text."

Several artists who participated in the COVID-19 initiative described benefits from additional time at home. "During the pandemic, I took a break off of school and it allowed me to stay home . . . I found that I wanted to pursue my art and just work on being an artist. The pandemic kind of made space for that. I was able to launch my art business and make a website," said Kunaq Tahbone (this volume, p. 104). Karen Garcia (this volume, p. 118) expressed a similar thought: "I have been home a lot during the pandemic, so that has brought on a lot of creativity. I have to say business is booming."

Other artists emphasized the value of increasing their online marketing efforts. "The COVID-19 pandemic has helped us to learn a lot of things that we would not have learned had this situation not come up. For me, time management was one area where I greatly improved. Creating a website, doing more social media, getting your work on other Facebook pages, basically interacting online with as many people as you can," said Mark Delutak Tetpon (this volume, p. 133). Ryder Erickson (this volume, p. 122) explained, "A lot of small businesses or mom-and-pop stores were hurt by the pandemic. I don't have a physical store. I interact with my customers mainly through the phone and internet and was able to fortunately thrive with my online presence."

Artists also expressed optimism for the future. "Right now I am working on expanding my art mediums. I want to focus on putting more content on my YouTube page to share the skills I am learning so that other people can learn," shared Kunaq Tahbone (this volume, p. 107). Josie Bourdon (this volume, p. 111) voiced excitement about the return of in-person workshops: "I am looking forward to places like UAF Northwest Campus, where you can do face-to-face teaching for a beading class or fill up an entire classroom instead of having to limit it to ten students." Sonya Kelliher-Combs (this volume, p. 147) reflected, "This time has allowed many of us

to look closer at our surroundings, both inside and out, and appreciate this beautiful, amazing place we live in. We have learned that we can communicate with, support, and take care of each other from a distance."

COMMUNITY STRENGTH IN HARDSHIP

While researching the history of the Spanish Influenza in the Bering Strait, I was struck by the selfless acts of individuals during this period of desperate crisis. In November 1918, the number of influenza cases in Nome and Fort Davis had climbed to 200. Dr. A. N. Kittleson, a retired physician in Nome who had since turned to mining, dusted off his medical supplies and lent his assistance to Dr. Henry Burson, who had become overwhelmed with cases after Dr. Daniel Neuman became infected.[54] Influenza swept through Alaska Native households in the bitter winter, leaving many children homeless or huddled together in freezing cabins. The Sons of the North made one of the first efforts to assist Alaska Natives and turned their hall over to the care of orphans and displaced families. Coast Guard crew members heated the building, gathered mattresses and bedding, and enlisted rotating shifts of volunteers.[55] One of those volunteers was Chris Anderson, who insisted on helping to care for orphans at the Sons of the North Hall until he himself became sick with influenza and perished.[56]

The *Nome Tri-Weekly Nugget* aided in the recruitment of local volunteers and admonished that "men and women that are well should show the fine Alaskan spirit of good will and cheerfully give what available time they can to the succor of the afflicted."[57] The paper also ran a "Call for Volunteers!" by Mayor G. J. Lomen that received a hearty response from local citizens (figure 0.25). Among

FIGURE 0.25. The *Nome Tri-Weekly Nugget* ran a "Call for Volunteers!" issued by City of Nome Mayor G. J. Lomen on November 14, 1918.

the good Samaritans were W. J. Rowe, who sent a horse team carrying supplies to relieve those suffering at Cape Woolley, and Mr. and Mrs. Harry Springstein, who volunteered their services at Holy Cross Hospital for an extended time until Mr. Springstein came down with influenza.[58]

Volunteers from Nome bundled up against the harsh winds and traveled by dogsled to surrounding villages to deliver medical supplies, food, and clothing. In late November 1918, Father LaFortune and Thomas Gaffney set off from Nome for Mary's Igloo and crossed paths on the trail with Isador Fix and Mat Anderson, who had left the community of Sheldon to also assist Alaska Native families at Mary's Igloo.[59] To the west, volunteers Joe McArthur and Thomas Jensen arrived in Teller on November 27 to find the village in the grip of the epidemic with even worse reports from Wales.[60] McArthur

returned to Nome for additional help while Jensen hurried on to Wales, where he was soon joined by half a dozen other volunteers including Coastguardsman L. A. Ashton, who drew from his past experience as a naval hospital steward to aid those who were ill.[61] At Wales, volunteers discovered that local teacher Arthur Nagozruk and resident nurse Mrs. Tashner had converted the school into a makeshift hospital with a range in the shop kitchen and patients who were ill placed in the schoolroom. "We worked hard trying to take care of the sick in the schoolroom at the same time sick ourselves before the relief came . . . I had to leave my family every meal time (who were all sick) to feed the orphans in the schoolroom and help cook for them" (Nagozruk 1919:2).

Acts of heroism during the Spanish Influenza were not confined to adults. At Wales, volunteers discovered a nine-year-old girl in an unheated home who had bundled two infants close to her and kept them alive by feeding them cans of milk she had kept from freezing by placing the metal containers next to her skin.[62] Other volunteers located four siblings at Rocky Point who had survived for five days in a fireless cabin after their parents had died. The oldest boy had frozen feet from removing his shoes and socks to provide more clothing for his younger siblings. The boy perished soon after the siblings arrived at Holy Cross Hospital in Nome.[63]

A rich history of Bering Strait residents helping one another shone through again during the COVID-19 pandemic. Nome businesses were some of the first to lend their assistance to those in need. At Bering Tea & Coffee, owner Kristine McRae (this volume, p. 66) noted that staff "brought coffees to the hospital, to Alaska Airlines, to the grocery stores, to some frontline people. It felt good to support the community early on in that way. When we opened, people were so supportive of us, and that's what has kept us going." Local auto repair shop Trinity Sails and Repair (TSR) partnered with Alaska Commercial Company in the spring of 2020 to offer complimentary delivery of groceries to households who were in quarantine or had sick family members. Similarly, Nome community members who tested positive or had been exposed to COVID-19 could call the Norton Sound Health Corporation Quarantine Team to request groceries, supplies, or other support delivered to their home.[64]

Community service organizations in Nome recognized the importance of remaining active to nurture mental health and wellness. At the XYZ Senior Center, director Rhonda Schneider (this volume, p. 91) explained that staff were "looking into creative ways for Elders who have participated in our exercise programs to stay active." Some activities offered to Elders included bingo games played from a distance and complimentary mini bicycles to promote continued exercise. For local youth, the Kegoayah Kozga Public Library transitioned from in-person preschool programming to curbside delivery of craft kits to-go that included hands-on activities and often a complimentary children's book. And in August 2020, the Carrie McLain Museum partnered with the Kegoayah Kozga Library and Katirvik Cultural Center to organize a community berry bucket event that encouraged families to spend time together out on the tundra (figure 0.26).

The COVID-19 pandemic also elicited a renewed sense of unity between cultural organizations in Nome and the region. City of Nome manager Glenn Steckman (this volume, p. 79) remarked that "one positive to come out of this is that it allowed the city government to start building a relationship again with Nome Eskimo Community and to also

FIGURE 0.26. Nome residents (L–R) Cussy Kauer, Gloria Karmun, and Gloria's two grandchildren hold berry buckets filled with summer supplies from the Carrie McLain Museum, Kegoayah Kozga Public Library, and Katirvik Cultural Center during a community wellness event in August 2020. Photograph by Amy Phillips-Chan.

build relationships with the tribal organizations, the hospital, and the villages, because we all needed to work together." Dr. Mark Peterson (this volume, p. 59) of NSHC expressed a similar view: "The history of Alaskans supporting one another really came through during this time. I think it's going to be the reason that the Bering Strait region will do well." In thinking of the pandemic's impact on the next generation, youth pastor James Ventress (this volume, p. 89) asserted, "We do certain things for other people because it's a service to them of compassion and caring. That ethos is what I hope remains for them."

CREATING THE PUBLICATION

This publication represents the work of over sixty individuals who participated in the project at various points over the four-year journey. First and foremost are the fifty-two community con-

tributors who generously shared their struggles, achievements, and hopes during the COVID-19 pandemic through oral histories, original artwork, and thought-provoking poetry. RB Smith and Carol Gales worked with oral history contributors on initial edits of their stories and accompanying photographs. Amy Phillips-Chan worked with artists and poets during creation of pieces that were hand-delivered, emailed, or air freighted to Nome. Project timelines lengthened in lockstep with the pandemic. What was meant to be a single round of oral histories in the fall of 2020 expanded to a second cycle in the spring of 2021. The creative process also pushed schedules, and while the first piece of pandemic-themed artwork was completed in November 2020 the final piece didn't arrive at the museum until February 2022. Photographer Michael Burnett flew to Nome with tubs of camera equipment in 2021 and again in 2022 to take images of artwork that he edited from his home in Petersburg, Alaska (figure 0.27).

Research for this introductory chapter began in the fall of 2020. The text encompasses one of the most thorough accounts of the Spanish Influenza in the Bering Strait due to the accessibility of original Nome newspapers from 1918 and 1919 in the Carrie McLain Museum archives. The chapter went through several revisions to include up-to-date information as the pandemic continued. Community contributors reviewed their own written submissions, photographs, and captions during initial manuscript preparation and again during layout and design to help check for accuracy and clarity of meaning. Amy Phillips-Chan served as the project manager for *Stronger Together* and provided editorial guidance to community contributors and publication team members to help see the project through to completion in 2023. The final publica-

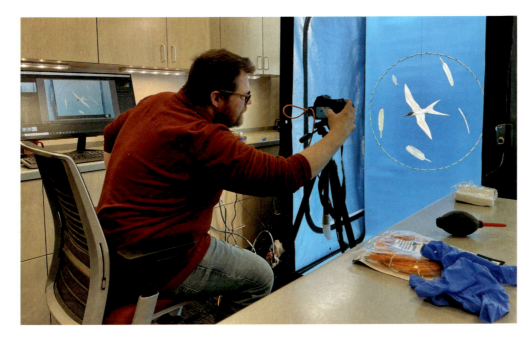

FIGURE 0.27. Photographer Michael Burnett captures an image of *Arctic Tern Mobile* by Sylvester Ayek for the *Stronger Together* publication in March 2022. Photograph by Amy Phillips-Chan.

tion in your hands represents a snapshot in time. The isolation and fears we felt in the spring of 2020 are slowly fading as we learn to live with the virus in our midst. We hope the stories and experiences shared here will resonate with future generations who turn to the past for understanding in another critical moment. As poignantly shared by Elaine Kingeekuk (this volume, p. 143), "This mask has made it possible to put together the knowledge that my whole family gave to me . . . Although it seems like the virus will be here all the time, there is hope in the world. We have someone watching over us."

POSTSCRIPT

Two years after the arrival of COVID-19 in Alaska, the community of Nome began to tentatively prepare for mushers to make the final push down Front Street in the 50th Iditarod Trail Sled Dog Race. Local organizations submitted activities to the special events calendar that ranged from ice sculpting for kids and dogsled rides to a snowshoe hike and reindeer dog grill out. The City of Nome posted COVID precautions and offered free test kits. Then we waited, and held our breath, and watched in awe as each flight of Alaska Airlines delivered a hundred visitors to our iced-in town. The overwhelming return of visitors to Nome stretched from Front Street to the Carrie McLain Museum to the Nome Recreation Center, where hundreds gathered to watch the Lonnie O'Connor Basketball Tournament and celebrate the victorious mushers at the Iditarod Awards Banquet (figure 0.28). In a way, the colorful presence of parka-clad visitors wearing joyful smiles and navigating our slick roads represented a feeling that we had made it, Nome had pulled through together, and the future looked bright.

FIGURE 0.28. The 50th Iditarod Trail Sled Dog Race saw a return of visitors to Nome in March 2022. Over 400 guests participated in programs at the Carrie M. McLain Memorial Museum and expressed enjoyment at being able to travel again after COVID-19. Photograph by Amy Phillips-Chan.

TABLE 0.1. Spanish influenza deaths in the Bering Strait region, 1918–1919

Alaska Native Deaths			Non-Native Deaths	
Community	Native Name	Number	Community	Number
Nome	Sitŋasuaq	175	*Victoria* Ship Passengers	34
Wales	Kiŋigin	170	Nome	27
Mary's Igloo	Tupqaġruk	68	Fort Davis	5
Teller	Iġaluŋniaġvik	65	Bluff	2
Solomon	Aŋuutaq	45	Teller	1
Sinrock	Siṅġak	37		
Penny River, Cripple River	Sitŋasuaqaq, Kayalashuak	28	Total	69
St. Michael	Taciq	25		
Agiapuk	Mikuqtut	18		
Golovin	Chinik	17		
Eldorado		17		
Spruce Creek	Okpiktulik	16		
Cape Nome	Ayasayaq	14		
Cape Woolley	Singiyak	11		
American River	Qaksuqtit	8		
Safety	Chingyak	7		
Rocky Point	Nuthlunak	5		
Mail Carriers		3		
Total		729		

Sources: Deaths: Kaloke (1979); Nagozruk (1919); *Nome Tri-Weekly Nugget*, 1918, 1919. Native names: Alvanna-Stimpfle (2019); Krauss (1995); Pratt et al. (2013); Ray (1971).

ACKNOWLEDGMENTS. Historical research for this introductory chapter would not have been undertaken without the accompanying oral histories and artwork from community members that provide rich content and invaluable context for the pandemic. Research on the Spanish Influenza included several intense weeks of scrutinizing the faded print of the *Nome Tri-Weekly Nugget* along with searching in the Carrie McLain Museum collections for related photographs, objects, reports, and oral histories. Gratitude is due to the 1918–1919 staff of the *Nugget* who, despite being laid low with influenza, still managed to put out the paper and leave us a rich historical record. Students of Nome-Beltz High School held a series of oral history interviews in the late 1970s and had the incredible forethought to record some of the last survivors of the Spanish Influenza from the Bering Strait region, who appear here in this text. Finally, Arthur Nagozruk demonstrated tremendous deter-

mination and courage at Wales while serving as the local teacher and unplanned medical assistant in 1918. Nagozruk lost his wife and two sons to influenza in November 1918 and although he caught the flu, he and his daughter Bertha survived (K. Smith and V. Smith 2001:359).[65] Nagozruk drafted a report in the summer of 1919 that detailed how influenza invaded their village and composed a list of all 312 people in Wales with the most demographic information on any Alaska Native community in the region at that time. To Nagozruk and his family I express my deepest admiration and appreciation.

Staff of the *Nome Nugget* newspaper covered the COVID-19 pandemic from its inception and generated an extensive body of local information that I relied upon during preparation of this chapter. Likewise, Norton Sound Hospital disseminated a steady stream of press releases, daily updates, and data dashboards that provided an invaluable method to track the ebb and flow of the pandemic across the Bering Strait region.

Historical photographs in this chapter derive from the archives of the Carrie McLain Museum, with the exception of the image of Fort Davis from the University of Alaska Anchorage Consortium Library. Photographers John Handeland and James Mason generously contributed local images of the COVID-19 pandemic. Professional photographer Michael Burnett captured the images of museum objects.

Earlier versions of this paper were presented at the 48th Annual Meeting of the Alaska Anthropological Association (AkAA) and 2021 Native American Art Studies Association Conference (NAASA). Sincere appreciation goes to my AkAA co-organizer Dawn Biddison and fellow presenters in the session "Alaska Museums and Artists Respond to the COVID-19 Pandemic": Hollis Mickey, Francesca DuBrock, Amy Meissner, Sonya Kelliher-Combs, Maureen Gruben, Melissa Shaginoff, Hayley Chambers, RB Smith, and Beth Weigel.

NOTES

1. Nonuse or use of a tilde, Inupiaq or Iñupiaq, is often dependent upon the location of the community and dialect(s) of Inupiaq spoken. In general, community members in the Bering Strait region speak Inupiaq, whereas those in North Alaska speak Iñupiaq. One can also use Inupiaqtun to refer to the language being spoken, lit. "speaking like an Inupiaq."
2. *The Nome Gold Digger*, July 4, 1900; Wolfe 1982:105–107.
3. *The Nome Nugget*, January 24, 1925.
4. *The Nome Nugget*, February 14, 1925.
5. *The Nome Nugget*, February 2, 1925.
6. *The Nome Nugget*, February 14, 1925.
7. *Nome Tri-Weekly Nugget*, September 13, 1918.
8. *Nome Tri-Weekly Nugget*, October 9, 1918.
9. *Nome Tri-Weekly Nugget*, October 21, 1918.
10. *Nome Tri-Weekly Nugget*, October 25, 1918.
11. *Nome Tri-Weekly Nugget*, October 21, 1918.
12. *Nome Tri-Weekly Nugget*, October 29, 1918.
13. *Nome Tri-Weekly Nugget*, November 4, 1918.
14. Kaloke traveled with his father and the other surviving children from Woolley to the Methodist mission and school at Sinrock, where he remained for a year, before a fire destroyed the mission and the children were resettled at the orphanage in Nome (Kaloke 1979:12–14).
15. *Nome Tri-Weekly Nugget*, November 29, 1918.
16. *Nome Tri-Weekly Nugget*, November 18, 1918.
17. *Nome Tri-Weekly Nugget*, December 2, 1918.
18. *Nome Tri-Weekly Nugget*, December 2, 1918.
19. *Nome Tri-Weekly Nugget*, December 25, 1918.
20. *Nome Tri-Weekly Nugget*, December 30, 1918.
21. *Nome Tri-Weekly Nugget*, January 6, 1919.
22. *Nome Tri-Weekly Nugget*, November 29, 1918.
23. That is, *Nome Tri-Weekly Nugget*, December 13, 1918.
24. *Nome Tri-Weekly Nugget*, November 12, 1918.

25. Carrie McLain Museum, Shields Collection, Accessions 2015.2, 2016.28, 2017.5.

26. *Nome Tri-Weekly Nugget*, November 27, 1918.

27. Carrie McLain Museum, Mielke Collection, Accession 1979.1.

28. *Nome Tri-Weekly Nugget*, December 20, 1918.

29. *Nome Tri-Weekly Nugget*, December 2, 13, 1918.

30. *Nome Tri-Weekly Nugget*, January 3, 1919.

31. *Nome Tri-Weekly Nugget*, March 21, 1919.

32. *The Nome Nugget*, October 14, 2021.

33. City of Nome Public Service Announcement, April 20, 2020.

34. *Nome Tri-Weekly Nugget*, October 21, 1918.

35. *Nome Tri-Weekly Nugget*, November 12, 1918.

36. *Nome Tri-Weekly Nugget*, December 16, 1918.

37. *Nome Tri-Weekly Nugget*, October 29, 1918.

38. City of Nome Public Service Announcement, March 26, 2020; Mason (2020).

39. City of Nome Public Service Announcement, April 20, 2020.

40. *Nome Tri-Weekly Nugget*, November 18, 1918.

41. *Nome Tri-Weekly Nugget*, November 27, 1918.

42. *Nome Tri-Weekly Nugget*, February 7, 1919.

43. *Nome Tri-Weekly Nugget*, November 4, 1918.

44. *Nome Tri-Weekly Nugget*, October 11 and 25, 1918.

45. City of Nome Public Service Announcement, April 2, 2020.

46. *Nome Tri-Weekly Nugget*, November 12, 1918.

47. *Nome Tri-Weekly Nugget*, October 29, 1918.

48. *Nome Tri-Weekly Nugget*, January 27, 1919.

49. *Nome Tri-Weekly Nugget*, November 22, 1918.

50. The Sheldon Jackson Museum, founded in 1888 in Sitka, was the first major museum in Alaska. An act of Congress in 1900 established the Historical Library and Museum, now the Alaska State Museum, in Juneau. And in 1917, the University of Alaska Museum in Fairbanks was included as part of the original legislation that established the university.

51. *The Kusko Times*, June 23, 1928. Samuel and his wife, Hazel, had five children and lived most of their life in Nome (Raymond Charles Nuipok, 2012, "Obituary," *Anchorage Daily News*, June 14). In 1944, Sam received a special service emblem as a civilian employee in Nome with 100 percent War Bond participation (*The Nome Nugget*, September 8, 1944).

52. Nome Communities of Memory Project Jukebox, https://jukebox.uaf.edu/site7/comnome.

53. *The Nome Nugget*, October 8, 2020.

54. *Nome Tri-Weekly Nugget*, November 4, 1918.

55. *Nome Tri-Weekly Nugget*, November 12, 1918.

56. *Nome Tri-Weekly Nugget*, November 22, 1918.

57. *Nome Tri-Weekly Nugget*, November 12, 1918.

58. *Nome Tri-Weekly Nugget*, November 14 and 22, 1918.

59. *Nome Tri-Weekly Nugget*, November 25, 1918.

60. *Nome Tri-Weekly Nugget*, December 2, 1918.

61. *Nome Tri-Weekly Nugget*, December 6 and 25, 1918.

62. *Nome Tri-Weekly Nugget*, December 30, 1918.

63. *Nome Tri-Weekly Nugget*, December 30, 1918.

64. Norton Sound Health Corporation, Facebook post, February 9, 2022.

65. Nagozruk began his teaching career in Wales in 1907 and taught in several Alaskan villages over the next forty years. In 1919, Nagozruk married Lucy Alvanna Ootuk, whose husband and son had perished during the influenza. Together, the couple had nine children (K. Smith and V. Smith 2001:359–361).

The Richard Foster Building in Nome serves as home to the Carrie M. McLain Memorial Museum, Kegoayah Kozga Public Library, and Katirvik Cultural Center. Photograph by Amy Phillips-Chan.

PART 1
Oral Histories 2020

Stronger Together: Bering Strait Communities Respond to the COVID-19 Pandemic began as a grassroots oral history project in the fall of 2020. At the time, the Carrie M. McLain Memorial Museum (Carrie McLain Museum) had been closed to the public for six months, and staff were searching for an opportunity to reconnect with the community and to document local experiences of the pandemic. As an initial step, the Carrie McLain Museum recruited news reporter RB Smith with the *Nome Nugget* to reach out to local community members and hold oral history interviews. From September 9 to November 12, 2020, Smith conducted twenty oral history interviews with a total of twenty-four participants. Each participant received a $50 gift card to a local store in addition to a copy of their interview recording and transcription and any photographs taken during the interview.

Part 1 opens with an introspective chapter by RB Smith followed by twenty COVID-19 oral histories from Nome residents in 2020. A short biography precedes each oral history account with details culled from the editors' local knowledge and information shared during the interview process. RB Smith conducted the oral history interviews in person (16), over the phone (2), and via Zoom (2), depending on participant preference. Locations of in-person interviews varied from places of business and the Carrie McLain Museum to participant homes and a restaurant. Although Nome had yet to experience an outbreak of COVID-19 cases, proactive safety measures were observed during in-person interviews including social distancing and use of face masks.

During his visits, Smith talked with community members about their thoughts upon first hearing of COVID-19, challenges they were encountering, activities being pursued for personal wellness, and what they would like future Nome residents to know about 2020.

The oral histories include stories from thirteen women and eleven men. Interviews are arranged by participant profession and include tribal leadership, students, medical personnel, business owners, media, Elders, city leadership, and community service providers as well as a commercial fisherman and a mechanic/welder (table 1.1). A portrait photograph taken by Smith or submitted by the participant is presented alongside a contextual image shared by the interviewee and/or chosen in partnership with the editors. Interviews were edited and abridged for this publication, but each community member participated in the review and final telling of their story.

TABLE 1.1. COVID-19 oral history participants, 2020

Interviewee	Profession	Date of Interview	Location
Tiffany Martinson	Tribal Leadership	October 23, 2020	Zoom
Ava Earthman	Student	November 5, 2020	Telephone
Tobin Hobbs	Student	September 25, 2020	Museum
Mark Peterson	Medical Personnel	September 22, 2020	Telephone
Ethan Ahkvaluk	Medical Personnel	October 14, 2020	Museum
Carol Seppilu	Medical Personnel	October 22, 2020	Museum
Truong Phan and Veronica Alviso Phan	Medical Personnel, Business Owner	September 16, 2020	Bering See Vision
Kristine McRae	Business Owner	September 14, 2020	Bering Tea & Coffee
Diana Haecker and Nils Hahn	Business Owner, Media	September 24, 2020	The Nome Nugget
Emily Hofstaedter	Media	November 6, 2020	KNOM Radio Station
Josephine Tatauq Bourdon	Elder	October 14, 2020	UAF Northwest Campus
Katherine Scott	Elder	November 12, 2020	Interviewee Home
John Handeland	City Leadership	September 9, 2020	Nome City Hall
Glenn Steckman	City Leadership	October 9, 2020	Nome City Hall
Adem Boeckmann	Fisherman	September 18, 2020	Airport Pizza
Derek McLarty	Mechanic/Welder	September 21, 2020	The Nome Nugget
Crystal Toolie	Community Service Provider	October 9, 2020	Zoom
MaryJane Litchard	Community Service Provider	September 10, 2020	Museum
James Ventress	Community Service Provider	September 17, 2020	Interviewee Home
Rhonda Schneider, Ruth Ann Glaser, and Ryan VandeVere	Community Service Provider	October 20, 2020	XYZ Senior Center

1

RB SMITH

*RB Smith hails from St. Louis, Missouri (figure 1.1). He graduated from Williams
College in 2020 and came to Nome soon after as a reporter for the* Nome Nugget.
*Smith provided extensive coverage on the pandemic and other regional stories from
2020 to 2021. This reflective article was submitted by RB Smith on December 5, 2020.*

As I began to learn about the experiences of some Nomeites through this project, I was also getting to know Nome. I had arrived in town just a few months prior to the pandemic, my first time in Alaska, and over the course of the project learned a lot about the community and its people. Due to my inexperience I undoubtedly neglected some questions that a longtime resident of Nome would have been sure to ask, and asked others that a true Nomeite might have avoided. My identity as a young white male non-Alaskan also undoubtedly had an impact on the responses I got, as people filtered what they said through their ideas of what [they thought] I was expecting and what they were comfortable sharing with me. But I would also like to think that my outsider's perspective shined a unique light on people's experiences, nudging them to reflect on their lives in a big-picture way that is interesting and informative to listeners of the future.

I also think it's important to mention the timing of the project. The first group of interviews was done in September, October, and November of 2020, before Nome saw its first major outbreak of COVID-19 in late November 2020. At the time of this writing, Nome has seen more cases in the last few weeks than in the first eight months of the pandemic combined, and case numbers only continue to climb. The outlooks shared in these recordings may not be typical of many Nomeites' recollections of the pandemic later down the line, when widespread shutdowns went into effect.

It's difficult to pull one salient theme or message out of the interviews, because the degree to which people's lives had been touched by the pandemic varied so greatly. Some said their daily routines had been left mostly unchanged, while others had to dramatically alter their lives. Some experienced the trauma of sick and dying family members firsthand, while others were skeptical of the gravity of the virus altogether. But if one thing stood out to me in common between the interviews, it would be a sense of resilience. With the daily uncertainty of the virus and grim messages in the news, it can be easy to fall into pessimism and despair. I was surprised and inspired by the degree to which those I interviewed insisted, "We'll get through this." Even those who had been impacted most drastically by

the pandemic maintained that through persever-ance and the support of their community, they would make it through these difficult times, and I believe that, in aggregate, these recordings are a testament to the resilience of Nome.

FIGURE 1.1. RB Smith stands outside the power plant once used to generate electricity for Nome. April 2021. Photograph by Amy Phillips-Chan.

2

TIFFANY MARTINSON

Tiffany Martinson comes from Nome, where she and her husband raised their children (figure 1.2). She served as the executive director of Nome Eskimo Community during the pandemic and now works as the Head Start Assistant Director with Kawerak, Inc. This conversation was held between Tiffany Martinson and RB Smith via Zoom on October 23, 2020.

Watching the news in late December 2019 and early January 2020, it was a little bit unbelievable; it hadn't hit home yet. The pandemic didn't seem necessarily real aside from watching the news. When it started migrating its way here in January of 2020, it caught my attention.

It was March 2020—I will never forget. It was my daughter Ellie's senior year, and we were in Anchorage for the regional basketball tournament. She was of course excited. But then things changed in an instant. Anchorage started shutting down, and we were away from Nome. I was starting to feel this need to get home.

I returned to work at Nome Eskimo Community the following Monday, March 16, and we wrapped up our operations. We had already been in planning mode, figuring out what it was going to look like if we had to work from home and what type of equipment we had to use. We closed our offices officially on March 18.

It was pretty intense. There was a lot of trying to figure out logistically how we were going to operate. We were learning what we were able to do and what we couldn't do from home. Thankfully, I have experience working outside the office because my job is

very mobile and there is a lot of travel required. So working from home has been the biggest change. We are still doing things very differently at work. We joke that we don't remember what it was like to have a normal day. It's been really exciting, and I appreciate the challenge. It's been a roller coaster in a good way.

Another positive I learned in light of adversity is what our team could do. We were able to come together and get what needed to be done with such a small group of people. Because Nome Eskimo Community is a federally recognized tribe, we started learning about the CARES Act. We received a significant amount of funding to respond to the pandemic in almost all the main areas of our service programs (figure 1.3). We are just making the best out of a difficult situation and moving ahead.

Although we're grateful for the funding that we have received, it has increased the workload and it will be nice to see that scale back. I haven't taken time off, and that's on me: I need to be able to set boundaries, but it's just been too busy. And if I'm here, why shouldn't I be at work?

Back in March, April, and May 2020, we were all working at home and my kids were home with me.

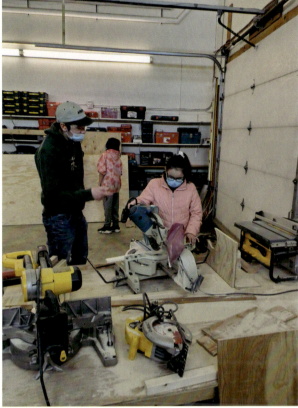

FIGURE 1.2. Tiffany Martinson smiles for a selfie at home in 2020. Nome Eskimo Community's administration went remote during the pandemic, and Martinson found she could do most of her work through email and teleconferencing. Photograph courtesy of Tiffany Martinson.

FIGURE 1.3. Nome Eskimo Community began to offer in-person events again during the last part of 2020. Over the winter they hosted a workshop where local youth made wood jigging sticks and went ice fishing for tomcod. Photograph courtesy of Tiffany Martinson.

That was a nightmare! At first, we were all set up at our kitchen table so I could monitor them while I was working. But it got to the point where I found myself doing things for them that they should be doing on their own. I would just have to put my foot down and say, "I'm not your babysitter. Just pretend I'm not here!"

But it was honestly a blessing because I got to spend more time with them, particularly with my daughter before she moved to college. We had a lot of funny moments, and there were periods of time where [I was] just not productive. We did a lot of baking together, and that was nice.

I did have a family member pass away during the pandemic. I got to speak with her over the phone after she was admitted to the hospital. I got to say, "I love you and goodbye." She got to speak with her sisters on Zoom one more time. Thankfully, she had led a full life and she was in her eighties.

Nome is home, so I'm happy to be home during this time. The availability of testing in our area has been tremendous; it was nice to be able to have that opportunity, knowing that it's not available everywhere. And the timing couldn't have been better, because summer was coming and everything we do is outside. It was liberating to be able to continue with those activities.

AVA EARTHMAN

Ava Earthman grew up in Nome and graduated from Nome-Beltz High School in May 2020 (figure 1.4). She currently attends Williams College in Williamstown, Massachusetts, where she is majoring in art and psychology. This conversation was held between Ava Earthman and RB Smith via telephone on November 5, 2020.

I was in Anchorage for cheer regionals when we heard about the pandemic. I remember we were super-worried because we thought we wouldn't get back home. They canceled the cheer competition and then they uncanceled it, then they moved it, and then they moved it again because each school would be shutting down. We were just like, wow, this is kind of crazy. We eventually had cheer finals, but it was in a very tiny high school and it was so odd. We didn't get to have the full competition. We had to perform in between the basketball games, and they pushed it all into one day rather than three days. Then we all came home early.

At first they said spring break is just going to be another extra week. So everyone was like, "Yay! Two weeks of spring break, then we'll come back!" Then they extended it until the end of the month. Then they extended it until the end of the month after that. Then it would have been two weeks of school left, so they eventually just canceled us returning to school.

Classes happened over the phone. I know the teachers were having a difficult time trying to get students to come to class and organizing everything. I remember my physics class started at eight in the morning, so I would call in and go back to sleep immediately. It was difficult, especially because I didn't have internet at home, so I was the only one calling in. Everybody else could see each other, and that was sad for me. I know a lot of people were feeling very defeated. Not a lot of kids showed up to classes at all, because your grade couldn't sink any more. Your grades could only get better. So the kids were like "Why am I going?" So the teachers got defeated. It was definitely a mess for the rest of the year.

For graduation, we all got into our own cars and had a parade through town. Then we met up at the high school and parked our cars in a little semi-circle around the stage (figure 1.5). We got to walk across the stage in groups of five. It ended up being very fun. But I was relieved when everything was over and done.

Around the summertime, I actually got a little bit more used to the pandemic. I was allowed to hang out with friends. We practiced social distancing and wore masks and gloves. It was all outdoors. My mom would not let me go inside any buildings. It got to be almost normal because Nome hadn't been hit too hard by then, and we could spend a lot more

FIGURE 1.4. Ava Earthman poses in a field of bright fireweed outside Nome for her high school senior photos in the summer of 2019. Photograph courtesy of Ava Earthman.

FIGURE 1.5. Ava Earthman holds her diploma with gloved hands during the outdoor graduation ceremony at Nome-Beltz High School in May 2020. Photograph courtesy of Ava Earthman.

time outside. I went to the beach quite a lot. I went on a lot of walks. I was still able to drive around with my friends. It was nice to have that time with friends before leaving for college.

My mom was very strict about the pandemic, and I did not want to wear a mask for the longest time, because I felt embarrassed. Some people were wearing them, and some people weren't. And the gloves—it just seemed a little bit silly to me, even though it was scary with everything happening. It was just a change. I also had a lot of quarantine time to read books that I hadn't read before. I had so much time that I made myself curtains. I attempted to learn how to cook. It was great.

I felt so lucky that the coronavirus was spread out and far away. Nome has such a small population and so many places to go outside compared to a city, where there are constantly people around. That would be very stressful. I have to say, I'm ready for the pandemic to be done. I am grateful to have had the time together with friends. It makes you think about how much you value other human interaction.

4

TOBIN HOBBS

Tobin Hobbs and his family have called Nome home for almost ten years (figure 1.6). The pandemic hit at the end of Hobbs's junior year and significantly altered his senior year of participation on the Nome-Beltz High School cross-country and ski teams. This conversation was held between Tobin Hobbs and RB Smith at the Carrie M. McLain Memorial Museum on September 25, 2020.

When COVID hit, everybody started freaking out. Everyone was really scared and cautious. At one point, Nome felt like a ghost town because of everything that was shut down. I didn't really care at first. I was homeschooled, so it didn't affect my schooling. What I was really worried about were sports and going places.

I am taking one class at Nome-Beltz High School, and at school you put on your mask when you walk in. When you sign in, you answer questions about if you've been close to a COVID patient or if you know anybody that has COVID. Then they take your temperature to make sure you don't have a fever. You have to do that every morning. Some of my friends barely graduated, because COVID hit. It was hard enough for a lot of people to have the motivation to show up for school. Then you throw in having to wear a mask for seven hours every day. They are probably not feeling very motivated, because you have to do something that you're not used to.

Everything got hectic when sports started because a girl on the volleyball team tested positive for COVID. They immediately shut down the school. All the cross-country runners were like "This is so stupid." We train outside, and they are inside. It was frustrating because we didn't have practice for almost three weeks. That's a big gap when you're trying to build a base for cross-country.

We have done a lot of virtual races. We find the flattest course and some bushes, so there's less wind, and you run as hard as you can to get the fastest time. This year, state finals for cross-country are just the top two runners from all the villages and smaller towns. There's not going to be any crowds, so nobody's going to be cheering (figure 1.7). The crowds are what makes it fun. There are people lining the trails the whole race long, and it's just intense and awesome.

The pandemic is really frustrating for my family because whenever you're trying to do something you have to remember, "Oh, I have to wear a mask. Why do I have to wear a mask? Well, to make sure other people are safe. But my mask isn't doing anything for me." You have to think, "Is this mask actually catching everything that's coming out of it?" Your opinions about the pandemic are also about what people you are listening to and what kind of information you're getting.

FIGURE 1.6. Tobin Hobbs pauses in running gear for a photo on Front Street in Nome. While most of his senior year classes were in person, many running and skiing competitions were cancelled due to the pandemic. 2020. Photograph by RB Smith.

FIGURE 1.7. Tobin Hobbs traveled to Anchorage in the fall of 2020 to compete in the high school cross-country state championships. During the competition, racers were spread out and regular spectators were not allowed to attend. Photograph courtesy of Alaska School Activities Association.

A lot of people in Nome are really worried about COVID because their parents or grandparents live with them. They don't want their kids going to school and coming back home with COVID because it might harm their grandparents. I don't know how I feel about that. My grandma had COVID for about a week. She didn't feel great at all, but after a week she felt fine. My girlfriend's grandma had it for almost two weeks. It seems like if you are healthy and old, you have it for a week and you feel like you're going to die, but don't die. Or you get it for a week and you just don't feel very good, but it's not that bad. Or you don't feel like you have it at all. It's a weird mixture.

There are definitely going to be people who will change because of the pandemic. There are people out there that are really cautious because they are scared of what the coronavirus might do to them or people that they love. But life is not going to stop. We have to keep life going because there are a lot of people in this country and a lot of people in this world. Hopefully people can figure stuff out so it's not like this for the rest of our lives.

5

MARK PETERSON

Mark Peterson, MD, has been serving rural Alaska for more than thirty years (figure 1.8). He began his Alaskan career as a traveling doctor in the Yukon-Kuskokwim region and now serves as medical director for Norton Sound Health Corporation (NSHC) in Nome. As a pivotal leader of NSHC, he directed much of the Bering Strait region's response to the COVID-19 public health emergency. This conversation was held between Dr. Peterson and RB Smith via telephone on September 22, 2020.

In 2017, I was asked to work as the medical director for Norton Sound Health Corporation. I did not expect a pandemic to be part of the position at the time, but in medicine you take what comes, and when you sign up for the job, you do what needs to be done. For doctors, there is a lot of pressure because you are not planning for a pandemic but now you have to deal with it. It was honestly terrifying and stressful. There was a lack of sleep and being "on" every day for several months just to be prepared. It was very worrisome because we didn't know if it was going to catch fire like the measles, which is highly contagious.

We were hoping the pandemic in New York would take longer to get to Alaska. But we quickly learned that the world is now a very small place. When the coronavirus was in the state of Washington, we knew that the game was on and that this was going to be a real thing.

I can still remember when the very first case of COVID-19 came through Anchorage. We knew it was in Anchorage, but we were hoping we could keep it out of the rest of Alaska. We put in travel bans and watched the news every day to see how many cases were in Anchorage.

Alaska did an outstanding job keeping the coronavirus at a minimum number of cases. What happened was, Alaska began to open up economically again. And when it did, we knew there would be a resurgence in cases, and there certainly was. That's when we really got nervous for Nome and Kotzebue and Barrow and Bethel and Dillingham.

The Spanish flu epidemic of 1918 and 1919 really set the tone for this pandemic. A lot of villages in the Bering Strait region were wiped out completely. So when this pandemic was coming, there was a fear that it was going to be as bad as the influenza epidemic. People had listened to stories and received wisdom from their ancestors who had survived the 1918 flu epidemic. The history of infectious diseases wiping out areas of Alaska really put fear into people. That's why you see really intense travel bans into Nome right now.

There was initially a cycle of fear and anxiety, but now we have the systems in place and it is working. Nome and the villages came together to put a plan into place to prevent this virus from spreading. We came together as a team. We formed our own incident command team that includes administrators, physicians, and nursing staff, and we met every

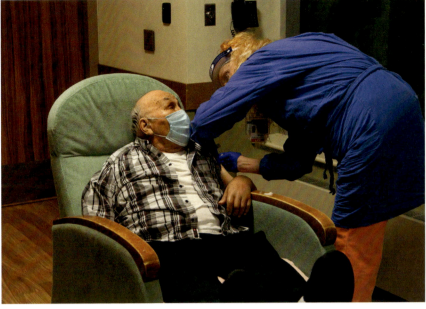

FIGURE 1.8. Dr. Mark Peterson splits his time between Nome and his family home in North Dakota. While in the Lower 48, he remained busy working remotely to coordinate testing and vaccinations. Photograph courtesy of Mark Peterson.

FIGURE 1.9. Phillip Dexter, a ninety-six-year-old resident of Quyanna Care Center in Nome, was the first regional resident to receive a COVID-19 vaccine in December 2020. The vaccine was administered by Marla Mayberry, LPN. Dr. Peterson advocated for Nome to receive ample vaccines, and for a few months the Bering Strait region led the country in the highest number of vaccinations. Photograph courtesy of Norton Sound Hospital.

morning for months. We bonded by leaning on the support of each other.

We are fortunate to have a good relationship with the Alaska Native Tribal Health Consortium and Alaska Native Medical Center. They worked hard and spent a lot of funding to get really good testing for us. They got ready and helped us get equipment. We put together an aggressive testing plan and quarantine rules that have tremendously helped limit the number of cases across the region. We have been able to continue medical care in the villages through telemedicine. It's amazing how much can be done by Zoom or by teleconference or telephone. Thank goodness we have all these key capabilities that we didn't have many years back. There is a benefit to having people receive medical appointments remotely because it limits the spread of viruses and germs.

I think the pandemic will change our behaviors in the long run. I am hoping people will be more diligent about getting vaccinations (figure 1.9). I think people will naturally be more comfortable wearing masks during flu season, and I think we will see people in the winter wearing masks. I think we'll see people distancing more. I think we'll probably see fewer people just routinely shaking hands. The country will be better prepared with more ventilators and more equipment stockpiled.

The pandemic brings out general characteristics of people that already exist, and I would say there's much more positive than negative aspects. The history of Alaskans supporting one another really came through during this time. I think it's going to be the reason that the Bering Strait region will do well. We will survive this, and we'll get to the other side and we'll be thankful for it.

6 ETHAN AHKVALUK

Ethan Ahkvaluk comes from Little Diomede and has lived in Nome for the past seven years (figure 1.10). During the pandemic, he worked at the Norton Sound Health Corporation (NSHC) patient hostel, where residents of smaller regional communities can stay when they travel for medical reasons. In 2020 and 2021 the patient hostel also served as quarantine and isolation housing for many who tested positive for COVID-19. This conversation was held between Ethan Ahkvaluk and RB Smith at the Carrie M. McLain Memorial Museum on October 14, 2020.

I never thought that we would have a pandemic like this. I had a feeling back in December of 2019 that the pandemic would hit, because I watched the news and saw that China had a pandemic. I noticed that there are flights from China that go to Anchorage, and that's how it started to spread across Alaska. If the rest of Alaska had shut their airports down right away, this pandemic wouldn't have come as quickly as it did. Once the pandemic arrived, I thought it was going to shut everything down. That we would have food shortages. That everyone would be staying home and no one would be able to go out.

I take my precautions seriously because I have an elder grandmother and three younger cousins in my house. I got into a rhythm when COVID first began. I bought six different masks to get prepared. It took quite an adjustment to start wearing a mask and to go out in public with it. I felt ridiculous when I was the only one wearing a mask here. People used to think the mask meant I had COVID and I'd say, "It's not mandated yet, but I'm still going to wear one." Now businesses started mandating wearing masks, so I don't feel ridiculous.

I work at the NSHC patient hostel. They update us every day when people test positive (figure 1.11).

The quarantine and isolation director at NSHC will call us and say, "We have a positive patient and I will be bringing them over. Can you get the beds ready?" The east wing is our isolation area for patients who test positive for COVID. People quarantining due to travel stay in the west wing. When we deliver food to the east wing, we go into full Martian mode and wear our protective suit. Then we head back out to the front desk and scrub our hands.

It took quite a while for me to get into the role of things while working; it was hard to do. We have to follow a lot of protocols. We wear masks and gloves and all those standard precautions. We wipe down everything. I wear my mask all the time unless I'm in our break room eating. I used to have calluses on the back of my ears from wearing my mask all day for eight hours. You have to learn the rhythm, and it takes a while.

It is nice to be in Nome. It's a lot different when you're in a smaller village, because you're stuck in the house and you're on lockdown throughout the whole pandemic. I am not grateful that we have positive cases here, because that's affecting the whole town and it's affecting Elders and people who have health-related issues. I'm hoping that the

FIGURE 1.10. Ethan Ahkvaluk stands masked in the lobby of the Richard Foster Building in Nome. Ethan worked in close proximity to COVID-19 patients and became used to strict masking and social distancing policies. 2020. Photograph by RB Smith.

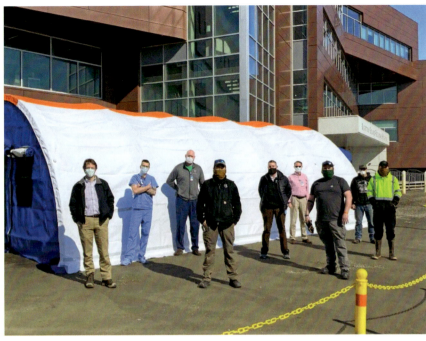

FIGURE 1.11. Norton Sound Health Corporation staff pose outside the testing tent in front of the hospital, where anyone could receive a free COVID-19 test. Departments of NSHC worked around the clock to help keep the coronavirus at bay. 2020. Photograph courtesy of Norton Sound Hospital.

coronavirus goes away for a long period of time and doesn't reoccur, but we will have to see what the Lower 48 does and how they react.

I'd like to tell future Nomeites that they were lucky that they weren't in this pandemic. They were lucky that they didn't have to wear a mask in public places. They will get to roam free instead of having to follow a mask mandate.

7

CAROL SEPPILU

Carol Seppilu moved to Nome almost thirty years ago when she was a child (figure 1.12). She now works at the Quyanna Care Center, where anxiety about the pandemic ran high. She is an avid long-distance runner and regularly attends races across Alaska and the Lower 48. This conversation was held between Carol Seppilu and RB Smith at the Carrie M. McLain Memorial Museum on October 22, 2020.

The beginning of the pandemic was fairly scary. I work at the Quyanna Care Center, the nursing home. Before the pandemic got really serious in town, Norton Sound Health Corporation shut Quyanna Care Center down so that only employees could go in and out. I was really worried about the elderly people and about myself because they weren't sure how it would affect me because I have a tracheostomy. I don't think the Elders were very concerned, but they weren't quite sure what was going on.

I remember everyone just staying away from each other. If I got too close to someone at the store, they would look at me weird, or I felt like I was invading their space if I got a bit too close to them. I think everyone was really cautious in the beginning. I think we all thought it was going to hit us immediately. We were going to see a hundred to a thousand cases right then and there. I was expecting the hospital to be overloaded with patients being sick and dying, and I had thought that I would have to work on the hospital side. I was worried about it, but that didn't happen. We actually didn't see our first case for a while.

I live alone, and for the first few months I didn't visit anyone. I stayed away from family and friends because my parents are both elderly and I didn't want to risk bringing the virus to them. My life before the pandemic was pretty quiet, but it was really lonely not being able to go visit my parents whenever I wanted to.

I was already being very cautious before the pandemic, because whenever I get the flu I have a very difficult time breathing. I can barely breathe because of my trach. It just gets really clogged, and 75 percent of my air is through my trach. So I try not to get any sort of respiratory illness. I am a lot more careful now because we don't really know a whole lot about the virus and I've been reading a lot of scary things about it. So I definitely don't ever want to get it.

At first I was only going to the store once a month. But over the summer I was like "Oh, I need to get this. I'm going to go tomorrow even though I went today." I am a bit more relaxed but still cautious. We still don't know a whole lot about the virus, and from what I have been reading about it, I don't want to catch it. I am an endurance athlete, so I don't want to not be able to go for a run.

I have been running since 2014. I started running to cope with depression and obesity. So I stuck

FIGURE 1.12. Carol Seppilu pauses for a photo outside the Carrie McLain Museum in Nome. She adopted careful precautions when the pandemic first arrived on account of her tracheostomy tube and daily contact with Elders. 2020. Photograph by RB Smith.

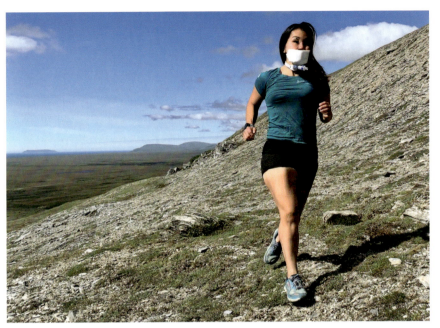

FIGURE 1.13. Carol Seppilu goes for a jog on a hillside north of Nome. During the summer of 2020, she completed three long-distance runs along Nome's three main roadways to raise awareness for mental health. Photograph courtesy of Carol Seppilu.

with running to deal with the anxiety that came with the pandemic. There was a lot of that anxiety, so running really helped me a lot. I usually travel all over the United States to go running. But I decided to stay home this year and just run in Alaska. I went down to Anchorage in August. I limited the people I came in contact with. I was joking around with my friends, "I don't want to get the virus yet. I can get it after my hundred-mile race!" I had been attempting that distance for a while, and I finally finished it. I was really worried they were going to cancel the race because of the pandemic. Every week closer to race day, the cases in Anchorage were going up and up and up, and I thought they were going to cancel it, but the race director decided to continue on with it. I was very happy.

Coming back from the race in Anchorage, it was really strange seeing how things are done at the Nome Airport. When I came back to Nome, they herded us all into someplace. I didn't know where we were going, and they were ordering us to do this and that. It felt really weird, kind of like a military thing.

The pandemic didn't affect my long-distance runs into Nome at all (figure 1.13). I was very worried that we weren't going to be able to go all the way to Teller, because there was an outbreak right before the day we decided to go out there to run. I thought they were going to tell us, "I'm sorry, you can't come into town." But no one stopped us from entering the village. I was very grateful for that and very happy with how it went.

8. TRUONG PHAN AND VERONICA ALVISO PHAN

Nome-born Truong Phan, OD, met Veronica Alviso when they attended college in Texas (figure 1.14). The couple own and operate the optometry practice Bering See Vision in Nome. This conversation was held between Dr. Phan, Veronica Alviso Phan, and RB Smith at Bering See Vision on September 16, 2020.

TRUONG: We had to cancel a few trips due to the pandemic. I had a training in Texas, and Veronica was going to come with me. We canceled the trip, and then the next day we got an email from Alaska Airlines about upcoming flight cancellations and restrictions.

VERONICA: When the pandemic first started, we obviously took it seriously. We knew that things were going to be a little bit different, traveling being the biggest one. My family is in Texas, so that has been difficult, especially because we have our young daughter, Elizabeth. I am thankful for FaceTime. That has really helped our daughter stay connected to the rest of our families.

My daughter and I have a genetic disorder. It's a blood vessel disorder that can sometimes really affect the blood vessels in the lungs. So we are at risk for damage to our lungs if we were to contract COVID. We're just more cautious. I've never been that kind of person; we wanted our daughter to get dirty. We wanted her to experience germs, to build her immune system. I have always lived with that mindset.

TRUONG: We have also been cautious because my parents live with us, and they are both in their mid- to late sixties. My mom really likes to go to the grocery store and to go shopping, but we asked her to limit herself with that.

VERONICA: The grand opening of our practice was supposed to be in March 2020, right around Iditarod time. Obviously, that's when things started getting a little bit more serious, so we postponed the opening. Our equipment had finally made it in, but there was still some training that we needed to have for the equipment. With travel being delayed and the different travel quarantines, we had to do some of our training online. Eventually, we slowly started seeing patients by emergency only.

We also had a little bit of a challenge because I am the volleyball coach, and when we started our season, I came into close contact with someone who had tested positive for COVID (figure 1.15). I was considered a close contact, so I isolated from both Truong and Elizabeth. Truong was still able to see patients on emergency, but we closed the practice for two weeks. It was very scary to think, "What if I brought it home?" It was horrible.

TRUONG: That was a very difficult two weeks—being so close to Veronica, and yet Elizabeth couldn't go see her mom. I don't think things are ever going to go back to the way they were. Things are never going to be normal. 9/11 is a great example. Back in the day, you could just go into the airport. Airports were open, and you could see people all the way to the gate, right to where they boarded the plane. None of that is going to happen again. Businesswise, we are not going to be "Oh yeah, walk-ins welcome. Come on in." I don't think we'll get to that point any time soon. The pandemic also means we are missing small things like game nights. I enjoy those but sometimes think, "I will pass on this one." Because we live with my parents and we have Elizabeth, we just pass for now. But we will get through it.

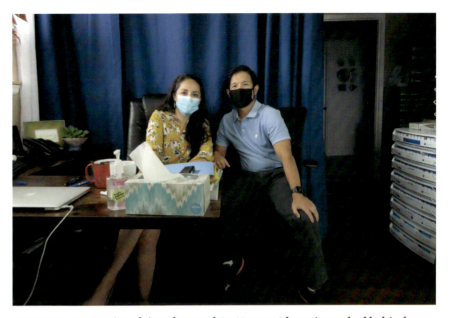

FIGURE 1.14. Veronica Alviso Phan and Dr. Truong Phan sit masked behind a desk with tissue and sanitizing gel in the reception area of Bering See Vision. Their optometry practice stayed open during the pandemic but only permitted one patient inside at a time. 2020. Photograph by RB Smith.

FIGURE 1.15. Volleyball coach Veronica Alviso Phan offers guidance to the Lady Nanooks. Nome high school volleyball met for practices and scrimmages but didn't have a regular competition season in 2020. Photograph courtesy of Veronica Alviso Phan.

KRISTINE MCRAE

Kristine McRae owns and operates Bering Tea & Coffee, located inside a historic building on Bering Street in Nome (figure 1.16). The popular café closed to the public at the start of the pandemic and then reopened in the summer of 2020 with innovative social distancing policies. This conversation was held between Kristine McRae and RB Smith at Bering Tea & Coffee on September 14, 2020.

We had all heard about the coronavirus but didn't quite understand what the effects were going to be. It was confusing for people. The Nome City Council held an emergency meeting on March 12, 2020, to get input from the community and medical professionals. I remember halfway through the meeting thinking, "I'm sitting in this crowded meeting listening about a dangerous virus behind these two guys who are coughing, and there's no escape."

I have a business, Bering Tea & Coffee, here in Nome. I immediately went to takeout only, and then on Sunday, March 15, 2020, we closed. I didn't know if it was premature or not. I did it because any building that stayed open was going to get overflow from the closed city buildings, restaurants, and bars. So I am looking around at our small shop, thinking, "I'm not quite sure if I want to be that spot." It made sense to close.

Closing took some stress off of us, in terms of the virus danger, but it also added stress because we had ordered a lot of supplies for Iditarod. For a lot of places in this region, revenues from Iditarod and birding carry them throughout the year. So we took a big hit financially after having made that initial investment and then not selling anything for six weeks. That was tricky.

Maybe a week or two after we closed, we were watching our own response teams and hospital workers gear up for the pandemic. So we did a bit of outreach with some of the supplies that we had from Iditarod. We brought coffees to the hospital, to Alaska Airlines, to the grocery stores, to some frontline people. It felt good to support the community early on in that way. When we opened, people were so supportive of us, and that's what has kept us going.

Bering Tea & Coffee initially stayed closed for six weeks. That time was confusing for us, as I'm sure it was for a lot of businesses and individuals who lost work. I thought about different ways that we could open. We built a shelf out the window (figure 1.17). We developed an app for mobile ordering. We started wearing masks as soon as we opened because it's better to err on the side of caution. If my staff gets sick, that's huge. There was a learning curve, but when we opened on April 29, 2020, we were insanely busy. People were so patient and we had a beautiful summer, which helped a lot. I feel like we are a fairly well-oiled machine right now.

We still have our music going, we still have a hustle and bustle, but we miss the physical people.

We are not really considering opening fully yet; it's hard to know what to do and when to do it. It's so hard to know what the right call is. Some of our customers coming to the window are wearing masks and some of them aren't; some of them believe in COVID and some of them don't. Everyone seems to be social distancing and making it work. I'm happy to see them. If I were to fully open my doors, I would lose those people who don't want to come in close contact with other folks during this pandemic. Service through the window seems to create a comfort level at this time.

Being in Nome, Alaska, during the coronavirus is not a bad thing. I feel really lucky to be where we are, and I am really impressed with the region for keeping the villages safe. That was the main reason we closed: because if this sickness reaches Elders, they will not survive. Because of our remote location, I don't think that we in Western Alaska are able to wrap our heads around the severity of the pandemic around the country and around the world. We are so blessed to have been here. To have community leaders who, granted, may have stumbled along the way, and have taken a lot of heat for a lot of things that aren't really in their power, but have done a really good job, along with Norton Sound Health Corporation, of keeping COVID from spreading in our region during an extraordinary time.

The pandemic has been divisive but not to the point where it's an awful place to be community-wise. Geographically, I don't think we could ask for a better place. We are a community that supports each other. I think if you were to ask people, "What's your true goal?" it would be to save lives and to keep people safe.

10 DIANA HAECKER AND NILS HAHN

Diana Haecker and Nils Hahn own and operate the Nome Nugget, *Alaska's oldest newspaper and the only printed newspaper in the Bering Strait region (figure 1.18). Avid dog mushers, Nils was participating in the Iditarod Trail Sled Dog Race when COVID-19 arrived in Alaska. Diana and Nils spent the rest of 2020 covering pandemic-related events for the newspaper. This conversation was held between Diana Haecker, Nils Hahn, and RB Smith at the* Nome Nugget *offices on September 24, 2020.*

NILS: We were preparing for the 2020 Iditarod Trail Sled Dog Race when we learned about the pandemic. We were working full-time training dogs and making travel arrangements to get the dog team from Nome to Anchorage.

DIANA: When we left Nome for Anchorage to get Nils to the ceremonial start, there began to be a real possibility that this could be a pandemic. But we had no inkling that this would eventually shut down the entire state and Nome. The focus was on Nils running the Iditarod, not Nils running the Iditarod while a pandemic happens.

NILS: You get to Anchorage and you have meetings where there are hundreds, if not thousands, of people who want to shake your hand and get your autograph. It was a great concern for us to not get sick, because that's the last thing you want to do when you're traveling a thousand miles with your dogs.

The thought was that you can't do anything about the pandemic. No matter what, the restart is coming up. Then the first week of March, we're traveling the trail and there's no news. I didn't have a phone or any kind of communication. Some other mushers have a smartphone, and they get whatever their spouse

tells them or whatever they pick up from who knows where. There are all these rumors going around.

You're pretty safe because you're on the trail and away from crowds, but at the same time you're worried about what's going on in the real world. What's going on with your family? What's going to happen after the race is done and it's back to real life?

DIANA: When Nils was on the trail, I came back to Nome. There was an emergency City Council meeting regarding COVID. The concern was that we cannot keep the coronavirus out indefinitely, but we have to make sure that it doesn't overwhelm our local hospital. The question was: How much can we handle? There was a panic ensuing of how we could keep the enemy out and yet at the same time not totally give up on life. That meeting really brought about how severe this pandemic is.

NILS: People started speculating about whether or not Iditarod would shut down the race midway (figure 1.19). And we didn't know if villages would let the mushers and staff come into the villages. Before the race, you send out 2,000 pounds of food to get you through. So you're dependent on all these villages to welcome the racers and staff in the village.

DIANA: As the wife of an Iditarod musher, I was shocked at the idea that they would turn mushers around. At that point they were pretty far along, and it would be more than a 1,000-mile trip to get them back home.

As a newspaper business we were an essential service, so we could maintain our business. But as an editor and publisher, it gives you a kick in the gut when there's a pandemic coming and you don't know what's next or if you can keep it going. But knock on wood, the *Nome Nugget* has managed to stay afloat for 120 years, and we continue to do so.

NILS: We chose to live out of town, and we like being with just our little family. So we didn't really feel any anxiety about the pandemic, and it was springtime. Mentally and physically, it didn't really affect us as much besides some worries about the business and the future of society in general and our fellow human beings and Nomeites.

One of the big concerns besides the newspaper and regular life was caring for the dogs. The scary thing for me was that everybody was talking about the supply chain and how many days of food there are in that supply chain. Up here, it's so extreme: if there's a storm in the winter and a plane doesn't make it in, you notice it in the stores right away. I was thinking at that time how vulnerable our area is to disruptions in the supply chain. We are self-sufficient in many ways, but we are very dependent on that supply chain.

DIANA: We get hammered not only by pandemics but by climate-change-driven emergencies. The pandemic might be a precursor of what may come as climate change gets worse. If we're failing right now, God help us later.

FIGURE 1.18. Diana Haecker and Nils Hahn at work inside The Nome Nugget, where they gathered and disseminated critical information on the pandemic. 2020. Photograph by RB Smith.

FIGURE 1.19. A small crowd cheers on Iditarod musher Lance Mackey as he prepares to cross the finish line in Nome. The pandemic kept many tourists and locals from attending the race in 2020. Photograph by Nils Hahn. Courtesy of The Nome Nugget.

Every disaster teaches us that it's not the disaster itself that does us in but the outfall from it, and the resources that you don't have. The pandemic has shined its light on our deficiencies. By looking at those deficiencies, as we have here in our little world, we are able to remedy them.

EMILY HOFSTAEDTER

Emily Hofstaedter first came to Nome in 2017 as a volunteer at KNOM radio station (figure 1.20). She returned to Nome in 2020 as the lead reporter at KNOM and oversaw most of the station's coverage of the pandemic. This conversation was held between Emily Hofstaedter and RB Smith at the KNOM studios on November 6, 2020.

The timing of COVID was particularly interesting for Nome. The understanding of how serious this disease was to our country happened during the middle of Iditarod, which is our biggest event. We're in these packed meetings in City Hall with 120 people, and they're talking about canceling the events. I mean, this is Nome canceling Iditarod. I think because COVID hit us in the middle of that really big event, it was pretty obvious that it was serious.

Iditarod is partially inspired by the diphtheria outbreak of 1925, but it's not actually the commemoration of that. This year, eerily, we did have a group of mushers do their own version of the Serum Run. I covered that event as a reporter. So all throughout the winter, before COVID, I was learning about the 1925 diphtheria outbreak and how serious a disease this was to somewhere like Nome. So I'm following this reenactment of the Serum Run, which is tracing a serious illness in Nome's history, right as we're starting to hear rumbles around the world of coronavirus.

Then, all of a sudden, the pandemic hits Seattle. It was nerve racking by that point because

Seattle is our point of entry to Alaska. All of a sudden, we know this is serious. I'm thinking of those other reporters whose accounts of the diphtheria outbreak I was reading, and I thought, "I'm one of those reporters now." We're living and writing through history.

At that point, I started to realize this is probably going to affect our lives. In the spring, it was quite hard because my friends and my boyfriend and I were among the people who took it seriously. I really tried to keep my distance. I went out to Safety Roadhouse a couple of times over the summer during off times, but I haven't been going out to restaurants or bars or even gatherings with most of my friends. It was very hard not to have the physical support of being with your friends and partner.

Especially in those early days, it was hard to find ways to recharge. Iditarod is a really busy time for us as reporters in the state. By the time Iditarod comes, you're already feeling burned out as a reporter up here. Then COVID happened, and it just happened and happened and happened. I don't even remember March through June. But I think people did appreciate having us running those

FIGURE 1.20. Emily Hofstaedter at work in a broadcasting studio at KNOM in Nome. Staff continued to come into the radio station during the pandemic to provide essential information to the public. 2020. Photograph by RB Smith.

FIGURE 1.21. Staff and volunteers put up Christmas decorations around the KNOM studio in 2020. Large Christmas gatherings were discouraged during the pandemic, but small groups still found quieter ways to celebrate the holiday. Photograph courtesy of Emily Hofstaedter.

news stories and those announcements, because people want to know what's going on and they're scared. So it was a time when I really felt like my job was part of the public good (figure 1.21).

I definitely hit my pandemic slump a lot later because I was so busy reporting on this crazy thing for so many months. But by the time the summer came, I was like "I don't know what to do. I'm burned out. I can't do this." That was hard.

One of the things that I missed so much is the Western Alaska potluck culture, a last-minute call-up of a bunch of people who throw together food. It's a really deep part of culture here, and obviously that isn't so much a thing right now.

I'm excited to get to travel again. One of the funny things about living in Nome is that you think, "I can't take a small town anymore," and then you go on a three-day trip to Anchorage and you come back and you're like "Wait, this is the best." But it's hard when you don't have that reset to be able to travel and see other people. It can feel a little claustrophobic. At the same time, there is an ever-present fear of how far the virus has spread, and it hasn't been here yet.

12

JOSEPHINE TATAUQ BOURDON

Nome-born Josephine "Josie" Tatauq Bourdon holds a long teaching career, including two years in her mother's hometown of Wales, and eighteen years with Nome Public Schools (figure 1.22). Recently retired, she cared for her mother, Esther Bourdon (1929–2021), during the pandemic and continues to teach Inupiaq language at the University of Alaska Fairbanks Northwest Campus. This conversation was held between Josie Bourdon and RB Smith at the University of Alaska Fairbanks Northwest Campus on October 14, 2020.

Effects of the pandemic really hit me in early March 2020, when my trips were getting canceled. I was in bed, and I just couldn't breathe. It felt like I was suffocating. I had to get out of bed. I had to get outside. I had to get fresh air. That was the realization that "oh, this is really happening."

I love to travel, and I had major trips planned in March. I was planning to meet my friends in Sacramento, California, for a week. I was leaving on Friday, and COVID really hit Sacramento that Thursday. So that was my first trip being canceled.

I haven't even gone to Anchorage in seven, eight months now. I normally frequent Anchorage about every month to visit my brother and to go shopping and dining. It's strange to have not been on an airplane. I have all these tickets in my Alaska Airlines wallet, and I can't wait to use them someday.

I'm happy because if I'm going to be anywhere during this time, I want to be home. One positive for me is that COVID created opportunities to complete a lot of home projects that I have wanted to do for a long time but would not have been able to do otherwise. I craft, so I occupy a lot of my time making masks for other people and sewing and knitting for family. That's how I've been occupying my time since COVID hit. I'm never idle; I'm one of those busy types.

We are fortunate in Alaska, and in rural places like Nome, because we are able to jump in our cars and be at our cabin or on the beach (figure 1.23). Alaskans live in such a vast country. Alaska Natives in particular are used to being out on the land. We're already social distancing, because we are never close to one another when we hunt or fish. In larger cities, people are really shut in. In that sense, it didn't impact me in terms of feeling like "oh gosh, I'm tied to my house."

I am bummed that we're not going to see sports. I'm a real sports person. I love to watch many sports, my favorite being ice hockey. I like to watch and support the home team, so I'm disappointed because I don't think we're going to see any Nanook basketball games.

My siblings and I know the severity of the pandemic. It has impacted how we're living our life. We're very careful. I have my ninety-one-year-old mother living with me, and in the meantime she's had some medical issues. Thankfully she rebounded, but she got really, really ill about a month and a half ago, to the point where the doc-

tor and I had to decide "do we keep her in the hospital, or is it a possibility she just goes home and perhaps she passes away at home?" That's an odd thing thrown at you: that you could die at the hospital without your family being there up until the last moment.

This morning I got a text from my cousin Becky, who lives in Anchorage, about her brother, my cousin Harvey. He and his wife tested positive for COVID, and she's on a ventilator. It hadn't hit me this close until somebody got COVID within my own family.

Not seeing my friends is probably the hardest thing. Everybody in Nome knows pretty much everybody, so you're happy to see each other but yet you can't get close to each other. When it's all said and done, we are going to be so happy to finally just embrace our loved ones, or our friends, our colleagues.

I'm a letter writer. I love to write, so that didn't stop. I kept in contact with friends and family through letter writing. I just kept writing to them wherever they live and enjoyed getting the mail.

What I want to tell people about this time is the importance of connection with the family and how tight it makes a family become. Your family circle's going to be the one that holds you up and keeps you glued together.

FIGURE 1.22. Josie Bourdon smiles behind her mask at the University of Alaska Fairbanks Northwest Campus in Nome before teaching an Inupiaq-language class. She held in-person classes during the fall of 2020 with social distancing and mask use in place. Photograph by RB Smith.

FIGURE 1.23. Josie Bourdon and her mother, Esther Bourdon, enjoy being out and about during Iditarod week in Nome in March 2017. Photograph courtesy of The Nome Nugget.

KATHERINE SCOTT

Katherine "Kitty" Scott was born and raised in Nome, where she has lived for almost ninety years (figure 1.24). Her home on Front Street looks out over Norton Sound and is filled with objects and photographs from Nome's past. This conversation was held between Kitty Scott and RB Smith at Kitty's home on November 12, 2020.

I was hoping for a trip to Phoenix this year. My son owns a condo in Phoenix, and I use it one month out of the year. I didn't go, and it's the first time I've missed it in four years. The trip is a really good break away from town and everyday life and the dark winter. No matter how long I have lived here, I do not like the dark. But I prefer to be home if I am going to end up sick.

Spontaneous visiting of friends was the first to go, and that's quite popular in smaller isolated locations. Visiting has come to a screeching dead halt, and I miss it. I might feel comfortable going to somebody's house, but they in turn may not feel comfortable having company. I'm a people person and widowed, and my children are grown and gone from home. I have not yet got used to so much solitude. That's probably my biggest upset with the pandemic, along with not being able to travel. But I don't want to be on an airplane with people you have never met and don't know if they are sick or not.

I do have grandchildren in Nome, as well as my son and his wife; we visit here in town. One of the things that I admire about my family is that we made a pact that we would feel free to visit each other. We all agreed that we wouldn't be careless and we would wear masks when we go out (figure 1.25). We have felt comfortable going into each other's homes.

I had some friends get really upset with me, and I felt bad about it. After church on a Sunday morning, they wanted me to go with about three or four other people down to the restaurant and I refused to go. They said, "Why not?" I said because I already made a promise to my family and I would not break the pact we have.

I trust our country to be diligently working to find a cure. We found a cure for so many other diseases that have been devastating, such as tuberculosis. There have been pandemics in Nome in the past. When the measles or mumps were here, the city required that quarantine notices be put on the outside of doors. Nobody complained about that, but they wouldn't do that now.

I am more comfortable since President Trump is no longer calling the shots for the country. I strongly resented that he competed with the medical experts. His decision making was not according to the medical experts. It's very scary. You're supposed to look at your president as the father of the country during their four years, you know?

That's a big thing that our president would question experts' advice. It just boggles my mind.

I have struggled with patience. I honestly thought the pandemic would last maybe three months. I think it's a long, big bump in the road, but I think we will recuperate. And we will recuperate faster if people listen to what the experts are saying.

FIGURE 1.24. Kitty Scott at home in Nome. Kitty and her family decided at the start of the pandemic to wear masks so they could continue to meet in a COVID-safe "bubble." 2020. Photograph by RB Smith.

FIGURE 1.25. The first two businesses in Nome to require face mask use during the pandemic included Hanson's grocery store, shown here, and the Alaska Commercial Company store. 2020. Photograph by RB Smith.

14 JOHN HANDELAND

John Handeland is proud to call Nome his one and only hometown, where he has served in many capacities, including manager of Nome Joint Utility System and mayor of the City of Nome (figure 1.26). He is an avid photographer, pug enthusiast, and board member of the Iditarod Trail Committee. This conversation was held between Mayor Handeland and RB Smith at Nome City Hall on September 9, 2020.

When word first started circulating about the pandemic, it seemed like quite a bit of hype. Although we had gone through a simulation exercise about a year before with Public Health Nursing for precisely this type of thing. The coronavirus was primarily on the East Coast, and then it started moving across the country. All of a sudden, the villages started to be concerned, and folks in town were starting to get alarmed as well. At that point, I started to read up a little more on it and trying to sort out what information was right and what was mistruth. There was a whole lot of conflicting information. When you started seeing the number of coronavirus cases in New York, hearing about all the folks that were perishing, and how exponentially it was growing, then it became much more real. My initial thought was that it was more hype than reality, but I had to quickly change my mind.

I got involved in the pandemic right from the beginning. It was during Iditarod time. I am on the Iditarod board and help to coordinate all of the activities on this end of the trail. There was quite a bit of lobbying to tamp down our visitors at that point in time. I didn't feel that we could turn mushers around and tell them, "No, you can't come into Nome," when they had already traveled 1,049 miles. If that was to be the case, we should have stopped them before they left Anchorage.

From the beginning, I believed that we could take steps on our own to be protective of ourselves. I am supportive of us continuing to be a little restrictive on folks coming into Nome, but there are certainly those who feel differently. Coming to some kind of an understanding or happy medium is very difficult because things change from day to day.

After the initial case of coronavirus we had in town, people freaked out. It took a little bit of education for people to accept the fact that the person who got this virus wasn't trying to get it. I think people are coming around to the reality that there really is something to this. Sometimes you don't take something seriously until it hits somebody that you actually know. I believe that we have had instances where some people have caught the virus but didn't show many symptoms. There have also been cases where people have been very seriously ill with it. For those, it's like, "Gee, I know that person," and that hits home a little better for people.

There were communities all over the state and all over the nation that were canceling their Fourth

FIGURE 1.26. Mayor John Handeland poses with a piece of driftwood painted with his name inside council chambers at Nome City Hall in 2020. Photograph by RB Smith.

FIGURE 1.27. Spectators scramble for candy tossed from vehicles as the Fourth of July parade makes its way down Front Street in 2020. Photograph courtesy of James Mason.

of July festivities. That was one of my first mayoral things to decide: shall we cancel our celebration? I decided that we would go ahead, but people still lobbied to have our celebration canceled. My thought was "Nope, we're going to be patriotic. We'll make adjustments to some of the things that we do, but we can do this safely and people need to learn to live with this thing." The Fourth of July celebration was a good thing here in Nome (figure 1.27).

We had a beautiful summer without a lot of rain, so folks didn't have to be cooped up in their homes and could enjoy our beautiful countryside. We have had to make major adjustments to what we do every day, especially because we have quite a few folks who are more susceptible or vulnerable to the virus. Holding meetings where not everyone is in the room is hard. For a lot of interaction in meet-

ings, you need to be able to see and read body language at the same time.

Normally, I would head out to Anchorage at least once a month for work or something personal, such as going to a doctor's appointment. My first televisit with a doctor was kind of strange. But after seeing how it worked the first time, I have had numerous appointments that way, and it's actually been nice to not have to jump on a plane and spend three days out of town to get some medical things done.

We have now learned how to work with the virus in our midst and know there are some things that you just can't still do. We need to continue to be vigilant and diligent in our safeguarding of ourselves and others as we're moving forward. You know the old saying "Those that forget history are doomed to repeat it."

15 GLENN STECKMAN

Glenn Steckman moved to Nome from Reading, Pennsylvania, in the fall of 2019 to serve as manager for the City of Nome (figure 1.28). Six months into the position, he was faced with the unexpected challenge of spearheading city efforts to combat the novel coronavirus. This conversation was held between Glenn Steckman and RB Smith at Nome City Hall on October 9, 2020.

We had the City Council meeting on March 12, 2020, because we were considering what to do with the Iditarod, which was scheduled to come to Nome and had already started in Anchorage before all hell broke loose. What was this outbreak going to be like? Do we keep city buildings open? We were having meetings with Iditarod officials trying to figure out what to do while trying to close the community down at the same time.

We went to the Nome Common Council with a proposal because they were asking staff what to do. The council said, "We want the buildings closed." So we immediately closed the buildings. We were speaking with Alaska Airlines to look at restricting the number of flights coming into Nome so we could better handle what was going on. We spoke about going down to just two days a week for passenger service. We also wanted to make sure freight service was not interrupted, because we don't survive unless we get our freight.

We are locking down everything in the community for the next few months. Winter is tough in this community. We shut the swimming pool down. The schools are going to online learning in a community that has very weak internet. I think there was hope

that this was not going to be something that would last anywhere near what it has lasted.

I think there's general stress with everybody. People are tired. People are feeling like they're trapped on the island, and if they get off the island, then they have a choice of going through a seven- or a fourteen-day quarantine. There's tension; there's struggle in the family units. There was a phenomenal increase in sexual assaults and domestic violence and probation violations in Nome. The number of police calls in April, May, and June shot from a normal number of about 200 calls to almost 500. We have seen a lot more arrests, all alcohol related.

I was working sixty to seventy hours a week, and probably ten hours of that were related to the normal day-to-day stuff here (figure 1.29). It was really about trying to balance the concerns of the Alaska Natives, who remember through generational stories the big sickness of 1918, and those in our community who didn't quite buy into the complete shutdown of the city. The virus is in some ways political. I have had threats made against me on Facebook. We had somebody up here get into a fistfight with another individual at the airport over what the city should do.

Alaskans don't want government interfering in their lives, but at the same time when they need something, they want government there. So you have that tension between government and residents. My philosophy is anybody can come in and speak to me. I'm more than willing to listen. Maybe there's something we can do. Maybe there's not, but at least come in and have a conversation. We are listening to all sides to make local government decisions. We're taking a tremendous amount of input as part of our decision making.

There are things the community is doing very well. People up here know how to sustain themselves. We've learned how to better handle the disease. The hospital has been a great partner. One positive to come out of this is that it allowed the city government to start building a relationship again with Nome Eskimo Community and to also build relationships with the tribal organizations, the hospital, and the villages, because we all needed to work together. We tried to bring everybody in so everybody was communicating with each other about what was going on and what was not going on. By working together and following many of the rules, we have stopped a major outbreak in the city of Nome and the surrounding communities, compared to the pandemic that had a devastating effect a hundred years earlier.

FIGURE 1.28. City of Nome manager Glenn Steckman looks over police reports in his office at City Hall. Calls for police assistance increased exponentially during the pandemic. Photograph by RB Smith.

FIGURE 1.29. Nome City Council meetings continued throughout the pandemic with distancing and masking requirements in place. Some council members chose to attend meetings over Zoom and were displayed on new televisions installed in 2020. Photograph courtesy of KNOM.

16 ADEM BOECKMANN

Adem Boeckmann arrived in Nome forty years ago to search for gold but soon turned to commercial fishing and a passionate pursuit of crab, herring, and halibut (figure 1.30). Adem has four sons and holds a deep appreciation for the freedom of the Alaskan countryside. This conversation was held between Adem Boeckmann and RB Smith at Airport Pizza in Nome on September 18, 2020.

I am in the camp that the pandemic should be taken seriously and we should figure out what it is about. At this point, I think we should be putting a bubble around the highest-risk groups and letting the rest get back to business because you want to make sure the cure isn't worse than the sickness.

Drinking is way up and domestic violence is way up in Nome. The pandemic has strained friendships. People are saying, "Wear your mask! If we would just stay at home for three weeks, it'll all be gone forever!" There are a lot of people who think it's just that simple, and maybe they're correct, but I don't think it's realistic.

I believe social media is causing a bigger and bigger rift between us. If I say, "Trump is the best guy in the whole world," do I start seeing more things to validate that? Or if I say, "Trump's the biggest tool in the world," do I see more things to polarize me? It's almost as if we have two of the biggest cults in the world.

On one hand people say, "Let's watch out for this stuff. It can kill some people. You should take it seriously." But at the same time, we need to take seriously that people haven't been able to work, are stressed out, are drinking too much, and are going to start snapping and doing harm to their families and themselves.

My attitude can be interpreted as insensitive to a lot of friends that could be in that high-risk group. You make a comment on social media and people say, "Oh, you want me to die?" It comes back sounding like "You don't think I'm worth living." But I don't think it's that black and white. I consider myself a blue-collar guy. I'm not a state employee. I didn't go for those long-term jobs that have real good security. A lot of the people with those kinds of attitudes have made those choices and have good security, but there are a lot of Americans that don't share that. I feel that I champion that group.

Take this restaurant, Airport Pizza—many restaurants like this are closed. This is an entrepreneurial venture. For every one restaurant that works, there are probably ten that had to close, in the best of times. When a restaurant fails, it's not just that one dream that has been killed. That was the one success, and it represented ten failures trying to get there. And restaurants don't come back right away; maybe they will never come back.

In Nome we have had forty-two documented cases so far. We have tested the heck out of it; we

have to have some of the highest testing in the state. I might know one or two of the guys who tested positive. Neither of the guys were sick; one had a sore throat. The way the pandemic is presented to the public is "Even if it doesn't kill you, it's going to maim you for life." But the vast majority of the people that I know say, "I got it, but I didn't know I had it!"

In the region we haven't had any confirmed false positives, but false positives are a thing. The inner circle of this one guy had coronavirus, so he got tested and was negative. Then he came to Nome and tested positive. Was he a false positive or a positive? It got me thinking. The news has done a very good job at making people very, very concerned over this, to the point where I think it's a mass hysteria.

We are beginning to get very comfortable here in Nome. My bubble is growing. It was pretty tight there for a while, but now I go out daily to the Gold Dust Saloon and I visit with people. I have done a little bit of halibut fishing. We don't have a lot of fishing quota, but I was able to get out on the water and do a little fishing (figure 1.31). It was good for the heart and soul.

FIGURE 1.30. Adem Boeckmann holds up his mug at Airport Pizza in September 2020. Several of Nome's restaurants were open to in-person dining during fall 2020, although staff wore masks and seated patrons far apart from one another. Photograph by RB Smith.

FIGURE 1.31. The City of Nome's small boat harbor was conspicuously empty during 2020, as many of the commercial fishing vessels and pleasure craft that travel north for the summer remained in southern waters. Photograph by RB Smith.

17

DEREK MCLARTY

Derek McLarty landed in Nome as a crane operator helping to expand the Nome port in 2004 (figure 1.32). Today, he offers welding and fabrication services for mining dredges and fishing vessels. He serves on the Nome Port Commission and board of the Nome Joint Utility System. This conversation was held between Derek McLarty and RB Smith outside the Nome Nugget *offices on September 21, 2020.*

I had seen news about the pandemic for two months. Then all of a sudden, it was like maybe Nome should do something about it. The City of Nome's decision to close things down was definitely made in a late fashion. Halfway through the week of events before Iditarod ended, the city was like "Well, I guess we're going to shut everything down, even though everybody's already here in Nome." I thought that was a little bit asinine, as the exposure was already here. They tried to have their cake and eat it too. They didn't want to stop the Iditarod, but in some ways they stopped the event anyway.

The pandemic affected every part of life, including local politics. There was quite a bit of backlash over the City of Nome's decision because everybody had their own opinion. Some people say it's ridiculous, and some people say it's super-serious. Instead of being reactionary, Nome is enacting really stringent rules and being proactive. But we're being proactive to something that's potentially imaginary. I'm not saying it is, but we could have maybe held on to a little bit of normalcy.

It's been very odd without tourism this year, and I'm going to throw miners in there because it's the same thing. The miners are normally up here spending money as well. It's just a shame because the price of gold is so elevated right now. All the people that would be offshore mining would spend their money in Nome. So Nome is not very funded right now.

The travel bans in Nome and the nation have made a strange dynamic. It has created a lot of isolationists or recluses. People have a strong intensity when you interact with them. We are at the extremes of everything, including isolation and political things. It's like elementary school—you have to huddle your two little buddies together and say, "Hey man, we have to learn to play together." It's just ridiculous.

I have had a ridiculously busy summer because none of the other people that would be servicing vessels and helping to fix things are here (figure 1.33). I am getting calls from all over. I would normally travel to the villages to work, but even that's changed. It hasn't changed the scenery, as the roads only go so far in either direction from Nome. I want to go traveling, see some family, play some disc golf on my course, watch some live music, and drink some microbrews.

I am an optimist. I try to think that this is just going to be short lived. I would say protect the susceptible, but protect your way of life, protect the economy. Stay in the middle. Don't go too far right; don't go too far left. For the people who never bought into it all the way, it didn't affect them much besides the inconvenience of remembering a mask. I think the people who really took this to heart are going to keep it to heart for a long time.

I think the long-term effects of the pandemic are going to be substantial. It's similar to people who lived through the Depression; they were frugal, hoarders until the day they died because of an event. It's going to be just as hard to go back as it was to go into the pandemic. I think that's going to be a really interesting social dynamic for a lot of people, because people just inherently don't like change. I think we're up for something that's going to be a lot harder of a pattern to break than it was to form.

FIGURE 1.32. Derek McLarty enjoys a sunny afternoon with a view of Nome City Hall in the background. His summer of freelance machine work was busier than ever, since many of the miners he usually competes with didn't travel to Nome in 2020. Photograph by RB Smith.

FIGURE 1.33. Suction dredges float near Belmont Point at the mouth of the Snake River in Nome. The handful of gold miners who made it to Nome in 2020 had a busy summer. Photograph courtesy of KNOM.

18 CRYSTAL TOOLIE

Crystal Toolie grew up in Nome and carries family ties to Savoonga and New Orleans, Louisiana (figure 1.34). Toolie works as a clerk at the Nome Courthouse, enjoys competing in long-distance marathons, and serves as president of the Nome–St. Lawrence Island Dance Group. She lives in Nome with her two daughters and one son. This conversation was held between Crystal Toolie and RB Smith via Zoom on October 9, 2020.

Initially, I didn't think too much of the pandemic, because I was uneducated about what the coronavirus was and how it would really affect our daily lives. Prior to us knowing it was in Alaska, I was commuting fairly regularly back and forth between Nome and Anchorage. My boyfriend is from Anchorage, and thankfully I was able to convince him to move to Nome about two weeks before there were travel restrictions. This was right before Iditarod. So he moved here mid-February 2020, and that's when things started happening.

The pandemic didn't affect me too much at first, because I was happy that I wasn't having to travel as much, because my boyfriend had just moved here. Work has kept me busy (figure 1.35). My girls have kept me busy. I have my new kitten, Jinx. I'd like to say I've been reading more, but I haven't. I'd like to say I've been running more, but I haven't. So there's a lot of things I know I want to do.

I have two daughters; one just turned ten, and one is about to turn sixteen. They missed a lot of school at the end of last year. One of my biggest fears during this time is that my kids won't be able to have in-school education, because I'm not a teacher. So I want to make sure that they are getting the education they need from professionals who know what they're doing.

All this uncertainty can be unsettling. Having certainty again, maybe when there is a vaccine, will be nice. I have not traveled since February 2020. I miss getting out. I love Nome, but it's nice to have like a weekend vacation or a week vacation.

I am also the president of the Nome–St. Lawrence Island Dance Group, and we haven't been practicing too much. We've tried to practice a couple of times outside this summer on really nice days. But we definitely haven't gathered as much because of COVID. Our singing and dancing is very special to us. It's our way of passing down tradition. We use it to celebrate happy things. We use it for healing. We use it just as something to share with others. It helps us bond. One of our members just passed on, maybe a month ago. Normally, we would dance at the reception and gather and have food, but that didn't happen. I don't know how to explain how that feels, especially since he was a large part of our group.

What's great about Nome is that we generally all support each other. The good thing is we have pro-

FIGURE 1.34. Crystal Toolie smiles for a selfie. Although she regularly traveled to Anchorage before the pandemic, she worked primarily from home in 2020. Photograph courtesy of Crystal Toolie.

FIGURE 1.35. The Nome Courthouse closed to in-person visits during the pandemic and required visitors to communicate with staff through a phone or computer outside the main doors shown here. Photograph by RB Smith.

grams like Zoom—as long as the tools are used in the right way. Of course we have to learn how to use them first, then I think it's a good thing. The bad thing is that people are social beings. FaceTiming is good; Zoom is good. But how can you make new connections if you're not out and about? If you're cooped up and you're not really an outdoorsy kind of person, I can see how that can affect people emo-

tionally, because usually we try to find connections. What I'm seeing is that people are forced to find other forms of communication, and there's less face-to-face interaction. I think people are appreciating the connections that they do have. So I hope that sticks around and people won't take those connections for granted.

MARYJANE LITCHARD

MaryJane Litchard grew up in the Bering Strait region and has lived on and off in Nome since she was a child (figure 1.36). She works with Kawerak, Inc. as an adult education / GED program specialist and enjoys drawing and creating artwork from natural materials. This conversation was held between MaryJane Litchard and RB Smith at the Carrie M. McLain Memorial Museum on September 10, 2020.

At the very beginning of the pandemic, I took it hard. When I worked in the Nome Public Schools bilingual programs, I read *People of Kauwerak* by William Oquilluk. He wrote that ancient Eskimos predicted that there would be another worldwide pandemic where many of our Native people will die.

At first I thought, "This is doomsday." I listened to the radio and watched TV world news. The virus went rampant in big cities. In the world news, it covered one foreign country hospital that was overwhelmed with patients coming to their hospital doors and staff were told not to accept patients over sixty-five due to lack of beds. I thought if it happens here, a lot of us Elders would die. I was crying about it one night when all of a sudden, I saw an image of Jesus. He clapped his hands above his head, then all of a sudden calmness came over me. I started feeling better. I thought, "Okay, I'm going to take good care of myself. I am going to drink a lot of water and make lots of hot soups."

I read that it is a very smart virus. It can transform itself. I figure it is going to last a couple of years, that it is not going to disappear. It will probably last through 2020 and 2021 and maybe finally die out in 2022.

I always follow my intuition. In October 2019 I went to Fairbanks for the Alaska Federation of Natives convention. I whipped out a lot of my drawings, and I took them to a printing shop. I spent $800 on prints. I went back to dig in my portfolio, and I whipped out more drawings. I asked myself, "What's wrong with me? Why am I acting this way?" It felt urgent to print my work. I did another round, and it was over $1,000 for printing. Now I know why: I was preparing for this pandemic so I could have artwork to work on and to sell.

We went to work at Kawerak for a little while. All of a sudden one day they told us, "Go home! Stay home!" because someone had tested positive in the building. We stayed home for two and a half months, and we now have to be tested for COVID every month.

I am a traveling teacher who travels every other week for my job. Now I have to take classes to learn how to teach students on the internet because we are on travel restrictions. I am all thumbs on the internet. I always have to ask for help. I am the type of person who was scared of microwaves and escalators. I was the first generation that did not live in a sod home and had to learn to speak a second lan-

FIGURE 1.36. MaryJane Litchard smiles with mask in hand at the Carrie McLain Museum in September 2020. Her creative design for the Norton Sound Health Corporation CAMP logo can be seen on the water bottle beside her. Photograph by RB Smith.

guage. I thought, "I can get over this fear and learn how to control the internet."

I do healing work. I like to help people with their pain or skin conditions. I collect about thirty pounds of edible greens every spring and summer (figure 1.37). I collect stinkweed and save the stems to make bundles that people burn to purify the air. I am learning about my healing abilities and remembering certain things that hurt me and learning how to heal from them.

FIGURE 1.37. MaryJane Litchard enjoys collecting edible greens in the spring and summer including tender *sura* (willow leaves) shown here. June 2023. Photograph courtesy of MaryJane Litchard.

20 JAMES VENTRESS

James Ventress has served as the youth pastor at Nome Covenant Church since 2011 (figure 1.38). He and his wife, Rachel, are the proud parents of five children and together operate the Checkpoint Youth Center, a bike repair shop, and other programs aimed at serving youth in the community. This conversation was held between Pastor James Ventress and RB Smith at the Ventress home on September 17, 2020.

COVID seemed really far away at first, but I remembered other viruses going through Asia and having serious effects. I didn't know what that would mean for our community or Alaska, but I figured living in a small town in an isolated place, we'll be all right. But what is it going to do to my parents who live in California? I was paying close attention to COVID because I knew it had the potential to be a big deal.

We were interpreting reports from down south through the lens of the historical context of 1918. New York was a major city, and they were falling behind in keeping up with the virus. We are a tiny town with not so many resources. That fear was what was occupying our minds a lot.

My daughter was born in Anchorage on St. Patrick's Day, March 17, of this year. COVID was all over the news when we flew down to Anchorage. We were at Providence Hospital for three or four days, and every day I watched the precautions the hospital was taking increase. Over the course of four days, they only wanted us to leave the hospital once a day. By the time we left Anchorage, they were shutting down Nome. We didn't know what that was going to look like. We were worried about

being able to get a flight home with this newborn. It was like everything changed when we came back to Nome with our daughter. The whole world had changed in those four days that we were gone.

We weren't meeting for church on Sunday mornings; everything had moved to Facebook. There are people with connectivity issues or who don't use technology, so how do you stay connected to each other and serve people when you can't see them and be with them face-to-face? The rules have changed, but we don't even know what the game is. We're still kind of figuring some of that out.

I run a drop-in youth center on Front Street called Checkpoint. The whole community shut down, and we weren't going to be able to open. We shut down for a while, and that was hard because so much of my interaction with youth is face-to-face. We are very relationship- and friendship-oriented. I can text the kids and say, "Hey, how are you doing? I haven't seen you in a while. Is everything all right?" But so much of what we do is over a bowl of soup; that's one of the ways that we care for young people (figure 1.39). I spent a lot of time outside of the house trying to be somewhere where

kids might be gathering. If I was in a public space, I was pretty guaranteed that I was going to bump into young people on the sidewalks.

I asked the young people one day if this was their 9/11 moment. Now life is different. It's a bellwether moment, like a threshold, a liminal moment, a doorway we all step through together.

I feel like we are weathering things pretty well. If there's going to be a global pandemic, rural Alaska is about as good as you're going to get and still have some of the benefits of society. We've been really fortunate here. People have had it here in town, and nobody's died from it. Our geographical isolation has helped with that. If COVID just stopped tomorrow and went away, I don't think we would be too shell shocked. I don't think we would be frozen in the time that we lost. I think we'd pick up a familiar routine of life pretty quickly.

When I'm in church on Sunday morning, I always wear a mask because I don't know who would feel unsafe or disrespected by me not wearing a mask. I don't know what their politics are about COVID or what they think or believe or feel. I wear a mask at church because that's the respectful thing to do. That's also what I'm seeing teens pick up on; we do certain things for other people because it's a service to them of compassion and caring. That ethos is what I hope remains for them: that they are concerned for their community and for other people beyond COVID.

FIGURE 1.38. James Ventress stands on his porch just down the street from Hanson's grocery store in Nome. The Ventress family opened their home for youth programs during the pandemic. Photograph by RB Smith.

FIGURE 1.39. James Ventress and Truong Phan wear COVID-19 protective gear while making tater tot casserole for dinner at Checkpoint Youth Center in 2020. Photograph courtesy of Veronica Alviso Phan.

RHONDA SCHNEIDER, RUTH ANN GLASER, AND RYAN VANDEVERE

Rhonda Schneider, Ruth Ann Glaser, and Ryan VandeVere worked with the Nome Community Center (NCC), that provides services to Elders, families, and youth from across the Bering Strait region (figure 1.40). During the pandemic, Schneider served as the executive director of NCC, Glaser oversaw the Nome Children's Home, and VandeVere managed the Boys & Girls Club. This conversation was held between Rhonda Schneider, Ruth Ann Glaser, Ryan VandeVere, and RB Smith at the XYZ Senior Center on October 20, 2020.

RUTH ANN: I am the director of the Nome Children's Home, an emergency shelter for kids. One of the biggest differences that we've seen this year is that family visitations have stopped. We've had one kid who has not seen her parents in a year. Because of travel restrictions in the region, kids and parents are unable to have those needed relationships. I hope the restrictions lighten because it's important to keep those relationships going.

It's been difficult because we have also had to pull back from community engagement, as there are a lot of different families in our home. We have to be very careful to limit our exposure out in the public, because if we have a full house of ten kids plus staff, we would be affecting a large number of people if someone was to get the virus.

RYAN: I am the director of the Boys & Girls Club. COVID has had a fairly big impact on us because a lot of what we do is to connect with individuals, corporations, and the community in order to give kids opportunities to do activities that they may otherwise have limited access to. The COVID regulations are making that very difficult.

Another challenge is enforcing COVID regulations in the clubhouse. A majority of the kids are pretty good about following the new rules. But it's a struggle, and the kids don't like the changes. They are tired of COVID. They don't really see the big picture, especially among the younger population who don't really understand everything that's involved in making safety decisions. Whether you believe in the virus or not, it's different in Nome, and kids don't understand that what's going on in other places affects Nome.

RHONDA: I am the executive director of Nome Community Center. While other organizations were closing up their buildings and asking employees to stay home or work from home, NCC employees were still coming to work. Folks were flocking to our office because we were the only ones open to help them fill out assistance applications and get connected with needed services.

Elders used to come to the XYZ Senior Center every day for lunch, and now we're doing all home deliveries. We are serving fewer meals, so we know that there are Elders that we are not reaching. When

we are not knocking on their door and delivering a meal to them, that means we are not checking on them. We try to make phone calls and safety checks, but we know that they are not getting services.

The Elders are really missing the socialization. We are trying to be creative with activities. For example, they love to play bingo, so we're playing bingo with them from a distance. We know they are not as physically active. We are looking into creative ways for Elders who have participated in our exercise programs to stay active. For instance, we have delivered mini-bicycles to them to encourage exercise and build their strength.

RYAN: Life goes on. Sometimes there are more difficulties involved, but you have to adapt and move on. I'm ready to move our operations back to normal, but right now we are focused on putting our best foot forward despite what we're dealing with. We are very mission and service oriented. The mindset of the mission lives on, and it will always find a way meet the purpose that it's there for: to provide our youth with opportunities to grow, learn, and have fun as young citizens in this community (figure 1.41).

RHONDA: We have made decisions about our organization and set up protocols that we think are responsible yet not so cumbersome that we can't do what we need to do and can't reach the folks we need to reach. In the future, something will surprise us again, and we'll use what we have learned during this time to get through it.

Nome is divided on some pretty key issues, and the handling of COVID is another one. There's a balance on every issue, and the divide seems greater than it might be in another community. But people have followed the recommendations and have been responsible and respectful.

RUTH ANN: I have learned how important physical touch and relationships are to people. I've had to learn how to stretch myself to show these kiddos that we still love them. They are in a new place and they're not with their families, and they need us to love them through that. We are resilient and we're going to make it. We're going to work through COVID, and this is not going to be our identity. To see how much Nome and the community has come together is pretty great.

FIGURE 1.40. Ruth Ann Glaser, Rhonda Schneider, and Ryan VandeVere gather for a photo in the XYZ Senior Center in Nome. The center staff delivered lunches to Elders' homes when they were unable to come to XYZ during the pandemic. Photograph by RB Smith.

FIGURE 1.41. The Boys & Girls Club visited the Nome Public Safety Building for a public service appreciation event during the pandemic in 2020. Photograph courtesy of Rhonda Schneider.

Artists Karen Olanna (left) and Joseph Kunnuk Sr. (right) hold up pandemic-themed artwork they created for the *Stronger Together* project. Photograph taken by Amy Phillips-Chan in November 2022 inside the Carrie McLain Museum.

PART 2
Artists Respond

The Carrie M. McLain Memorial Museum (Carrie McLain Museum) launched an artist initiative in October 2020 to complement the oral histories in *Stronger Together: Bering Strait Communities Respond to the COVID-19 Pandemic*. The initiative focused on artists with ties to the Bering Strait region and carried three primary goals: to foster creative and visual expressions of the pandemic, to provide an economic stimulus to artists, and to produce a collection of artworks for the museum that would evoke the historical experiences of COVID-19. While museum staff weren't sure what the project would ultimately look like, we did know that there should be an opportunity for artists' voices to be heard and for visitors to ultimately engage with the artwork. In the end, project budget and scope allowed the museum to invite twelve artists to submit pieces of pandemic-themed work.

COVID-19 oral histories recorded for *Stronger Together* were limited in that they focused on Nome and left out alternate perspectives from the greater Bering Strait region. The artist initiative created an opportunity for the museum to expand its reach and include community voices from artists living in Anchorage, Fairbanks, Unalakleet, Savoonga, and Nome. Working with museum director Amy Phillips-Chan, artists were invited to send a sketch of their idea or a written description along with a cost estimate. Upon completion of their piece, each artist was invited to share thoughts on their work through an informal interview or conversation. From November 6, 2020, to April 1, 2022, Phillips-Chan held interviews with artists in person (5), over the phone (5), and via Zoom (2). Each artist received a $100 gift card for participating in an interview and assisting with review of their interview materials.

Part 2 presents contributions from twelve artists who speak to COVID-19 and whose works also touch on Indigenous history, resilience, family, and community. Artist contributions are loosely arranged by medium, from local natural resources,

including walrus ivory and sealskin, to painting, photography, and mixed media (table 2.1). Artwork was commissioned or purchased directly by the Carrie McLain Museum and is now in the permanent collection in Nome.

Biographical summaries written in consultation with the artists appear before an edited and abridged interview or story illustrated with images shared by the artists. Stories speak to emerging opportunities for forming virtual communities of artists, pivoting to online sales, and reimagining artistic heritage practices through the lens of the pandemic. Interwoven throughout these pandemic stories are expressions of gratitude for increased time with family and an optimism for the future of the arts in Alaska.

PANDEMIC ART CARRIES MESSAGES OF RESILIENCE AND TRANSFORMATION

Artwork from the COVID-19 initiative features images and symbolism that offer an intimate glimpse into the physical and mental impact of the pandemic on the artists. Many pieces include natural materials and cultural signifiers that reference the histories, traditions, and, in some instances, commodification, of Alaska Native peoples. Dominant within the work is an emphasis on raw materials and the creative process as seen through the delicate stitches in a piece of tanned sealskin, file marks across a walrus tusk, and a wood knot integrated into a block print design. Together, the work speaks to a transformative period in Alaska art in which artists are finding new purpose in their work and a capacity to adapt and grow in the face of extreme challenges.

King Island artists Joseph Kunnuk Sr. (Inupiaq) and Sylvester Ayek (Inupiaq) both drew from a cultural tradition of using walrus ivory for tools and artwork but took very different approaches to creating their sinuous sculptures. Kunnuk (this volume, p. 100) recalls, "We started carving when we were young, down on King Island. Nine or ten years old. My dad gave me a piece of file and a walrus tooth and he said, 'Time to learn.'" For *Inupiaq Family and Mask*, Kunnuk depicted a family group continuing their time-honored subsistence activities and traditional dancing despite the pandemic (figure 2.1). On the large walrus tusk, the wife and husband are situated six inches apart in representation of six-feet social distancing. The female figure is shown holding a berry picker and bucket, while the male hunter has caught a seal and is dragging it home across the ice. Son and daughter figures are dancing atop a smaller walrus tusk and wearing kerchiefs over their mouths, a repurposed use of the headscarf that many Inupiaq women once wore. An ivory mask with inset baleen dots looms larger than life as a symbol of its dominance within our new world.

TABLE 2.1. COVID-19 artist participants, 2020–2022

Artist	Medium	Date of Interview	Location
Joseph Kunnuk Sr.	Walrus Ivory	November 6, 2020	Interviewee Home
Marjorie Kunaq Tahbone	Skin Sewing	January 15, 2021	Telephone
Josephine Tatauq Bourdon	Beadwork	June 4, 2021	Museum
Michael Burnett	Photography	January 25, 2021	Zoom
John Handeland	Photography	September 9, 2020	Nome City Hall
Karen Garcia	Watercolor Painting	May 5, 2021	Telephone
Ryder Erickson	Acrylic Painting	May 11, 2021	Telephone
Karen Olanna	Woodblock Printing	March 13, 2020, and February 26, 2021	Museum, Email
Mark Delutak Tetpon	Wood and Walrus Ivory	March 19, 2021	Zoom
Elaine Kingeekuk	Marine Mammal Intestine and Skin Sewing	August 18, 2020, September 24, 2020, October 28, 2020, January 6, 2021, and June 3, 2021.	Telephone
Sonya Kelliher-Combs	Mixed Media	March 3, 2021, and June 9, 2021	Zoom, Telephone
Sylvester Ayek	Walrus Ivory and Metal	April 1, 2022	Museum

In contrast to the smaller, figural tradition of ivory artwork, *Arctic Tern Mobile* by Sylvester Ayek is a large, semiabstract sculpture that challenges the immobility of walrus ivory through gentle movement (figure 2.42). An arctic tern expertly constructed from multiple walrus tusks hangs suspended from a metal hoop wrapped with colorful glass beads indicative of trade beads, a historically prized commodity within the Bering Strait region. Five feathers fashioned from walrus ivory appear to flutter around the seabird's outstretched wings. Ayek spent several months researching the flight patterns of arctic terns and sketching the bird's profile, a studied attention visible in the graceful and lifelike curves of the bird's body. Due to the complexity of the project, Ayek ended up working on the project in both his Nome and Anchorage studios. Ayek (this volume, p. 151) remarked, "One of the most exciting aspects of this project was coming up with solutions every time a challenge presented itself, such as emphasizing the very subtle lay of the bird's wings or figuring out that Czechoslovakian beads would really make the metal frame pop."

Artists Marjorie Kunaq Tahbone (Iñupiaq and Kiowa) and Elaine Kingeekuk (St. Lawrence Island Yupik) also turned to natural materials to create their hand-stitched face masks made from animal skins. Tahbone first created two sketches of masks designed to demonstrate a range of techniques and materials that she had assembled over the years. "I looked at the materials I had and thought about all the people who

were at home making their own masks," said Tahbone (this volume, p. 104). "I had alder-dyed sealskin and some *naluaq*, bleached sealskin. I had *siksrik* (ground squirrel) hide. Then I had this piece of *qupak* that I had sewn maybe ten years ago." For her first mask, *Family Protection*, the artist chose to pair her family's *qupak* design made of black and white calfskin with Arctic ground squirrel (siksrik) skins to acknowledge the skill and love it took for a seamstress to create a traditional fancy parka that could require over fifty ground squirrel pelts (figure 2.4). Her mask *Ceremonial Healing* features alder-dyed sealskin that Tahbone hand-tanned and designed with colorful beadwork in a style that she saw in a book of cultural heritage items, which brought to mind healing from ceremonial practices (figure 2.5). "There's no direct tie to making masks like this from my ancestors," says Tahbone (this volume, p. 107). "I was definitely being an artist and creating things out of my mind."

Elaine Kingeekuk also envisioned educational potential in a face mask that could serve as a catalogue of materials and stitching techniques used by St. Lawrence Island skin sewers and carvers. Her *Protector Mask* includes a fabulous array of natural materials from walrus intestine, polar bear hair, and sea otter fur, to walrus ivory, bone, and baleen (figure 2.34). Each material carries a unique story of how the artist acquired it and its relevance to St. Lawrence Island Yupik culture. Prominent on the left cheek of the mask is a sealskin medallion that features a stitched animistic design from the Okvik culture. Kingeekuk (this volume, p. 134) explains the design's references: "this mask is of a great protector, a leader, who wears clothing decorated with his possessions for special occasions." The artist crafted the main mask from winter-bleached walrus intestine that she hand-tanned over the course of several seasons and refers to as her "COVID-19 gut material." Walrus intestine is incredibly susceptible to tears, as noted by Kingeekuk, who has assisted several museums with repairs to their ceremonial gut skin parkas. The complexity of the design and skillful use of materials on *Protector Mask* are nothing short of remarkable. "While I worked on this mask, I thought of them . . . All the women who taught me in my lifetime. This thing is a little bit of my life story," says the artist (this volume, pp. 136–137).

Hand-stitched beadwork and floral motifs done in vivid colors characterize the artwork of Josephine Tatauq Bourdon (Inupiaq) and Karen Garcia (Inupiaq). Bourdon comes from an extended family of beaders who stitched circular floral designs for the tops of sealskin slippers. Over time, the beadwork tops shifted to decorative wall hangings or "mandalas," which Bourdon learned to sew from her mother. "The beadwork went from a needed income to supplementing her income to buy groceries" to wanting to "have her hands busy all the time so she would do these beaded mandalas," says the artist of her mother (this volume, p. 108). During the pandemic, Bourdon made twelve beaded mandalas in shades of lavender and gray for her niece's

wedding, a time-intensive project that the artist credits for keeping her "sane" during COVID-19. For the artist initiative, Bourdon designed *Four Seasons Mandalas* with intricate floral patterns in colorful shades of beads indicative of the seasons in Nome (figure 2.8). "The spring mandala shows the colors stirring and the ice going to melt soon. In summer it is green and lush out there . . . The fall mandala has rusty autumn colors. Then we are enveloped in winter. The winter mandala represents all our snow with a lot of blue, teal, and white," says the artist (this volume, p. 111). The seasonal hues of the mandalas speak to the passing of time during the pandemic while also offering a brilliant optimism for the future.

Karen Garcia grew up watching her mother sew *kuspuks*, a hooded overshirt with a large front pocket commonly worn among Alaska Native peoples, at their kitchen table and observing her grandma stretch sealskins for the soles of slippers. "Growing up, I can remember some of my first experiences were playing with beads that I wasn't supposed to be touching. My grandma had a lot of little cookie tins around, and they had slipper tops with flowers on them," says the artist (this volume, p. 118). Childhood memories filled with fabric and beadwork are evident in her vibrant watercolor paintings *Nurse in Blue Kuspuk* and *Nurse in Yellow Kuspuk* (figure. 2.19 and 2.20). The two life-size paintings illustrate nurses wearing traditional kuspuks with printed floral patterns, front pockets, and rickrack around the cuffs and hem. The nurses wear fancy mukluks, winter boots, trimmed with fur and decorated with beaded flower tops. During the pandemic, Garcia's son became ill with COVID-19 and the artist herself underwent surgery, two medical experiences that increased her gratitude for nurses who served on the front lines during the pandemic. Garcia (this volume, p. 121) says, "On the paintings, I put hearts on their lanyards and badges to represent the love we have for them throughout this difficult time."

Photography flourished in Nome during the COVID-19 pandemic, and the images of two photographers, Michael Burnett and John Handeland, are included in this project. When COVID cancelled Iditarod events in 2020, a friend reached out to Michael Burnett with the idea to organize an "on the porch" shoot, a photography movement at that time sweeping across the Lower 48. Burnett shared the opportunity on Facebook and within a couple of days had over a dozen families lined up requesting photographs. What developed was a series of portraits taken with a telephoto lens titled *Photos from the Porch* that illustrate Nome residents huddled close in intimate family gatherings or dressed up for elaborate staged tableaus (figures 2.12–2.15). "It was a brief moment where the family got to think of a creative idea and step outside on the porch together and, for some, to show the kookiness of Nome," says Burnett (this volume, p. 112). Participants receive free copies of the digital images, and Burnett remarks that the project gave him needed respite at a time when "people were getting cabin fever."

City of Nome mayor and avid photographer John Handeland can be seen at most public events in Nome, capturing images of his beloved hometown. From the start of the pandemic, Handeland snapped photographs of masked Nomeites while they shopped for groceries, waited to board an airplane, or stood in line to get tested for COVID-19. Over 200 folks appear in his collection *Masked People* that Handeland (this volume, p. 116) explains "are just the smiling eyes of people wearing a mask." Handeland posted the informal portraits on Facebook, where the digital images were tagged, reshared, and distributed by hundreds of community members across the Bering Strait region. Thanks to Handeland's photographic commitment, *Masked People* created an extensive visual history of the people of Nome during 2020 and 2021 (figure 2.18).

The artwork for *Stronger Together* communicates a compelling narrative and drive to share personal experiences with COVID-19. The importance of story sharing can be seen in the painting *Quality Time* by Ryder Erickson (Inupiaq and Norwegian) from Unalakleet (figure 2.23). *Quality Time* uses bold colors and concentrated areas of detail to form a brilliant blue and green landscape where a multigenerational family is working side by side at a fish camp to sew mukluks, mend a fish net, and till a garden. "I tried to reflect a lot of my feelings about subsistence culture and a self-sustaining lifestyle, like hunting, fishing, and gardening," says the artist (this volume, p. 122). Erickson says he wanted to focus on a positive aspect of the pandemic, which included additional time to learn from Elders. "Our Elders retained a lot of outdoor living skills, and these are timeless and always useful, like how to make a fire, how to cut a fish, how to butcher a caribou ... Those skills could be taught during this time," says Erickson (this volume, p. 124).

A series of three woodblock prints titled *Pandemic Response* by Karen Olanna vividly depicts her personal journey through COVID-19 (figures 2.26–2.28). *Pandemic Response* features the intertwined imagery of a mermaid embracing the world while seals peer over her shoulder, and a large salmon rises from the ocean floor in an attempt to escape unfolding events. Olanna (this volume, p. 127) explains that the mermaid represents a "water world version of Mother Earth." "From the Alaskan Sedna stories, I see her as involved with humans, emotionally responsive to the ethical undercurrents of humans' relationship to their planet." The woodblock design underwent a transformation during the pandemic as colors changed to mirror the artist's emotive state and experiences. The stark black and red colors of the first piece represent an initial response to the pandemic as an existential idea about an unbelievable lockdown. During this period, the 2020 Iditarod Fine Art Show for which the artist had prepared was cancelled, and rubber gloves were worn each time she went to the grocery store. The second print depicts the earth red hot as the virus became

real and crossed oceans. This print also speaks to a family member getting sick with COVID-19 and the artist putting up fish and homegrown vegetables with thoughts of food insecurity looming overhead. The final print depicts hope after the rollout of COVID-19 vaccinations. "I felt elated while driving home from my first vaccination shot. Real brightness shot through me: the pandemic would end," says Olanna (this volume, p. 128). The artist remarks that there is a surrealism to the neon colors as the world and normalcy have now changed.

Mark Delutak Tetpon (Inupiaq) drew from the stories of his grandparents for his monumental mask *Hunter of the North* carved out of red cedar (figure 2.31). The hoop mask derives from the tradition of elaborate masks that were danced at Kivġiq, the Messenger Feast, as well as other gift-giving festivals once widely held among Inupiaq and Central Yup'ik communities. A series of appendages surround the main face and end in pairs of hands, flippers, dancers holding fans, walrus, and seals carved from walrus ivory. A hunter with a raised harpoon is poised in a kayak at the top of the mask. "The *Hunter of the North* mask depicts the animals that are in that region of land . . . When I drill holes in the hands, it means to let some of the game go through your hands; don't overhunt the land," says Tetpon (this volume, p. 130). Miniature blue masks are tucked around the faces of the dancers, while a dark blue mask printed with "Save Lives" in English and Inupiaqtun covers the main face.

In contrast to the weighty presence of *Hunter of the North*, a translucent collection of delicately stitched pieces titled *Hair Portraits* by Sonya Kelliher-Combs (Iñupiaq/ Athabascan) invites the viewer in for closer reflection (figure 2.38). *Hair Portraits* comes from a series called *From the Body, Land, Sea and Air* that Kelliher-Combs began with the onset of the COVID-19 pandemic. Each *Hair Portrait* is made of acrylic polymer, paper, human hair, and nylon thread and carries the date when it was created. The artist began to gather her hair after each shower starting on March 13, 2020, the day after the first case of COVID-19 appeared in Alaska. Kelliher-Combs (this volume, p. 146) recalls, "I remember taking a shower after learning about the first case in Alaska and feeling very vulnerable. I always collect my hair for the most part but had not done so in such a documentary way." While the stitched hair visualizes the emotional impact of the pandemic on the body, the whirl-like designs speak to the artist's views on cultural tradition and spirituality. "Most of the *Hair Portraits* are circular because historically and metaphorically, it is a reference to letting go, such as letting the spirit of a harvested animal return to the natural world," says the artist (this volume, p. 146). Kelliher-Combs made over 250 *Hair Portraits* before a vaccination for COVID-19 was introduced in December 2020.

22 JOSEPH KUNNUK SR.

Joseph Kunnuk Sr. (Inupiaq) was born to parents Leo Kunnuk and Agnes Olanna. He grew up on King Island, where he learned to hunt marine mammals and carve walrus ivory (figure 2.2). Joe and his wife, Mary, live in a log cabin in Nome, where they are surrounded by their children and grandchildren. This conversation was held between Joseph Kunnuk Sr. and Amy Phillips-Chan at the Kunnuk home on November 6, 2020.

We started carving when we were young, down on King Island. Nine or ten years old. My dad gave me a piece of file and a walrus tooth and he said, "Time to learn." The only way we learned to carve was to watch other people. They never taught us how to do it. You have to watch what they do. That's how I learned in the clubhouse, the *qagri*. I used to tell my students when I taught at Nome-Beltz High School, "Don't make fun of anybody's carving." If they think a figurine is ugly, they don't need to laugh at it, because they will get good in the future. That's what happened to me. I remember when I was down on King Island, I made a little ugly walrus as a child. They laughed at it. I said to myself, "One of these days, I'm going to really start carving," which I did.

Over the years, when I used to carve a lot, I liked to carve polar bears, figures, kayak, two-man kayak. I made lots of ivory bracelets. I learned that from my dad's dad. This is the first time I made a carving about when people get sick (figure 2.1). For the mask, it took me a while to work on it. I had to cut a big piece of ivory and make it so it looks like there is a nose piece on there. The dots are made from baleen. One big piece of baleen from St. Lawrence Island costs $200 nowadays.

For the man and woman sculpture, when they say six feet apart, I put them six inches apart. Seems like I used a whole walrus tusk on this one. I tried to use only female tusks. I was going to just make them stand there and look like they are apart, but I decided to put that berry comb on there and make a berry picker and then make a hunter with his spear and pulled seal, the one he caught. Not too many people go seal hunting around here anymore. We get our seal meat from Teller. A few people hunt for me.

King Island people go year-round hunting down there when it's nice. In springtime, they never stop hunting, especially when the walrus start coming through, beginning in late April then through May and June. After that, some people in King Island want to go here to Nome. They travel from King Island by skin boat. It takes about fourteen or fifteen hours to get here. Traveling nowadays because of COVID is pretty hard. We didn't even go to Teller this year.

For the boy and girl carving, I decided to make it look like they were wearing scarf masks. In the old days, ladies used scarves. I hardly see those nowadays. But if you go down south, you will see some people still wearing scarves, even in Shishmaref. I

FIGURE 2.1. Joseph Kunnuk Sr. *Inupiaq Family and Mask*. 2020. Left: A female berry pick-
er carved from walrus ivory holds a bucket made from caribou horn and a berry picker
of old ivory and copper wire. On the other end is a male hunter made from walrus ivo-
ry carrying a harpoon and dragging a seal carved of old ivory. The two are standing on a
walrus tusk base. Length 36 cm (14 in.). Middle: A girl and boy of walrus ivory are wear-
ing masks and dancing on a walrus tusk base. Length 13 cm (5 in.). Right: A walrus ivory
mask with inset baleen dots and elastic cord. Length 13 cm (5 in.). CMMM 2020.21.1.

FIGURE 2.2.
Joseph Kunnuk
Sr. holds up the
ivory mask he
carved inside
his workshop
in Nome. 2020.
Photograph by
Amy Phillips-Chan.

wanted to make the boy and girl so the arms were moving around like they were dancing.

The King Island people have lots of Eskimo songs (figure 2.3). My grandfather's clubhouse was Aguliit. In the middle of the island, between the houses, there was the clubhouse called Qagriuraaġmiut.

Then way on the east side on the end is Nutaat. I used to go to my grandpa's clubhouse, Aguliit. That's where they carve and do whatever they're doing. Then Nutaat—that's where my dad used to go and carve there. You decided which clubhouse to go to sometimes depending on which one you were

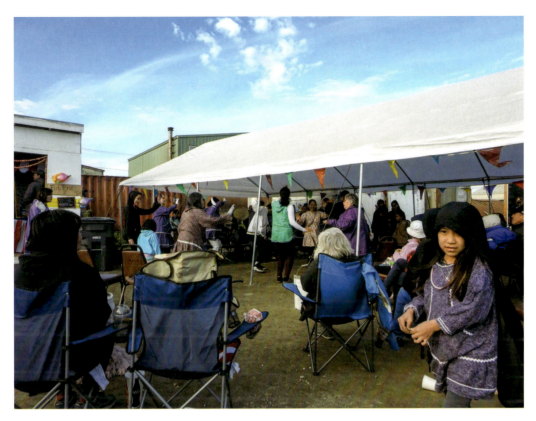

FIGURE 2.3.
Bering Strait
dancers perform
an invitational
dance in the
open air during
Nome's Midnight
Sun Festival
in June 2021.
Photograph by
Leon Boardway.

close to. Sometimes I go to Qagriuraaġmiut—that's the bigger clubhouse, where they dance. I used to watch the older people drum on the weekend and learn how to do the dancing and singing. They are real quiet. When we go in there, they say, "You stay quiet too."

If I want to buy some walrus ivory, I don't just take it away from somebody, I have to pay for it. People come around from St. Lawrence Island asking to sell walrus ivory for $55 a pound. Long ago, I had a good friend who used to call me and ask if I want ivory and sold it for $18 a pound. He's gone now, and I have to buy whatever. They lower the price sometimes nowadays because of this COVID thing. I use a *qayuun* (adze) to take off the outer part of the walrus tusk. Then I use a sander. I have two different types of sanders, a table sander and a hand sander. I use a coping saw and a hand saw to split the tusk. I pencil the figurine around the tusk, and then I cut it up. After I cut it up, that's when I use the Foredom tool to shape it. There was one King Islander long ago, Charles Kokoluk, he used to carve a little duck; he coping saw it, coping saw it, until he could file it down. I watched him down on King Island. He just cut it up with the coping saw like he knows what he's doing. He made beautiful birds. There are not too many carvers nowadays. It's lots of work, I tell you. Nowadays, I'm kind of slow, I just take my time. It takes concentration.

MARJORIE KUNAQ TAHBONE

Marjorie Kunaq Tahbone (Iñupiaq and Kiowa) was raised at her family fish camp outside Nome. She enjoys learning traditional techniques using resources from the land, including tanning hides, sewing furs, carving, beading, and tattooing. Kunaq moved to Nome following the pandemic where she now serves as director of the Katirvik Cultural Center (figure 2.6). This conversation was held between Marjorie Kunaq Tahbone and Amy Phillips-Chan via telephone on January 15, 2021.

I grew up in Nome and am trying to finish my master's degree here in Fairbanks. During the pandemic, I took a break off of school and it allowed me to stay home, which we all were having to do. When I stayed home, I found that I wanted to pursue my art and just work on being an artist. The pandemic kind of made space for that. I was able to launch my art business and make a website. So the pandemic has thrown things for a loop, but it really made an opportunity for me to grow as an artist. So I'm really grateful for that. All the COVID-19 relief assistance that our tribes have provided has also helped us not to have as stressful a time as I know other people have had.

I focus on art that I get from the land. Part of that is learning the process of tanning hides, like seal hides, that come from our land and creating things from them. Along with that is being motivated to keep our traditional skills alive for the next generation. That includes tanning and sewing traditional garments, like mukluks and parkas, but also realizing that we live in this modern time and we have adapted. So our art has also adapted and what we create. For example, creating fancy mukluks that aren't necessarily good for the cold but are beautiful to look at is something that I try to do. Or even just creating a parka that wouldn't be fit for a really cold day but it's beautiful, fits nicely, and you could wear it in the city. Adapting those skills in our environment is something that I do to try and encourage the youth to get involved in and to learn the skills as well. These skills are geared towards mental wellness and cultural identity that I feel has been oppressed. Historical trauma has been a real issue within our communities and families. I strongly believe that speaking our languages and learning our traditional skills and eating our food is the best path to be happy and healthy within our families and communities. That kind of drives me to do the art that I do in all kinds of mediums.

For this project, I looked at the materials I had and thought about all the people who were at home making their own masks. They were using materials that they had available, scraps of fabric, and just making do with what they had. So I did that in my own way, by using the traditional materials that I had on hand (figure 2.7). I had alder-dyed sealskin and some *naluaq*, bleached sealskin. I had *siksrik* (ground squirrel) hide. Then I had this piece of *qupak* that I had sewn maybe ten years ago, and it was just there.

FIGURE 2.4.
Marjorie Kunaq Tahbone. *Family Protection*. 2020. Mask of *siksrik* (ground squirrel) skins with a black-and-white calfskin *qupak* in the center. Black calfskin leather straps and felt and leather backing. Stitched in red thread. Length 17 cm (6.7 in.). CMMM 2020.20.2.

FIGURE 2.5.
Marjorie Kunaq Tahbone. *Ceremonial Healing*. 2020. Mask of alder-dyed sealskin with fish skin trim around the edges. Woven design from strips of *naluaq* (bleached sealskin) and alder-dyed sealskin. Red, white, turquoise, and black beads. Imitation suede straps and felt backing. Stitched in red thread. Length 22.5 cm (8.9 in.). CMMM 2020.20.1.

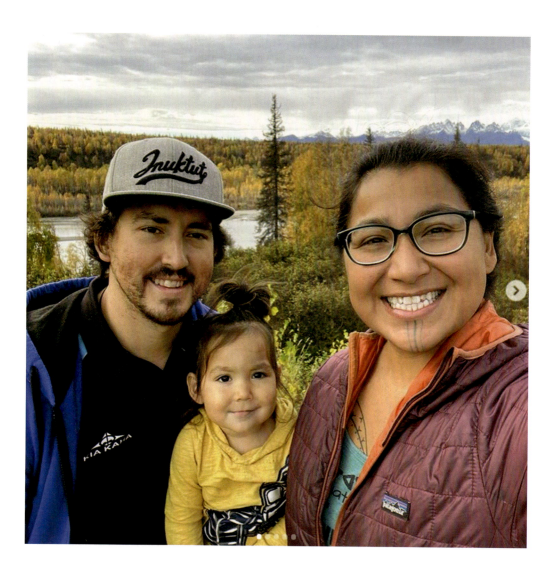

FIGURE 2.6. Kunaq Tahbone, her husband, Dewey, and their daughter, Telele Iŋmaġana, gather natural resources for food and artwork in the Fairbanks area. Photograph courtesy of Marjorie Kunaq Tahbone.

For the mask *Family Protection*, my ideas were acknowledging that our traditional fancy parkas were made out of ground squirrels, siksrik, and were a huge component of our families (figure 2.4). It showed skill. It showed that the seamstress was highly revered in their work. It showed patience, and it showed love. I wanted to portray that through this mask with my family's qupak design made of calfskin that also incorporated siksrik hide. Acknowledging our family and protecting our family.

The *Ceremonial Healing* mask came about from looking in a book and seeing some beadwork that was worn by women and men (figure 2.5). The style seemed like it brought back the healing of ceremony. The alder-dyed sealskin really pops, and the

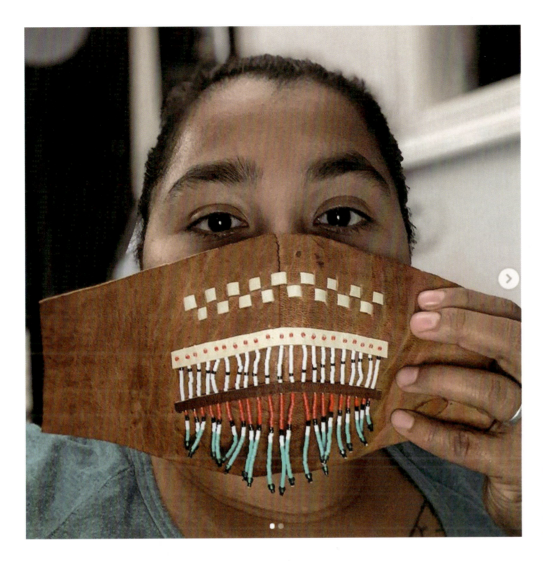

FIGURE 2.7. Kunaq Tahbone holds up her in-progress *Ceremonial Mask* crafted from beads and alder-dyed sealskin. Photograph courtesy of Marjorie Kunaq Tahbone.

beadwork just adds to it. I really wanted to have those two together and show the richness of our cultures through the colors. There's no direct tie to making masks like this from my ancestors. I was definitely being an artist and creating things out of my mind. It was something new and really fun for me to make.

Right now, I am working on expanding my art mediums. I want to focus on putting more content on my YouTube page to share the skills I am learning so that other people can learn. I was honored with a couple of fellowships, so those will allow me to pursue my art as a full-time gig. I am pretty excited for 2021.

JOSEPHINE TATAUQ BOURDON

Josephine "Josie" Tatauq Bourdon (Inupiaq) of Nome created stacks of knitted mittens, beaded mandalas, and embroidered pillowcases to relax during the pandemic (figure 2.9). Josie participated in an oral history interview for this project in October 2020 when the region first began to experience active cases of COVID-19. For this artist interview in June 2021, she noted that residents seemed less tense but still wary of air travelers and their potential to carry the coronavirus. This interview was held between Josie Bourdon and Amy Phillips-Chan at the Carrie M. McLain Memorial Museum on June 4, 2021.

My hands are rarely idle. From the moment I wake up, I have to have my coffee, and then I will be stitching or knitting something. It is my way to keep relaxed from my busy world. My mother, Esther Bourdon, lives in my home, and she and her family have always been beaders. Their beading was originally for the tops of sealskin slippers or the tops of mukluks. They beaded for added income and for gifts. I grew up learning how to bead by watching my aunts, my grandmother, and especially my mother. As you get older and you keep doing beadwork, you reach your own level of perfection, such as what colors complement the beads you are working with.

I learned from my mother how to do this type of hanging wall decoration that I call a beaded mandala. The mandalas trace back to the practice of my mom and her grandmother and her siblings and cousins in the villages putting beautiful beaded tops on sealskin slippers with the pretty cuff around the top. The slippers were originally a needed source of income for people in the villages or even here in Nome. When my mom moved into Bering View housing, she started making mandalas. It was getting hard for her to get large pieces of sealskin for the slippers, and when you are getting elderly, it's hard to sew through thick sealskin.

I think all on her own, she started making bigger and bigger pieces. She would give them to her family that came to town so that they would have a special art from my mother. That's how it transitioned. The beadwork went from a needed income to supplementing her income to buy groceries or to have money on hand, and then to where she didn't need the income but she wanted to have her hands busy all the time so she would do these beaded mandalas. She stopped making mandalas maybe twenty years ago because of her loss of vision and the dexterity it takes to do beadwork. I was always impressed by her natural knack to make it look so pretty. I have kept several of her pieces for my walls because she made them and they are special to me.

My mother introduced me to the type of beading on the mandalas, which is a two-needle beading technique. One is a beading needle, and the other is what I call a tacking needle because it tacks down the beads onto the backing. For the backing, I cut out a piece of felt and then use a brown paper bag on the bottom to make it sturdy. After beading, I cover the paper with another piece of felt so you don't see the stitchery or knots (figure 2.10). I will use a pen or pencil to mark the middle and kind of outline where I want the design to go. There is some folding into

FIGURE 2.8. Josephine Tatauq Bourdon. *Four Seasons Mandalas*. 2021. Beads, felt, paper. Diameter (each) 10.8 cm (4.25 in.). CMMM 2021.7.1, 2021.7.2, 2021.7.3, 2021.7.4.

FIGURE 2.9. Josie Bourdon holds up two of her beaded mandalas among the budding willows outside the Carrie McLain Museum in the spring of 2021. Photograph by Amy Phillips-Chan.

FIGURE 2.10. The felt backing on the reverse of the *Four Seasons* mandalas are as colorful as the beaded fronts. CMMM 2021.7.1, 2021.7.2, 2021.7.3, 2021.7.4.

fourths or eighths, so each section is pretty evenly spaced. When you bead, you start from the middle and work your way out in whatever color scheme you want to use or with beads that complement each other. Then just make a nice hanger for it. Each mandala takes maybe three or four days, depending on how much time I have to spend on it.

During the pandemic, I made twelve mandalas for my niece, who got married on July 2, 2020 (figure 2.11). They were for her bridal party and in-laws as thank-you gifts for being in the wedding. The mandalas are all in shades of lavender, off-white, gray, and almost a purple black that's in her color scheme. Each one is unique. I put a note on the back of each one with the wedding date and put them in white boxes with a ribbon. I made so many of those! That was my contribution to the wedding, and it kept me sane during the pandemic.

For this project, I made four beaded mandalas to represent the four seasons (figure 2.8). During the pandemic we were all just keeping to our homes, but we saw the seasons pass us by. I think being cooped up here in Alaska, we saw those seasons go by in one year and hoped things would go back to normal again. That we could jump on jets and meet with other people in the community. Some of us weren't able to go to church because they were closed, or concerts, theaters—you couldn't do a whole lot of things with other people. I think we saw it all go by, and we all tried to cope in our houses and keep our fingers real busy, especially if we were artisans.

In Alaska, we have some nice beautiful seasons no matter what part of the state you are in. In Nome, our seasons are so short, except for winter, and

we are very adept at seeing and recognizing them. When we get the meltdown and see the new shoots of willows coming, we know it is spring and getting warmer. The spring mandala shows the colors stirring and the ice going to melt soon. In summer it is green and lush out there. I was picking up trash by Fort Davis yesterday, and there were also those teeny-tiny lilac flowers and beautiful yellow flowers. Just gorgeous. If you are not looking, you will just drive by and miss them. So the summer mandala is picking up rose shades and bright greens.

We get so disappointed in the fall. Everything turns orange, brown. The tundra is no longer vibrant green, more of a lime green, because things are not photosynthesizing as much anymore. The fall mandala has rusty autumn colors. Then we are enveloped in winter. The winter mandala represents all our snow with a lot of blue, teal, and white. We had so much snow this last year; I think I shoveled three miles of snow just from my yard. There was no set design for the mandalas. Those are the primary colors I thought of for the seasons, and the beads just went where they went.

I always admired my mother's beaded mandalas and thought, "Okay, this is something I could teach at cultural studies," when I taught at Nome Elementary School. I taught the kids beading, because they could handle a needle and beads, and they did a very nice job. Some made pins or necklaces, whatever they wanted to adorn. Nowadays, I mostly make mandalas for friends and try to keep a few on hand because I know there is a need. I rarely sell mandalas to make a profit; usually I'm just doing them for gifting or a fundraiser.

For the future, I am looking forward to places like UAF Northwest Campus, where you can do face-to-face teaching for a beading class or fill up an entire classroom instead of having to limit it to

ten students when there is room for forty. I am also really looking forward to community choir. Maybe now that we have had a year of no socialization, somebody is going to say, "Wow, we need this choir again." I am looking forward to more community involvement for cultural things and social gatherings. I missed that bigger scene. But I will continue to do my beading. It makes me happy. In fact, I might be doing a whole other set of mandalas for my nephew, in their wedding colors. That will keep my fingers busy beading through August!

FIGURE 2.11. Bourdon's pandemic beading projects included a set of intricate mandalas designed in the wedding colors of her niece. Photograph courtesy of Josie Bourdon.

25

MICHAEL BURNETT

Michael Burnett moved to Nome in 2015 and over the next several years launched a professional photography business, opened an art supply store, and worked as a massage therapist. He served on the board of the Nome Arts Council and led organization of the Iditarod Fine Arts Show. Michael and his wife, Violet, moved to Petersburg, Alaska, in the midst of the pandemic in 2020. This conversation was held between Michael Burnett and Amy Phillips-Chan via Zoom on January 25, 2021.

Photos from the Porch were taken shortly after Iditarod in March 2020. They changed everything for Iditarod week at the last minute, and the town started locking up. We decided at the Nome Arts Council to not have the art show for the week. Then everything else just started closing for safety. I remember how there was still a small group of people who came down to Front Street to watch the mushers, but it wasn't the same at all. If there wasn't a musher, the streets were empty. The eeriness of it all was very palpable. It wasn't a great winter.

Then Honie Culley, a friend of mine who is a state trooper, saw something on Facebook about a photographer in the Lower 48 offering to do photos for people and started this thing called "Photos from the Porch." Honie reached out to me and said, "Hey, have you thought about doing something like this?" Up to that point, I had to turn down several photo sessions that people had hired me for due to the pandemic. All the people I had been talking to on the phone were getting cabin fever. You had fear because you didn't know what was happening. It seemed like every day was getting worse. People were looking for things to do. So I saw that idea, and I thought, "You know, Nome's full of people who can

get creative at the last minute." I made a Facebook page and offered to take the photos for free, saying I would come by with a 70- to 200-millimeter lens so we would be at a safe distance; this was at the peak of when you were not supposed to go near anyone.

I put it out there for anyone who was interested, and a bunch of people stepped up. They had fun with it, dressed up, and put on outfits. It was a brief moment where the family got to think of a creative idea and step outside on the porch together and, for some, to show the kookiness of Nome. I would send them the link to the photo, and they could do whatever they wanted with it.

The very first photo I took was of Honie Culley and her family because she was the one who got the ball rolling (figure 2.14). Honie was in a bathrobe and had some kind of gold face cream on. Her husband was dressed like he had just got done working out. He had on a tank top and an '80s headband, and the steam was coming off his body. The kids were all dressed up in goofy stuff.

One of my favorite photos to shoot was of Kim Knudsen and her family (figure 2.12). When I got there, they were all out on their front yard. They made it look like a beach theme. Their youngest

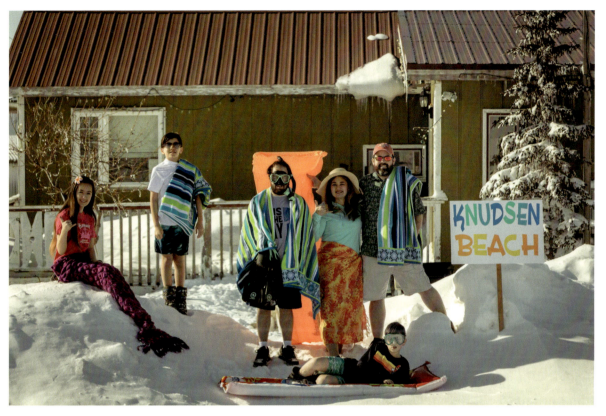

FIGURE 2.12. Michael Burnett. *Knudsen Beach*. 2020. From the series *Photos from the Porch*. Pictured left to right: Addison, Aiden, Jeremy, Kim, Sean, and Reese (on the float) Knudsen. Digital image. Photograph courtesy of Michael Burnett.

daughter had a mermaid blanket over her legs sitting in the snow; they had on shorts and swimsuits and had made a little sign for the yard. Up to that point, it had just been people dressed up, standing together on the porch. So I was not expecting that. It was awesome.

Shortly after the Knudsen family photo, I drove over to take a photo of Emily Hofstaedter and Jackie Reader, and they were literally pulling out a carpet and a table (figure 2.13). They had on these little furs, fake cigarettes, and martini glasses to look like it was the roaring '20s. The best part was when they were setting up, I was across the street and putting all my stuff on the tripod. I saw a couple of trucks drive by, and no one batted an eye at what was there. You saw them look over, then look straight ahead, and just keep driving. I don't think they could have been shocked by anything. People are just kind of like "Hey, it's Nome, and I wouldn't expect anything less." That was definitely a memorable moment.

There were also some photos that had serious messages. One person had family in the Lower 48, so she held up a letter that they could read. Other people didn't want their photos shared, because it was more of a private moment for them and their family. That was really touching. I took two photos of families who hadn't had a family photo in a long time, and they dressed up really nice (figure 2.15).

It was interesting to see how each family had their own idea.

I think the last image I took for *Photos from the Porch* was maybe six or seven weeks after the start of pandemic restrictions in Nome. I remember driving around taking pictures and how empty the town was—no one was out walking around; it was just still. Nome is already isolated, and we dropped down to one flight a day and that's the only way out of town. Then you couldn't go outside because it was too cold or too windy. It definitely added to me wanting to get out there and shoot, and people needed something fun to do. It worked out.

One of the positive things I have noticed from the pandemic is that it has forced people to use their imaginations more and to get creative. I have seen an abundance of people wanting to learn to paint or get out to do photography. Last year you could order art supplies online, and they would be here in no time flat. Now a lot of cameras and other supplies are all back-ordered. I love seeing an increase in the number of kids who are wanting to learn how to paint or draw and who ask me about photography. People are doing more things now than they would have done before.

FIGURE 2.13. Michael Burnett. *Nome Socialites*. 2020. From the series *Photos from the Porch*. Pictured left to right: Jackie Reader and Emily Hofstaedter. Digital image. Photograph courtesy of Michael Burnett.

FIGURE 2.14. Michael Burnett. *The Culley Family*. 2020. From the series *Photos from the Porch*. Pictured left to right: Honie, Matt, "G," and Maddy Culley. Digital image. Photograph courtesy of Michael Burnett.

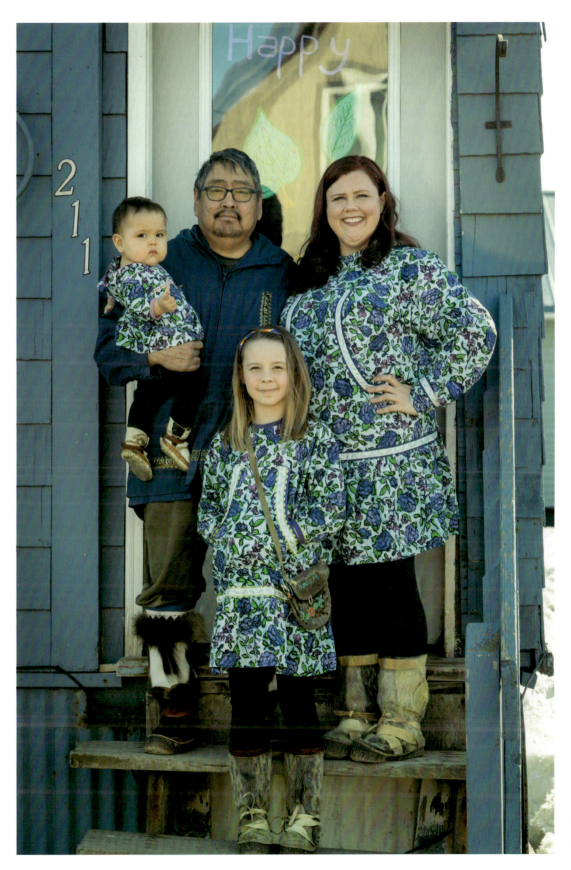

FIGURE 2.15. Michael Burnett. *The Alvanna Family*. 2020. From the series *Photos from the Porch*. Pictured left to right: JJ holding Suluk, Audrey, and Shauntel Alvanna. Digital image. Photograph courtesy of Michael Burnett.

26 JOHN HANDELAND

City of Nome mayor John Handeland grew up in Nome and began capturing images of his community in high school, when he covered the 1974 flood for the Nome Nugget *newspaper (figure 2.16). He shares his images with hundreds of ardent followers on Facebook, where tags and comments offer a microhistory on the daily lives of Nomeites. This conversation was held between John Handeland and RB Smith at Nome City Hall on September 9, 2020.*

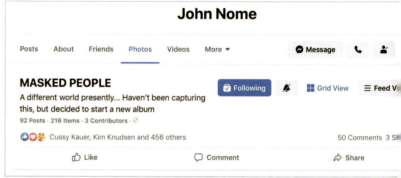

FIGURE 2.17. The "Masked People" album on John Handeland's Facebook page includes over 200 images of Bering Strait residents during the pandemic.

FIGURE 2.16. John Handeland and Kalaggina Muktoyuk give an air hug inside the Alaska Commercial Company store in Nome at the start of the pandemic, when toilet tissue was a precious commodity. 2020. Photograph courtesy of John Handeland.

Since I was a kid, I was into photography because it was one more thing to play with. I had my own black-and-white darkroom set up at home in the bathroom on top of Mother's laundry equipment. Once a week she'd make me tear it all down so she could wash clothes. I was totally into photography, and then video started to become a little more prevalent and usable as well as accessible and affordable. The equipment was huge to carry around. Now you can take photographs and video on your iPhone and darn near everything. Sometimes I think people get annoyed with me popping up and taking their pictures. I also like to take pictures of scenery and events but mostly with people in them. During the pandemic, I started a thing called "Masked People" as an album on my Facebook page (figure 2.17). I have hundreds of pictures that I've taken of folks in town (figure 2.18). They are just the smiling eyes of people wearing a mask.

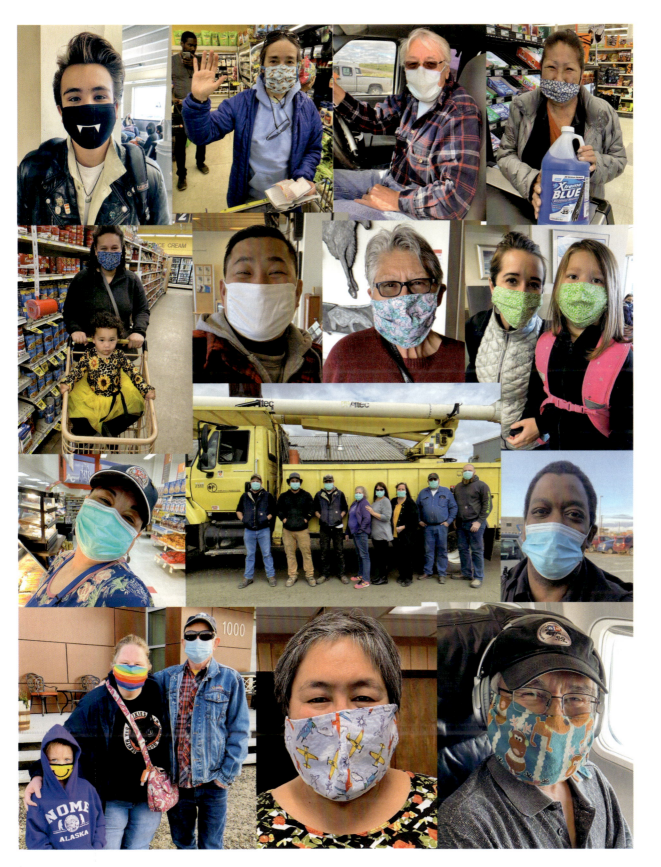

FIGURE 2.18. John Handeland. *Masked People.* 2020. Digital images. Top row (left to right): Andrew Hafner, Gay Sheffield, Robbie O'Connor, Blue Martin. Second row (left to right): Mackenzie Lynn and Bianca Cabrera, John Nguyen, Beth Avessuk, Tracey and Kayla Adams. Third row (left to right): Linda Scott, Nome Joint Utility System staff, Alfred Durgo. Bottom row (left to right): Teegs, Joleen, and Craig Oleson, Annette Piscoya, Roy Ashenfelter. Photographs courtesy of John Handeland.

27

KAREN GARCIA

Karen Garcia (Inupiaq) was born in Anchorage, where she lives with her husband, their son, and four dogs (figure 2.21). Childhood memories of her family from Unalakleet, White Mountain, and Shaktoolik inspire her vivid watercolor paintings. She has fond memories of stories told by her grandparents Wayne and Sarah Eben, and her mother Amy Paris, of Unalakleet and watching their hands as they sewed and carved. This conversation was held between Karen Garcia and Amy Phillips-Chan via telephone on May 5, 2021.

I remember when the pandemic first happened, it seemed surreal. Then, once you realize the whole world will be affected, it was very scary. I work with an engineering firm, and we are still working remotely. For our family, it was a matter of adjusting and trying to figure out, okay, how are we going to do this and not get sick? My son did get COVID-19 from working at Home Depot. He was sick overnight and then on the mend the next day. My husband and I have been lucky enough not to have gotten it. For me it's very scary, because I have asthma and lung problems, and the coronavirus is still out there.

I have been home a lot during the pandemic, so that has brought on a lot of creativity. I have to say business is booming as other people have been staying home as well, and I have received a lot of new orders. I am a vendor for Princess Cruises with Holland America, but I lost that account due to the pandemic. There's also a small gallery in downtown Anchorage where my work is, but their sales have plummeted. I had my work up at Fat Ptarmigan for First Friday when the pandemic hit, and it was only supposed to be up for a month but ended up being there for a year. So for several of us artists, it has

affected us in good and bad ways. We are adjusting, trying to be safe, and waiting for it to end.

Growing up in the Alaska Native culture, everybody went to grandma's house, where there was always bread going and it smelled so good. Everyone would sit around the table and eat Alaska Native food (figure 2.22). There was hooligan and salmon fishing in the summer. My uncles, cousins, grandpa, and dad would all go hunting. The only thing I remember is that they would be gone for a while, and then they'd come back and would be busy in the kitchen cutting up meat. I had a really good childhood growing up. When they say it's the good old days, they really mean it. It won't be like that again, because the key people are missing. So it's up to us to carry the spirit on and the tradition and the culture.

Growing up, I can remember some of my first experiences were playing with beads that I wasn't supposed to be touching. My grandma had a lot of little cookie tins around, and they had slipper tops with flowers on them or sometimes there were just beads in there. My grandma made a lot of beaded slippers, gloves, hats, and heavy parkas.

FIGURE 2.19.
Karen Garcia.
Nurse in Blue Kuspuk. 2021.
Watercolor, ink, and acrylic paint on paper. Height 178 cm (70 in.).
CMMM 2021.4.1.

FIGURE 2.20.
Karen Garcia.
Nurse in Yellow Kuspuk. 2021.
Watercolor, ink, and acrylic paint on paper. Height 175 cm (69 in.).
CMMM 2021.4.2.

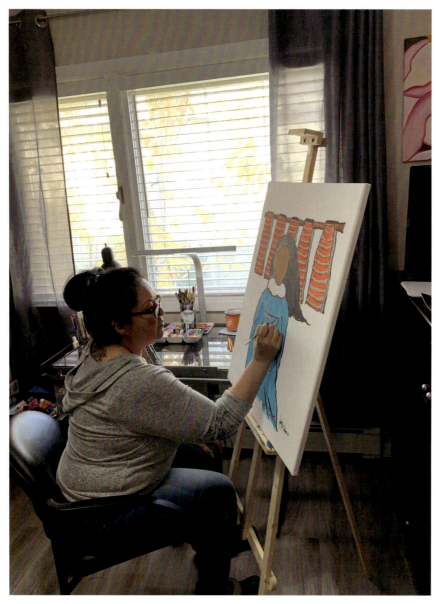

FIGURE 2.21. Karen Garcia works on a watercolor painting inside her home studio in Anchorage 2021. Photograph courtesy of Karen Garcia.

She and Papa worked together on making the slippers. While my grandpa was making a sole, my grandma was doing the beadwork. They would cut the leather out, and my grandpa would attach the hard soles to the leather. My grandma would then use one of those really old Singer sewing machines and it was the loudest, most clankiest thing, but I would give anything to hear it again. They worked really well together, and the pieces that came out were just amazing.

My mom was a seamstress and an Alaska Native art teacher at the school district in Anchorage. She made *kuspuks*. My mom had a lot of fabric everywhere. I basically grew up watching my mom cutting fabric on the kitchen table for customers or being at my grandparents' house and my grandma sitting there and doing her beadwork in front of the living room window. They also taught me how to do beadwork, but it just didn't really catch on for me.

There were times when I had to help my mom with the kuspuks, and for her they had to be perfect. You had to line certain patterns up and do it a certain way. For the slippers, that was watching my grandma stretching the hides and hammering on the soles. I would cut out the fur tops for her. As kids we couldn't do a whole lot, because you have to use a razor blade for thick ones. While we were inside doing that, my grandpa's out back working on soapstone and ivory. He would let us play with the pieces that were just squares and not used yet. But when he was pretty much done, he would let us buff them for him. That was a learning experience too.

We were raised out in Peters Creek before the highway went out there. I was raised to keep your hands busy to stay out of trouble. We have a lot of boys in the family, and I think that was directed

more towards them, but as kids we never complained about being bored. We went to a private school, and our focus was really on God and sports. We had a lot of study time outdoors, so there was a great love of animals and the environment. I would pick flowers and leaves and dry them and make bookmarks or paint on them. Then, years later, after my mom passed away, I started painting as a form of healing therapy. It just kind of took off. I started painting memories of growing up, my family and what they did, and things that we were taught.

I like using watercolor because it's more forgiving, and I like the bright, vibrant colors rather than muted earth tones. The bright colors cheer you up. I also use negative space so the colors really pop out on the artwork. Kuspuks are kind of my favorite thing to paint because they have the bright colors, and then of course it's tradition. You will see new styles of kuspuks out there with cowl necks or shortened sleeves, which I don't paint. I paint the old style. It's the more traditional pattern that I remember growing up with; it has a pocket on the front and sleeves that go all the way to the wrist.

The nurse paintings illustrate how very grateful I am to all the nurses out there (figures 2.19–2.20). They took care of me just recently while I was having surgery, and they have also been on the front lines during the pandemic. Not only doing their job but protecting the community in a sense. They are very brave people. We can't thank them enough for what they do, and they're appreciated every single day. On the paintings, I put hearts on their lanyards and badges to represent the love we have for them throughout this difficult time. I hope a whole lot of people around the world have a new respect for what they do; they deserve it.

FIGURE 2.22. Karen Garcia. *Tea Time With Papa*. 2020. Watercolor and mixed media on paper. Height 36 cm (14 in.). Courtesy of Karen Garcia.

28 RYDER ERICKSON

Ryder Erickson (Inupiaq and Norwegian) was raised in Savoonga, St. Michael, and Unalakleet and has family connections to Utqiagvik and Shishmaref. His acrylic paintings use bold colors and dreamlike landscapes to express the beauty of North Alaska and the way of life of those who call this area home (figure 2.24). Ryder and his wife, Annette, moved with their three children from Unalakleet to a homestead in Nikolaevsk, Alaska following the story below. This conversation was held between Ryder Erickson and Amy Phillips-Chan via telephone on May 11, 2021.

Our family is really home based. The kids are home-schooled, my wife is a stay-at-home mother, and I work from home in a studio in my house, so we were able to roll with the punches and just keep pushing on like we usually do. Overall, we were not affected too much by the COVID-19 pandemic. While everyone else was adjusting to their kids being home because school was closed or wondering how they were going to work from home, we had already been doing that for a few years. So the transition wasn't too hard for our family. I am grateful for that.

A lot of small businesses or mom-and-pop stores were hurt by the pandemic. I don't have a physical store. I interact with my customers mainly through the phone and internet and was able to fortunately thrive with my online presence. I also teach painting, and for the past five or six years have been teaching art via Skype to villages in the Bering Strait School District. So although I was unable to teach in person this past year, I was able to continue teaching art using Skype and other online platforms.

A lot of people, if they can't create income, they are not going to buy art. Many artists, musicians, and people in the creative fields have been affected by this because people couldn't afford art or couldn't buy art for many reasons with everything that is going on in our world. But the pandemic has given me time to reflect and more time to spend working on art and being around my kids.

For the painting *Quality Time*, I tried to reflect a lot of my feelings about subsistence culture and a self-sustaining lifestyle, like hunting, fishing, and gardening (figure 2.23). I think about all the villages I grew up in and the Native culture that I was immersed in. I grew up in the Eskimo culture, but I was also raised with the Scandinavian culture, with people who were fishermen and gardeners and farmers. You have to know a lot of outdoor living skills to survive in the Norton Sound area. The winters are harsh, and you have to know how to put enough food in the freezer (figure 2.25). You have to know how to dry fish. So this painting references things that I have learned and are useful for survival.

It is not lost on me that during this past year with COVID-19, there are some people who may be in an abusive household and may be stuck and things are harder for them. But I want this painting to reflect the positive things that might come out of this situation. Grandparents might have more

FIGURE 2.23. Ryder Erickson. *Quality Time*. 2021. Acrylic on canvas. Length 91 cm (36 in.). CMMM 2021.1.1.

time to spend with their grandkids because their grandkids are off from school that day. Parents may be able to teach skills to their kids, since they are able to work from home. The pandemic has provided more time for families to be together, to learn from each other, to work together, and to provide for themselves in a subsistence way.

Everything has changed so much in the last fifty or seventy years from the skills our grandparents learned and the things they grew up doing. There are so many good things that came out of Western culture—electricity, indoor plumbing, and other conveniences. But our Elders retained a lot of outdoor living skills, and these are timeless and always useful, like how to make a fire, how to cut a fish, how to butcher a caribou. Other skills, like how to survive on the tundra or know what to do if your boat capsizes and how to survive until someone finds you. I really think that everyone should learn these types of skills from their Elders if they can because they are going to need them someday. You will want to teach them to your kids too because perhaps at some point they won't be able to have YouTube or Google at their fingertips. Those skills are a true wealth and knowledge that exists in this region. Those skills could be taught during this time. I call this painting *Quality Time* because I think of the pandemic as time to spend with your family and learn from your Elders and make yourself more self-sustainable.

I think a lot of people could do some self-reflection during this time to think about what's important in life. Creating communities, whether they be your family and relatives or the people in your village. Sharing skills and knowledge, learning the old ways and the outdoor living skills that I truly believe in as being wealth. Learning from our Elders, spending time with our children, learning new things, or developing new skills to become more self-sufficient so when hard times come we have the skills to survive, and even to thrive. Some people will drown their sorrows. Some people will seek other means to try to escape their reality. But I truly believe that everyone in a way creates their own reality by how they act and think and feel and how they interact with each other. This pandemic has offered so many opportunities for self-reflection and how to grow as a person. It has also allowed time to spend with Elders who hold all those old skills that I hold so highly in my mind. Through my art, I try to depict things that can help in some way to preserve not only my Eskimo culture but all of my heritage. I am grateful that *Quality Time* is a part of this initiative because if there is anything good that can come out of these times, I am happy to be a part of it.

FIGURE 2.25. Ryder Erickson. *Food Cache Ladies*. 2017. Acrylic on canvas. Length 91 cm (36 in.). Courtesy of Ryder Erickson.

KAREN OLANNA

Multimedia artist Karen Olanna works in bone, bronze, oil paint, and woodblock (figure 2.29). Her block prints feature bold lines and intertwined imagery that illustrate the land and myths of the Seward Peninsula. Karen splits her time between Anchorage and Nome, where she enjoys fishing, berry picking, and painting among the hills. This story features excerpts from an interview held with Karen Olanna by Amy Phillips-Chan at the Carrie M. McLain Memorial Museum on March 13, 2020, and a written narrative by Karen Olanna from February 26, 2021.

When I was a student at the University of Alaska Fairbanks, my instructors emphasized abstract art. I loved it. After winning Art Student of the Year, I was invited to hold a solo exhibition at the Alaska State Museum in Juneau.

I moved on from university student life and headed to Shishmaref, where I had a family. My life was no longer abstract. Abstract art lost its relevancy among everyday life on the Seward Peninsula. This new environment offered inspiring landscapes, animals, activities, and mythologies. I needed to learn representational art.

I began carving antler and bone figures as I adapted my aesthetic to the northern environment. Then I started carving simple images onto wood blocks for printing. Block printing is an old, simple method that can be done by hand in rural Alaska.

Later on, I took a landscape painting class from UAF professor Bill Brody, who traveled to Nome to teach as part of the Northwest Campus Community College. We camped out for a weekend painting at the Boy Scout camp, about twenty miles northeast of Nome. His teaching method inspired me to paint landscapes. Now I enjoy walking the hills, settling in with the wind and mosquitoes, and painting the patterns of hills and rivers.

Block printing is essentially carving marks into a smooth, flat surface, typically a block of wood, and then rolling thick ink across the top of the board, not into the cracks. The carved image is transferred by carefully laying the paper on the surface and pressing. Tremendous variety in the art form can be created through synchronized layering, a broad color palette, and use of exotic papers. The intermingling effect of the inks cannot be reproduced digitally.

To create my prints, I carve boards of wood as well as modern synthetics, such as linoleum. I follow the European tradition of numbering and signing prints in small editions. My prints also fall into the select category of "artist pulled prints," as I control all aspects of the process. Each print is individually inked, and some prints are hand-painted with watercolors for additional creativity and uniqueness (figure 2.30). Block printing represents a historic, low-tech artform that will retain inherent value for its unique imprint of the human hand.

PANDEMIC RESPONSE 2020–2021
THREE WOODBLOCK PRINT SERIES
OF COLORFUL MEANINGS

Pandemic Response I: An Existential Idea
(figure 2.26)

> *My mermaid symbolizes a water world version of Mother Earth. Ancient myths and modern commercialization now combine to make mermaids a familiar image across cultural divides. From the Alaskan Sedna stories, I see her as involved with humans, emotionally responsive to the ethical undercurrents of humans' relationship to their planet. In these stark colors, she looks concerned and caring about the new calamity enveloping the world. There is a touch of "I tried to warn you" in her expression.*

In the beginning, COVID-19 was an existential idea. We watched news from China of an unbelievable "lockdown": people not allowed to leave their apartments, shouting encouragement to each other from balconies. How could people live like that? TV news became more ominous but conflicting. A US health minister said she told her children to get ready for a major disruption in their lives. I wondered, blankly, what would that look like? Then the virus hit New York City, and Governor Cuomo became the daily voice of reason, explanation, and humanity.

Living in Nome, I had no doubt it would reach us. It felt dire. Every move now in public felt dangerous. I wore rubber gloves to the bank and grocery store.

I had lived long enough in rural Alaska to know many stories of the flu epidemic of 1918. I knew people who had lived in the orphanage in Brevig Mission with some terrible stories of children being home with dead parents. Shishmaref quarantined their village while Wales' vigorous population was decimated. I thought the future would bring

FIGURE 2.26. Karen Olanna. *Pandemic Response I.* 2020. Woodblock print. 1/40. Height 91 cm (36 in.). CMMM 2020.18.1.

mass deaths, so I supported the Nome City Council's decision to shut down most Iditarod activities. Even though I had worked hard all winter preparing for art activities for Iditarod week, I believed it was the right government decree for public safety, even though COVID was still just an idea, coming from far away. This is the phase of the virus my first print represents.

FIGURE 2.27.
Karen Olanna. *Pandemic Response II.* 2020. Woodblock print. 2/40. Height 91 cm (36 in.). CMMM 2021.2.1.

Pandemic Response II: Pain Becomes Real (figure 2.27)

The red in this print expresses hot pain, crisis, isolation as the pandemic crosses oceans and covers most countries. Animals too are infected. My mermaid is no longer aloof and abstracted but encompassed in the emotions of a "blue" earth.

My brother in Seattle got sick with COVID-19 and had, almost without knowing, visited our mom in a senior home, which could have infected many, so the virus became real. Mom became strictly isolated and depressed. Tourism, much of the livelihood of carvers and artists in Alaska, all shut down. I spent hours on the phone listening to stories of hardship. Images of boarded-up stores in downtown Anchorage. I worked extra hard growing a vegetable garden in Nome and putting up fish, expecting disruption of food distribution. Long quarantine times for families trying to visit or come home from work and school. I felt lucky being in Nome, where we can get out in nature. I was impressed with Norton Sound Health Corporation directing care and rules for village travel, prioritizing safety. Nome area's isolation helped, but it seemed a matter of time before the pain of COVID-19 would overwhelm us. It seemed clear that no one really knew what was going to happen.

Pandemic Response III: Hope Explodes (figure 2.28)

The mermaid looks taken aback by the strong turn humans have taken, making our country vastly changed. Hope explodes in bright colors with the vaccine rollout: however, there is a phantasmagoric quality to the colors. There's no sense of nature in the print's colors. "Normalcy" has changed.

I felt elated while driving home from my first vaccination shot. Real brightness shot through me: the pandemic would end. There is cause for celebration of scientists and medical engineers all over the world who have worked so hard to bring fast vaccines: a sense of unity for the world community all in this together. Weirdly, that joy coincides now with seeing the world vastly changed by COVID. Social divisions are exacerbated. What's real and what's fantasy?

FIGURE 2.28. Karen Olanna. *Pandemic Response III.* 2021. Woodblock print with watercolor. 3/40. Height 91 cm (36 in.). CMMM 2021.2.2.

FIGURE 2.29. Karen Olanna adjusts the lighting for her show *Inspirations from the Seward Peninsula,* a special exhibit that coincided with the reopening of the Carrie McLain Museum to visitors in July 2021. Photograph by Amy Phillips-Chan.

FIGURE 2.30. A new series of woodblock prints are underway in Karen Olanna's Anchorage-based studio in 2022. Photograph courtesy of Karen Olanna.

MARK DELUTAK TETPON

Mark Delutak Tetpon (Inupiaq) was born in Anchorage and carries family connections to Shaktoolik. He has been creating artwork for over twenty years, specializing in ivory, wood, baleen, and fossilized whalebone. Mask forms are inspired by the stories of his grandparents and the carvings of his grandfather Eric Tetpon Sr. and father John Nasoalook Tetpon. This conversation was held between Mark Delutak Tetpon and Amy Phillips-Chan via Zoom on March 19, 2021.

My dad, John Nasoalook Tetpon, ran a gallery in Homer when I was growing up, so growing up was a little bit different for me. I didn't really have chores. I had to do things in the shop like sanding or polishing artwork that he did. As an adult, I worked on the North Slope for quite a while, and then petroleum plants in the Lower 48, but I came back to Alaska; that was when the economy crashed. So I decided, well, I'll do artwork full time. So I took the leap and never looked back. Artwork is kind of like a therapy for a lot of people, including me. So I enjoy that part of it. I wake up early. My shop is right here, attached to my house. Sometimes I do long nights, and it's easy to just take a shower, crash, and wake up and do it again. It's definitely better than doing a regular nine to five.

Everything that I work on with my dad, we work on together. We don't need to say anything to each other about who's going to do what. We already know. We just go to work, and that way things get done quickly. Sometimes he will hand something off to me or I will hand something off to him, and he will finish it or vice versa.

A lot of the pieces that we do are patterns that my dad got from his dad. A lot of the masks that we do have stories that go along with them. For instance, *Walrus Transformation*, the half-man, half-walrus sculpture, comes from a story my grandfather told us (figure 2.32). One time he was out seal hunting, and it was a nice and sunny day like this. But by the time he reached a small iceberg, there was a snowstorm. When you park your kayak on an iceberg, you point your kayak back at shore, so you know which way to go back home. But the iceberg started spinning and he couldn't figure out which way was the right way to go back. Pretty soon he heard drumming, which he thought had to be coming from shore. So he got in his kayak and started paddling back, and on the beach was a walrus. The walrus was hitting the side of a thirty-five-gallon drum with his flipper. So that's how he got directed back home, and he was saved. My grandfather said, "Maybe that was a shaman, because I was totally lost. I couldn't see my way in the storm. I was just being directed by the sound of the drum."

Almost every mask has some sort of meaning. The *Hunter of the North* mask depicts the animals that are in that region of land (figure 2.31). When I drill holes in the hands, it means to let some of the game go through your hands; don't overhunt the land. For the loons and loon masks that I create, my grandma said that the loon carries the problems

FIGURE 2.31. Mark Delutak Tetpon and John Nasoalook Tetpon. *Hunter of the North.* 2021. Hoop mask with main face carved from red cedar and painted white. Face features ivory eyes with baleen centers and mineralized ivory labrets. Wood hoops painted black. Appendages include walrus ivory hands, flippers, dancers holding feather fans, seals, polar bears, and kayak. Fabric mask made by Kim Koval of Anchorage. Height 102 cm (40 in.). CMMM 2021.3.1. Photograph courtesy of Mark Tetpon.

FIGURE 2.32. Mark Delutak Tetpon. *Walrus Transformation*. 2021. Basswood, baleen, and ivory. Height 50 cm (19.5 in.). CMMM 2021.3.2.

of the world on its back—that's how it got all of its spots. The loon washes itself each morning so that you can start your day off new and you don't have to worry about anything.

I like to use different woods for different projects because they all have unique characteristics that will influence what the piece looks like. I chose red cedar for the *Hunter of the North* mask because the grain is real tight and straight. When you are trying to carve something straight like a face, that's a perfect medium to use. Sometimes I like to use Alaskan yellow cedar, but you have to really let it air-dry or kiln-dry to ensure that it doesn't crack later on. I like to use cherrywood because, gosh, it's so pretty when you put the stain on. The basswood that I used for *Walrus Transformation* is super easy to carve; it cuts like butter. However, you have to sand it quite a bit to get a smooth finish. I see many inspiring artists carving but not spending a lot of time doing the finish. The finish is an important part. It's key to helping you get your artwork sold and being proud of your work.

During the pandemic, it has been harder to get the materials I need, particularly quality ivory and quality baleen, because I can't go and see it (figure 2.33). Trying to get quality tools and space to work is another challenge that a lot of Alaska Native carvers face. In my shop, I mostly use a Foredom tool for carving, as well as belt sanders and band saws. If I carved the way they did in the old days, I would never get done with a mask. It would take me forever. I had to start off that way, using hand tools, when I didn't have the funds to purchase power tools. It did help me to learn how to make shapes and do things different ways. I continue to learn every day, just by doing little things that end up making the work easier or better.

The COVID-19 pandemic has helped us to learn a lot of things that we would not have learned had

this situation not come up. For me, time management was one area where I greatly improved. Creating a website, doing more social media, getting your work on other Facebook pages, basically interacting online with as many people as you can. A lot of the main events were canceled due to the pandemic, such as the annual meeting of the Alaska Federation of Natives. I'm glad the Fur Rondy at the Dimond Center in Anchorage went off well, but we didn't have the turnout like we normally would. I encourage other artists to get yourself out there and attend as many events as you can. You do have to be careful and wear your mask and follow precautions. I am thankful we have the vaccinations now.

Through the pieces that we create, I am trying to carry on my heritage. Stories that my grandfather told my dad and that my dad taught me. There is a beauty in artwork. I want people to see something in them that can bring them happiness.

FIGURE 2.33. Walrus tusks rest beside a lathe inside Mark Delutak Tetpon's workshop in Anchorage. Photograph courtesy of Mark Delutak Tetpon.

ELAINE KINGEEKUK

Elaine Kingeekuk (St. Lawrence Island Yupik), of Savoonga, is a skin sewer and doll maker who works with walrus and seal intestine, sealskin, polar bear hide, and other natural materials (figure 2.35). She frequently collaborates with museums on conservation and Indigenous language projects. Kingeekuk is a fluent St. Lawrence Island Yupik speaker and singer who strives to pass on cultural arts to young people. The following story features excerpts from telephone conversations between Elaine Kingeekuk and Amy Phillips-Chan between August 8, 2020, and June 3, 2021.

I felt a little hopeless when I first found out there were cases of COVID-19 in Savoonga. I had thought, "COVID will not get here. The community is too small, and people are harvesting and being careful." I was afraid to even go to Nome for a medical appointment, because I didn't want to stay in Quyanna Care Center patient housing. The pandemic happening to the world is making me think about my ancestors, the ones who have left before us.

During my teaching career, none of our Elders said anything about masks. I have been meaning to ask a lady in Savoonga who is ninety years old what they used to do long ago to cover their faces in case there was bad air or dust. Before this project, I had been making cloth masks. When I am in the store or outside with my cloth mask, my glasses fog up. It made me think about the waterproof type of sewing that our ancestors did, so I knew I wanted to add that type of stitching to the mask.

After I started the mask, I took some pictures and thought, "How should I do this? Should I make it a woman's mask, a manly woman's mask, or a man's mask?" Then I found my design of a crab medallion and decided I would do a manly mask. In our culture, the man is the one who protects the family if an enemy comes. This mask is of a great protector, a leader, who wears clothing decorated with his possessions for special occasions (figure 2.34). The person wearing this mask would be a good leader, one who learned the stars and the ocean, and a good doctor, one who is gifted to heal people. The story of the mask changed from the past to the present, a protector of our people during the pandemic.

I decided to make this an educational mask and use all the materials we traditionally used, from bone and ivory to skin and fur. I am excited to be teaching in a way like how they taught in the old days and with what they used. Much of our traditional clothing is still the same, but many of the old traditional designs of artwork we used in sewing are gone.

WINTER-BLEACHED GUT SKIN

The main material used for this mask is winter-bleached gut skin from a walrus. I call it my "COVID-19 gut material." The gut skin was from a younger walrus that we got in Savoonga. As I was working on it and stretching it out, the gut kept getting bubbles. Then we had really cold weather, and

FIGURE 2.34.
Elaine Kingeekuk.
Protector Mask. 2021.
Walrus intestine,
seal intestine, hog
intestine, sealskin,
baleen, bone, walrus
ivory, beads, polar bear
hair, fur seal, ribbon
seal, land otter fur,
sea otter fur, rabbit
hair, reindeer hair,
auklet feathers and
beaks, whale sinew,
and cotton thread.
Length 46 cm (18 in.).
CMMM 2021.8.1.

FIGURE 2.35. Elaine Kingeekuk tries on her in-process *Protector Mask* featuring traditional St. Lawrence Island Yupik materials and designs. Photograph courtesy of Elaine Kingeekuk.

we lost most of our heat for almost four days, which affected the gut that I was tanning. Right after that we had a two-week quarantine. I wanted to throw the gut away so many times, but I kept working on it. I finally finished my COVID gut in the summer of 2020.

At the top of the mask, I used intestine from a young bearded seal that I got from my aunt in Savoonga. She gave it to me while I still lived in Anchorage. The gut was super white and thin. They don't normally use this type of intestine for clothing, but she made it so I wanted to use a little piece of it. I used it as a fold to cover the top leather string on the mask. My aunt passed away in the spring of 2021, and my mind kept going blank. I prayed for God to motivate me. I kept saying, "I could have finished this mask while she was still alive." But then I found that bearded seal intestine she gave me, and I put it right there.

There is a small tear on the neck part of the mask. I accidentally tore it when I was sewing. If the material wasn't that rare, I would replace it. If it was for a great leader or they were going to use it for

hunting, they would cover it. I was going to sew on a piece of leather to cover the patch, but I thought I could just leave it there for people to see our stitching and it can be part of the story.

My mom taught me how to patch raincoat-type gut by putting another piece of gut underneath the tear to hold the stitch holes. If you don't, the stitch holes will get bigger and bigger until the material is ruined. That's how I fixed the ceremonial gut parka at the Smithsonian. My aunt said that long ago, my grandma used to use muslin, knit-looking fabric, to repair holes in weatherproof or windbreaker-type walrus gut parkas without any designs.

If this was a long time ago, springtime would be a patching time for all the women. They would be mending garments if they weren't too old. Or they would be busy making brand-new sealskin pants or waterproof gut parkas before the hunting season. I opened the flaps to the mask when I put the bib on. I had to stretch the immediate front of the bib to curve it. I had to curve the gut and sew it on evenly, which is difficult with a real delicate raincoat-type gut. Preparing the material you sew on takes time. You have to dampen the gut and stretch it. You keep the gut in a cool, dry place or a glass container with a small amount of water to keep it damp.

When I tried the mask on, I could smell the gut a little bit (figure 2.35). You can actually breathe through it, but I don't really like the smell. Because this is fresh walrus intestine from last year. But the bearded seal intestine I have from my aunt, the smell is not there anymore. Normally I put Bounce dryer sheets in with the gut to have them absorb the smell.

When anybody who works with lots of gut, or has made formal regalia, sees this mask, they will say, "Girl, you were taught well. That is impossible to do, and you did it." While I worked on this mask,

I thought of them. I thought of all their teachings. All the women who taught me in my lifetime. This thing is a little bit of my life story. The history of the materials, and I have everything right there.

BLUE AND RED DYED GUT SKIN

The mask has red, white, and blue designs on the top. I had a little bit of blue and red dyed gut, so I sewed it along the top edge. The two-colored design right there is compatible to the old way of sewing mukluks with liners. Red is an old common color. They used red alder bark for dye and sometimes red ocher that they would pound and use for dye. So they had red-red.

When trading beads came along, red, white, and blue were popular colors for hair beads. They also used the beads to make net-like designs on top of baby hats or net-like beaded necklaces. I never learned how to make those, but red, white, blue, and sometimes black are our traditional colors. When I saw the mask, I told myself, "All-American colors," without first thinking about the colors St. Lawrence Islanders traditionally had. The colors represent our national flag. They also represent Americans working together with the rest of the world at this time.

MEDALLION

My mother, Ruthelle Kingeekuk, found a walrus ivory medallion on Punuk Island in the 1970s. The medallion was small and thin and decorated like all the oldest artifacts with Okvik designs. There was a slit on both sides. My father showed the medallion to an old man from my mother's clan, and he knew what it was right away. He said, "This medallion is like a rank for a fighter. It would be sewn onto your parka in the center of your chest. People would be able to read the design and recognize it as a great leader's medallion. A potential challenger would see the medallion and recognize that they are not good enough to compete or fight with him." All of the animals the leader caught were engraved on the ivory medallion, including a crab, bowhead whale, ducks, and geese. I wanted to use the crab design because due to COVID-19, everybody in this whole world, for the first time in a long time, was holding on together like a crab. Scientists were trying to get a vaccine, and religious people were praying for each other. We were all listening to the news and holding on together.

For the mask, I didn't use the actual artifact from my past but the story that was passed on. I first drew my mom's artifact design in the 1980s and kept transferring it onto paper over the years. I wanted to embroider the design on the mask, but I couldn't transfer my design onto the gut material. Instead, I drew the design on a small piece of real fine bleached sealskin that one of the ladies in Savoonga gave to me. Then I embroidered the little lines with black cotton sewing machine thread. The first time I ever sewed the design, I think I used nylon thread, but it was too thick. You have to take your time. I found a small piece of ribbon seal hair my mom had stretched real thin for her dolls and stretched that around the crab medallion using round-nosed pliers. It looked perfect. I put it on the cheek part so you can read his biography and see that this great leader fights like a crab, but he is also a good doctor who heals and protects.

POLAR BEAR DRAWING

This polar bear is based on my mom's drawing that she embroidered on the trim of my nephew's parka.

FIGURE 2.36. Detail of *Protector Mask* by Elaine Kingeekuk. A carved whale's tail, sealskin pouch, and bird carving appear at the top. The crested auklet curl is in the center surrounded by trim made from a variety of marine mammals.

It shows a young bear on its back with its arms and legs up in a playful mood. I found her original drawing and drew it on a piece of my aunt's clear, unborn ribbon seal intestine. I was going to embroider the bear, but I was going to destroy it, so I used permanent ink and sewed it onto the right cheek.

WALRUS DRAWING

This drawing is based on a design that I have seen on a harpoon head. It shows a walrus, puffin, owl, and rabbit. I drew it with permanent marker on another piece of unborn ribbon seal intestine from my aunt and sewed it on.

WHALE CARVING

I found a walrus tooth and carved it into the shape of a bowhead whale and seal. I was thinking of those buttons that men used to wear on their hunting hats. I carved it in the old way like that. I drew a piece of whale sinew through the bottom of it and put it on the top part of the mask.

They caught a whale in Savoonga the day before Christmas, on December 24, 2020. The whale made me think, "What a big blessing. We know now that our God is watching over us." I was thinking about when this pandemic is going to end. In a very small village like this, people are crowded, and there is more than one family living in some of the homes. I was thinking, "Now we don't have to be so afraid. We have somebody watching over us. A provider." I am grateful that this region, thank God, is doing all right during the pandemic.

WHALE'S TAIL

The center of the whale's tail is made from a piece of green baleen from a younger bowhead whale (figure 2.36). I started shaping the baleen quite some time ago when I lived in Anchorage. I found a small piece of the baleen, shined it, and put it with two old ivory pieces that, when strung together, looked like a whale's tail. On either side of the tail, I strung brownish-red beads that we call garnets and are commonly used in Savoonga. There is also a trade bead that I found at an old village site. A single baleen bead is at the end of each string. The baleen and ivory represent old materials, and the beads represent a new or modern material that we use.

SEALSKIN POUCH

This pouch is made from red and white sealskin and sewn with one of our special stitches. The teardrop shape is a traditional design found on our ceremonial clothing. For the pandemic, the shape represents all the tears we have shed because of COVID-19.

BIRD CARVING

This bone carving is in the shape of a bird with a large beak. The carving was started by my late husband, Tom. I found it and filed it smooth. Our ancestors used walrus bone as well as ivory for tools. I have found a bunch of old fishing and hunting tools made out of bone and ivory with animals on some of them. The people of the past who couldn't afford ivory used bone. Great leaders would have decorated their gear with ivory.

LAND OTTER FUR

These three little tufts of land otter fur are from my auntie. The fur would be hanging down on the sides of a ceremonial parka.

TUSK-SHAPED DESIGNS

The two walrus-tusk-shaped designs are made out of bleached sealskin. If they were on a parka, they would be on the front in the center and pointed down. The yellow rabbit fur is embroidered with a special stitch that was often used on a traditional game ball. The yellow fur was gifted to me by a lady who taught me how to do the traditional braid, which I used here for the bird carving.

CRESTED AUKLET

Crested auklet curls are used on the parkas of men's and women's formal regalia. My great-aunt Ruby gave me some crested auklet curls that she saved. I took the curls with me to Washington, DC, when I went to repair the formal gut parka at the Smithsonian that is now in the Anchorage Museum. I added fur to the Smithsonian parka, but none of the little orange beaks had fallen off. I saved the beaks and curls and used them on this mask.

This was the first time I sewed on a beak. Nobody taught me. I looked at the picture I took of a parka in the Alaska Heritage Museum at Wells Fargo in Anchorage. I zoomed in and looked at how they were sewed on. The beaks I had were very dry. I washed them and cleaned them. The first patch that I cut, the little feathers came apart. I cut them on the skin side. The feathers have to be cut and sewed on a certain way. But I figured it out, almost the way they did in the past. I used two beaks and a little extra fur on the top, which is traditionally cut off, but I left it to signify this is not the old way of sewing on the design but a modern way. The crested auklet fur was first sewn on a small piece of gut and then sewn onto the mask with a red piece of sealskin leather across the edges of the beaks; that was challenging.

FUR SEAL SKIN

Long ago, in the 1980s or 1990s, Larry Kava caught a fur seal. That was very special to the community. All the Elders were happy. It was so special because they had never seen a fur seal around this area for many years. Elsie Kava dried the sealskin and gave a piece of it to all the ladies who sewed in Savoonga, probably in Gambell too. A few years later, she

brought me a piece of that fur. She said, "You are a very young artist; you use this." The fur is brown and really cushiony soft. I knew I still had a piece of it because I used to use it after she was gone. I would use it only for special occasions, on something special that I was going to make. A piece of that fur seal is here on the bib.

CIRCLE, OVAL, AND LINE DESIGNS

The circle, oval, and line designs are made from sealskin that is natural, bleached white, and dyed red. For the two small pieces of fur seal I sewed on the bib, my stitches were too big. If it was the old way of doing things; I could almost hear my grandma say, "Undo it and do it again." But this is intestine and if I took it off, I might tear it. So I just let it be and covered my stitches with the circles made of super-white leather.

RED ZIGZAGS AND BLUE TUFTS

At one time my mom had bought blue and red dyed rabbit skin. I found her pieces and decided to use those for a little bit of design work to represent rabbit. Sewers of our past had rabbits that they imported from Siberia. They are seeing rabbits now from Siberia on St. Lawrence Island that crossed from the south side. I saw a real huge one, a wild rabbit with big feet, an Arctic hare. I couldn't believe it.

The zigzag designs on the bib are done using long rabbit hairs that have been dyed red. I saw a different up-and-down design one time that a lady did on gloves using red long-hair rabbit skin. Mine kind of turned out. On the bottom you can still see my pencil marks where I was going to do blue zigzags, but it was too much. The blue tufts are made from the blue-dyed rabbit skin. Later, sewers did these types of embroidered designs with yarn instead of hair.

S DESIGN

The S design is based on an engraved walrus tooth that I found. One time I was walking along the bank of the dried-up lake at Kukulik. I had my shovel, and it had mud on it from where I was digging. I passed a hole on the bank with water in it, and I decided to rinse my shovel. I stuck in my shovel, pulled it out, and all of a sudden something black came right out. I thought it was a rock, but I looked at it for a moment and thought, "Gee, it's a walrus tooth." I dried the tooth, wrapped it in a paper towel, and showed it to my friend. I said, "I love the color of this walrus tooth. It's pitch black. I'm going to make it into a necklace or something." I brought the tooth home and put it away on top of my dresser. Later, when I took a look at it, I saw lots of different designs. First, I saw a bearded seal, and then when I looked at it from the side, I saw these twirly fabric designs with a dot in the middle of the S. While I was admiring it, my sister-in-law came out of her room, and I asked her to tell me what she saw. She said, "Some kind of fabric-like designs." I couldn't believe it. We never heard anyone talking about fabric designs in our life. For the S design on the mask, I used the hairs of an unborn baby reindeer and sewed it down with blue thread. For embroidery, we often use the long hairs of an adult reindeer.

SEA OTTER FUR

The sea otter is from my oldest auntie. It was caught here on the island, and she gave me a piece of it to use on my sewing. When they give us these things,

what we do is we use them for something special. Like if we are going to make something as a fundraiser for a family. They taught me how to do that.

POLAR BEAR FUR

Because all my designs were too close to the edge of the bib, I sewed on a strip of gut along the edge in order to sew the furs on without tearing the bib. I almost used white cloth, but I looked through my stuff and thought about it for a day. Then I found a strip of raincoat-type walrus gut skin, so I sewed that along the edge. I sewed the polar bear and sea otter furs together, and then sewed them on. I sewed on the fur seal, sea otter, and the polar bear without tearing the gut skin. Impossible. Done. Because when you see the regular garments, both the raincoat and windbreaker parkas, the fur that they put on the bottom of the parkas and on the sleeves is sewed up and down because it might tear. Amazingly, I sewed the furs from left to right, which is very difficult.

FIGURE 2.37. Delicate stitches can be seen on the reverse of the translucent gut-skin mask. A miniature ivory harpoon head and round ivory bead are used as toggles on the red sealskin straps.

HARPOON HEAD AND CIRCLE TOGGLES

There are two strings, a top and bottom, on the mask. For the bottom string, I used a circle-style piece of ivory that I polished for a toggle. The top string has a harpoon head that I carved and turned into a toggle (figure 2.37). On a skin boat, they have an artifact on the boat for a line holder; the harpoon head symbolizes that. I tried to follow two different style of harpoon heads. The lines I made turned out like Okvik and Old Bering Sea designs. The designs show a whale, bird, man, woman, and child who are holding on during the pandemic.

One time I found a harpoon head at Kukulik, and it was soft from being buried in the mud. All of the designs on it were carved in the style of Okvik. It didn't have prongs. My cousin French Kingeekuk told me about different kinds of harpoons and what they were used for before I looked them up in an artifact book. Some of the oldest harpoon heads have two or three prongs, which is why I carved my harpoon head with three prongs.

SEALSKIN STRIPS

Before you sew with sealskin, you have to stretch the skin, scrape it, and then shave off the fur. To make a sealskin strip, you have to strip the skin with a knife real slow. I don't draw a line on the sealskin. I just watch it in my mind. It has to be a super-straight line all the way to the other end. If you accidentally make it wide and then thin, it will not look right when you sew it on. Tanning the sealskin, softening the leather, splitting the strips, and working with them takes time. You have to think how you are going to use this thin material. I cannot gamble on sewing because if I tear it, there goes all that work.

The top sealskin strip around the face of the mask is made from a sealskin that my grandma colored with artificial red dye. I had a thin strip of my auntie's sealskin that I was going to use for the bottom one, but as I was stretching it the leather snapped. So I added on a piece of my mother's sealskin that had a little bit more oil in it and was prepared differently.

On the bib, there is a strip of red leather that my mom colored out of old-fashioned traditional dye from bark. It has more of an orange color and used to have a tree smell. My mom's sealskins were made traditionally with no cuts like a seal poke with the feet and arms left in. They let the hair fall out and then turned them into traditional white leather. I stripped that orange-type leather from the last sealskin my mom prepared and dyed. It took me a whole eight-hour night to sew on that single strip.

STITCHING

There are several different types of stitching from our region on the mask besides the different materials. I used waterproof stitching, like you would use for mukluks, in the center of the mask where the left and right cheek pieces connect. The bib is fully decorated with embroidery, including twirling S designs and zigzag designs. It was a very challenging thing because gut is a very delicate material for doing embroidery.

This mask is the history of my people and our sewing. The mask is also my story of the people who taught me and gave me the materials I used. A story for the families of the women who have died and who gave this material to me. All the women who prepare these rare materials, I found pieces of their work, and I put them on. It is my family's custom

that I learned how to do this sewing, and I hope it will remind people of the significance of their aunties teaching them and how it benefits them in the long run. I told myself what my Grandma told me, "Hold on like a crab." I pinched it and held onto it, and I have learned. This mask has made it possible to put together the knowledge that my whole family gave to me, all the people who gave me material, right there. The mask is a new history of the pandemic. Although it seems like the virus will be here all the time, there is hope in the world. We have someone watching over us.

32 SONYA KELLIHER-COMBS

Sonya Kelliher-Combs (Iñupiaq/Athabascan) grew up in Nome and now lives in Anchorage, where she and her husband, Shaun, spend summers gathering and harvesting resources at their cabin in Kasilof, Alaska. Kelliher-Combs is an accomplished curator and artist whose mixed-media paintings, sculptures, and drawings interweave organic and synthetic materials into visual narratives that speak to self-definition, contemporary culture, and environmental activism (figure 2.39). This story contains excerpts from an online presentation given by Sonya Kelliher-Combs during the Alaska Anthropological Association Annual Meeting on March 3, 2021, and a conversation held between Sonya Kelliher-Combs and Amy Phillips-Chan via telephone on June 9, 2021.

From the Body, Land, Sea and Air was proposed as an in-person reciprocal residency exchange sponsored by the Inuit Arts Foundation. Due to the COVID-19 pandemic, it was transformed into a distance exchange with Canadian artist Maureen Gruben. Maureen is from Tuktuyaaqtuuq, Canada. Due to the pandemic we weren't able to work in person, but we decided we still wanted to work together. So our exchange was spent communicating through FaceTime, on the phone, and via text. The conversation and shared imagery fueled a deep connection. We were familiar with each other's work from a previous short visit but soon realized the connection between our art and lives. We are both inspired by place, culture, and relationship to the natural environment and man's impact on these. Maureen and I are also both big collectors. We started talking about how isolating the pandemic has been and how much more time we were getting to spend out in nature. We began collecting things and transforming them.

At the beginning, I wanted to collect only natural things from the land. But then I was finding so much man-made garbage and discarded objects that I started collecting them as well. I began to think about how hundreds of years ago, Western society began collecting things our people had discarded, buried with our ancestors, or simply lost—meant to return to the earth. The objects from our past and our ancestors become precious through this process, commodifying our material culture and relegating them to be housed in museums and private collections. It reminded me of being a kid in Nome and visiting the museum, seeing all these beautiful historical objects cased away. I began to think about the implications of collecting material culture and how often they are housed far away, hidden from the culture from which it was made.

I collect things from the land all the time. Other people send me things they think I might use. My mom and dad send me objects they find on the tundra: shed antlers, bones, or other objects. The content and actual physical making of artworks from these collected objects sometimes takes a really long time. Often I will have objects and materials for years before they become a part of my work. Gathering, processing, and living with them allow time for that creative dialogue.

So with these ideas in mind, Maureen and I approached the series *From the Body, Land, Sea and Air* as a collaborative project. We collected and began making work. We would work independently for the week, and then talk and share images. The

FIGURE 2.38. Sonya Kelliher-Combs. 2020–2021. *Hair Portraits*. Acrylic polymer, paper, human hair, and nylon thread. Height (each) 15.2 cm (6 in.). CMMM 2021.11. Purchased with support from the Rasmuson Foundation.

FIGURE 2.39. Sonya Kelliher-Combs cradles a carved walrus ivory seal at the Carrie McLain Museum. 2022. Photograph by Amy Phillips-Chan.

hair from a single day. I remember taking a shower after learning about the first case in Alaska and feeling very vulnerable. I always collect my hair for the most part but had not done so in such a documentary way. I started to catalogue the hair, where each little ball became a hair drawing or hair portrait, representing each day. The stitched hair also speaks to the emotional and physical stress of the pandemic on the body.

Most of the *Hair Portraits* are circular because historically and metaphorically, it is a reference to letting go, such as letting the spirit of a harvested animal return to the natural world. It also relates to a series I make titled *Secrets*; these works address the unhealthiness of negative secrets, historical, physical, emotional traumas that we need to acknowledge and heal from. I have created over 250 *Hair Portraits* and plan to keep on working on them until a cure is found for COVID-19 or COVID-19 is no longer with us.

The two other series I've worked on, *From the Land* and *From the Sea*, incorporate materials that I have found from those locations. I spent the summer of 2020 at our cabin in Kasilof, Alaska, and it was there that I began to collect objects and materials that had come from the ocean and land. I thought it was important to catalogue and document them before I picked them up and they made the journey back to my studio. I photographed where each object originally came from, wrote down the location and the date, and that became part of the process. Basically, just documenting and assigning a value to these things and transforming them into artifacts, elevating them, through this process of collecting.

Found Artifact II is a carved piece in the *From the Land* series (figure 2.40). It is a large eight-foot piece of driftwood that I found while walking on the beach. I had my husband put it in our truck and haul it back to our cabin at Kasilof. I eventually

work spoke to each other—it was a beautiful and wonderful exchange.

The first of the series I began was *Hair Portraits, From the Body*. I started it on March 13, 2020, the day after the first case of COVID-19 appeared in Alaska (figure 2.38). I started collecting my hair every time I took a shower, and each portrait includes stitched

FIGURE 2.40. Sonya Kelliher-Combs. 2020. *Found Artifact II, Kasilof Beach, 6/14/2020. It's From the Land via the Sea An artifact hidden in plain sight Relations to the bowhead Age is filled with strength and wisdom Shh . . . if we are quiet there are stories and lessons to learn.* Photograph courtesy of Sonya Kelliher-Combs.

FIGURE 2.41. Sonya Kelliher-Combs. 2020. *New Artifact, Tether. Tether: a line to which someone or something is attached, the limit of one's strength or resources.* Photograph courtesy of Sonya Kelliher-Combs.

brought it home to Anchorage and kept thinking about how long it had been on the beach and where it came from. Then I began to consider a shared image from Maureen, a beautiful fishing spear she had found on the beach near her home. It led me to think of an old artifact my father had given to me when I was a child that today I wear as a pendant. He said, "This will make you strong," because I was afraid to go to school. It made me consider the strength of these objects and their beautiful history and the power of our material culture. By the end of summer, I knew what I wanted to do with this piece of driftwood. I began to carve on it, and it became *Artifact II*. It has a series of circular puncture marks on it that are akin to my *Brand* or *Portrait* series that illustrate an opening or passage.

New Artifact, Tether is part of the series *From the Sea* (figure 2.41). It is a large rope from a vessel that we found early in the spring of 2020. It hung around our yard at the cabin for the majority of the summer, and in the fall after working on the hair portraits I knew what I wanted to do with it.

I wanted to transform this tether into a sculpture symbolic for our tie to each other even though we were far apart. I decided to reclaim this discarded rope by stitching my hair onto it.

I think the series *From the Body, Land, Sea and Air* is a snapshot in time, a moment of collaboration and contemplation during a trying time. This time has allowed many of us to look closer at our surroundings, both inside and out, and appreciate this beautiful, amazing place we live in. We have learned that we can communicate with, support, and take care of each other from a distance. It has also enabled Maureen and me to engage in a dialogue about issues important to us, including the endangered state of where we live and how each of us can contribute to a healthy north.

33 SYLVESTER AYEK

Sylvester Ayek (Inupiaq) grew up on King Island, where he learned to hunt walrus and seal in spring and perform dance songs in the qagri during winter. Ayek began his artistic career as a walrus ivory carver before he transitioned to large-scale sculptures in wood, ivory, and metal. He received the first Distinguished Artist Award from the Rasmuson Foundation in 2004, and today his work can be found in collections across the country. Ayek is a King Island Inupiaq speaker and traditional knowledge expert who has served as a cultural advisor for collections-based projects, among them, the Smithsonian Sharing Our Knowledge project and Our Stories Etched in Ivory publication (figure 2.43). This conversation was held between Sylvester Ayek and Amy Phillips-Chan at the Carrie M. McLain Memorial Museum on April 1, 2022.

The COVID-19 pandemic really affected me and my work. For two years, I hardly did any kind of artwork. I was afraid to travel, and when I finally did settle down in Anchorage this mobile is a result of that. It was a relief to go back to what I was doing before the pandemic. The piece allowed me to not only catch up with nagging bills, but it allowed me to help my daughter not to worry so much about money, so she could stay in college.

For this project, I wanted to do something a little different (figure 2.42). As long as I have been around, I have never seen any crafts people carve an arctic tern out of walrus ivory, or any kind of traditional material for that matter. So that was an interesting challenge. I sat down and did some drawings and thought, "You know, this could be done. I could pin the long slender wings to the body." After I saw it could be done, I started drawing the designs on paper and cutting up the walrus ivory that I had (figure 2.45). I carved the body, the wings, and the tail separately, making sure that they would be in proportion once it was put together. Once the pieces were pinned and glued, I began planning and plotting on how to display the bird.

A few years back I bought these metal hoops from one of the crafts suppliers in Anchorage before he closed. I bought a lot of stuff thinking that eventually it would come in handy. So I had about four or five of these metal hoops laying around. I created two large mobiles for Norton Sound Hospital several years ago and thought it would be interesting to make a mobile inside these hoops. And that's what I did. I experimented with how I was going to hang the piece and what else I was going to place inside. I drew the design on my drafting table, and the feathers were a result of that. I also didn't want the hoop to be plain, so I decided to wrap quarter-inch beads around the hoop for aesthetics. The stainless steel cables are the type you get at beadwork stores. I used ten-pound cable for the feathers and I think forty-five-pound cable for the tern. I like the fact that you can hardly see the cables from a distance.

I have always been interested in mobiles. I used to share with people that all the good ideas had been done by Alexander Calder. His pieces had beautiful balance. But this tern mobile makes me think that maybe there are still good ideas.

I used to work on walrus ivory all the time in my younger days. I did lots and lots of ivory work. Then I went to school and discovered that there are different materials, nontraditional, that we can use.

FIGURE 2.42. Sylvester Ayek. 2022. *Arctic Tern Mobile*. Walrus ivory, metal, beads. Diameter 68.5 cm (27 in.). CMMM 2022.3.1.

FIGURE 2.43. Sylvester Ayek discusses the publication *Our Stories Etched in Ivory* on the KICY radio station in Nome on July 29, 2021. Photograph by Amy Phillips-Chan.

From there I started getting away from traditional materials. But I go back to using ivory if there is a new idea or something totally different that I can do with it. And that's the result of this tern.

I started using feathers on my work during the late 1960s or early 1970s. I was inspired by one artist from California who carved a beautiful feather, and I couldn't get over it. At the time I was making all different kinds of hardwood masks. I decided to try carving feathers out of ivory for the mask appendages, and they turned out good (figure 2.45). There is one of my big masks at the Southcentral Foundation in Anchorage. I used seven-inch feathers made out of hardwood for that mask, which stretches twenty feet wide.

Feathers were prized in our culture. Real feathers were used for our dances, such as eagle feathers for the headdresses worn during the Wolf Dance. Most of the eagle feathers we used at King Island came from the mainland. We hardly ever saw eagles on King Island. I saw one eagle way out of nowhere many years ago, only once. So there are some eagles out there but not many. You would have had to walk for miles and miles on the mainland to find any kind of eagle to take home. Then of course, before modern times, they did lots of trading. The eagle feathers that we traditionally used for the Wolf Dance may have come from as far away as Athabascan country.

It's fascinating to me how our people were able to come up with solutions to the most difficult

FIGURE 2.44. Detail of *Arctic Tern Mobile* with a walrus ivory feather and glass beads encircling the metal hoop.

FIGURE 2.45. Sketches and reference material for *Arctic Tern Mobile* are shown in Sylvester Ayek's studio in Anchorage during the summer of 2021. Photograph courtesy of Sylvester Ayek.

situations or problems before modern technology. Not only did they use their common sense; they also had really technical minds to survive in a real harsh environment. And King Islanders are no exception to that. They had to have the minds of structural engineers to do what they did 100 or 200 years ago, such as moving big boulders around the island or anchoring their houses in very shallow dirt.

One of the most exciting aspects of this project was coming up with solutions every time a challenge presented itself, such as emphasizing the very subtle lay of the bird's wings or figuring out that Czechoslovakian beads would really make the metal frame pop. I love pieces that are challenging to work on. The bigger they are, the more challenging they may be. I like the challenges that I have to solve along the way, and it's been like that for me for a few years now. Coming up with solutions as I go along and, sometimes, they turn out decent.

There are many good artists out there. I feel like I am just one of many. And I just try to have humble acceptance of this blessing or gift that I was given to share with the world.

PART 3
Oral Histories 2021

Nome experienced its first outbreak of COVID-19 more than eight months after the first case was confirmed in Alaska. On November 26, 2020, a positive case of COVID-19 at a Nome bar led to a surge of fifty active cases in just a few weeks. The Nome City Council decided to reclose bars and restaurants, and other local organizations soon followed. Nome residents felt the full severity of the pandemic as holiday celebrations across town were cancelled and friends and family members began to get infected. After the outbreak in cases, the Carrie M. McLain Memorial Museum (Carrie McLain Museum) recognized the need to launch another round of oral histories to better understand the impact of COVID-19 on Nome. In spring 2021, the museum recruited Nome historian Carol Gales to coordinate a second group of oral history interviews. From March 23 to April 15, 2021, Gales held ten interviews about the COVID-19 pandemic with a total of twelve participants. As in 2020, each oral history participant received a $50 gift card as well as copies of all interview materials.

Part 3 features an editorial reflection by Carol Gales and ten COVID-19 oral histories shared by Nome residents in 2021. A short biography introduces each community participant and features details shared during the interview as well as information drawn from the editors' personal relationships with participants. Gales held the oral history interviews via Zoom (5) and in person (5) at homes, businesses, and the Carrie McLain Museum. Only a handful of active COVID-19 cases were present in Nome during the interview period, which prompted several participants to relax and communicate without masks.

The oral histories highlight community members' experiences during the first COVID-19 outbreak in Nome, including contracting the virus, operating a business, working remotely, and giving birth during a pandemic. Stories shared by the seven women and five men speak to disbelief at becoming infected with COVID-19,

(*opposite*) Nome Arts Council members Julia Slingsby (left), Marguerite La Riviere (center) and Carol Gales (right) hand out treats to David Winston Chan (front) during a Halloween trunk-or-treat event organized by Norton Sound Regional Hospital in 2021. Photograph by Amy Phillips-Chan.

personal loss, memories of past epidemics, and gratitude for resuming visits to extended family members. Participants speak from their perspectives as Elders, business owners, subsistence users, teachers, new parents, and working families who navigated school at home.

The COVID-19 interviews from 2021 are organized chronologically and offer insight into the transformation of activities and perspectives of Nome residents at a pivotal moment in the Bering Strait region (table 3.1). Participant review of each edited interview has helped to ensure that the words shared here are those that community members wish to convey to future generations. Portrait photographs accompanying the oral histories were taken by Gales or submitted by participants with additional images chosen by community members to help illustrate their stories.

TABLE 3.1. COVID-19 oral history participants, 2021

Interviewee	Profession	Date of Interview	Location
Bob and Vera Metcalf	Elders, Tribal Leadership	March 23, 2021	Zoom
Sherri Anderson	Community Service Provider	March 24, 2021	Zoom
John Lane	Community Service Provider	March 25, 2021	Interviewee Home
Brandon Ahmasuk	Tribal Leadership	March 30, 2021	Zoom
Melissa Ford	Business Owner	April 2, 2021	Zoom
Anne Marie Ozenna	Medical Personnel	April 6, 2021	Norton Sound Hospital
Josie Stiles	Community Service Provider	April 8, 2021	State of Alaska Office Building
Mike Hoyt	Teacher	April 11, 2021	Zoom
Mary Ruud-Pomrenke	Medical Personnel	April 13, 2021	Interviewee Home
Howard and Julie Farley	Elders, Business Owners	April 15, 2021	Museum

34 CAROL GALES

Carol Gales landed in Nome over twenty-five years ago to take a communications position with Norton Sound Health Corporation. She became active in the Nome Arts Council, worked for UAF Northwest Campus, and bought the former Discovery Saloon, the oldest surviving building in Nome. Today, Gales serves on the board of the Alaska Historical Society, offers graphic design assistance, and operates a small tour company called Roam Nome. She and her husband, Jim Dory, play in the string band Landbridge Tollbooth and enjoy trekking across the Seward Peninsula (figure 3.1). This article was submitted by Carol Gales on September 8, 2021.

It's September 2021 as I sit to write this, and I'm still wearing a face mask to the grocery store and post office. COVID-19 patients of all ages are filling hospital beds in Alaska and across the country. Case counts in Nome and area villages are creeping upward. Will this virus ever be under control—or is this our new normal?

Seven months ago, in March 2021, I agreed to interview ten Nome residents about their COVID experience as part of the Carrie M. McLain Memorial Museum's effort to document the pandemic for future generations. I was eager to learn how others had fared in the year since city officials had shut down community Iditarod festivities and imposed testing and quarantine mandates at the Nome airport.

My own COVID year had been amazing.

My husband, Jim, is retired, and I run two small businesses that allow me to work from home. So unlike many people, we did not have to deal with altered working conditions. With my new tour guiding business dead in the water and most commitments wiped off my calendar, I enjoyed a sunny summer of socially distanced hiking, bird-ing, backpacking, and paddling adventures with a couple of friends. Winter brought snowshoe and cross-country ski outings in the quiet wilderness near Nome. I learned to bake bread and began producing a steady supply of sandwich bread, double-chocolate zucchini bread, and pumpkin cookies to share with Jim and friends. I sewed hundreds of face masks for friends, family, and the hospital, tweaking my design with innovations shared by mask sewers across the country who networked through Facebook. I was better connected than ever to my large and widely scattered family through a sibling text thread and monthly Zoom meetups. Friday-evening Zooms connected Jim and me with friends just ten miles away in Dexter.

So it was a bit of a shock when an interviewee invited me to his house for our conversation. I balked. He pointed out that both of us had been vaccinated. He regularly sanitized things around the house. We could sit six feet apart on opposite sides of his large dining room table. Masks would not be needed.

There was no valid reason to insist on a phone or Zoom interview. I agreed to go to his home.

When John Lane opened the door in answer to my knock, I hesitated outside for a few moments, looking past him to see if anyone else was inside. There was no one. "So," I said nervously, "I just come in?"

Thus began my slow transition to a more normal life with COVID. In the end, half of my interviews took place in person, half via Zoom.

In selecting people to speak with, I sought a mix of ages, occupations, cultural backgrounds, and life circumstances. Everyone I interviewed already knew me.

I found that my own COVID experiences had much in common with those of most interviewees. All had been vaccinated. Most continued to mask up when in public places. Most limited errands to once a week. A few had initially wiped down groceries in an effort to keep virus particles out of the house. Likewise, some had let their mail sit unopened for a few days after bringing it home from the post office. Some filled their new free time with crafting or outdoor adventures.

Unlike me, however, every person I interviewed had traveled outside of Nome during the prior year. And while some conceded that perhaps something good had come from that year (a clean or decluttered house, a finished project), none called their pandemic year "amazing." Isolation, distance from loved ones, some severe cases of COVID, the loss of a faraway relative, and continuing to work despite difficult conditions were hardships described by some interviewees.

Since completing the interviews, my own life has started to resemble something more like normal. I traveled outside of Nome in August to meet up with a visiting niece in Anchorage for a few days—but I never ate at a restaurant and always masked up in public indoor places. Jim and I have

FIGURE 3.1. Carol Gales (left) takes a selfie with fellow backpacker Kate Persons at a COVID-safe distance in the Kigluaik Mountains north of Nome in August 2020. Photograph courtesy of Carol Gales.

visited friends in their homes—but sometimes were hosted out on a deck. I've driven many visitors out the Nome roads since May to see birds and our beautiful wilderness—after verifying they have been vaccinated.

Should "normal" ever return, what will it look like? Nearly two years into the COVID-19 pandemic, the question remains unanswerable.

POSTSCRIPT: I finally returned to Iowa to visit my father for several weeks over the holiday season at the end of 2021. I returned to Iowa in September 2022 after learning that he had been hospitalized with COVID. He passed away five weeks later as a result of complications caused by the virus.

35 BOB AND VERA METCALF

Vera Metcalf was born and raised in Savoonga, on St. Lawrence Island. Bob Metcalf moved to the Bering Strait region in 1976 from the East Coast. He and Vera were married in Savoonga and lived there until moving to Nome in 1981 (figure 3.2). Bob recently retired as director of the University of Alaska Fairbanks Northwest Campus. Vera works at Kawerak, Inc., as director of the Eskimo Walrus Commission. This conversation was held between Bob and Vera Metcalf and Carol Gales via Zoom on March 23, 2021.

VERA: Since March of last year, I have been tele-working from home. I had to quickly adjust to a different way of doing my work. This time of year I would be going out to St. Lawrence Island for hunter meetings and bringing in colleagues to report back with research results. I miss that part of working with others and seeing family, friends, and relatives. I also miss the meetings and dialogues, making important decisions.

I worked a lot with Norton Sound Hospital doing public service announcements for them in Yupik. I did the best I could to figure out new terminology and explain all the precautions we have to do, especially during our spring season, when boats are getting ready to go out. How do you explain being safe when you have to go out and harvest an animal? Telling people to stay away, or remain your distance when you're in a boat. You are all together—how do you do that?

BOB: I retired in June 2019, and that fall we were traveling all the time. Then the pandemic happened. That changed the plans from following Vera to all these exotic places to staying home and doing

the shopping and washing dishes. I am also Vera's IT specialist and admin assistant.

One of our first concerns was for our granddaughter, who takes immune-suppressant drugs because she has juvenile arthritis. We didn't travel until we finally decided we needed to see our family. It was August of 2020. We got tested before we went. We were super-cautious. Our granddaughter is eleven years old. She was so happy to see us. It was a really great time with her. The most important thing we have had to do is to keep in contact with our family and be a part of their life and her life (figure 3.3).

VERA: My sister passed away during the pandemic and we couldn't go, and Bob's mom passed away. Those things are heartbreaking.

BOB: That's still haunting me. My mom had a health episode that put her in the hospital for weeks. Every time I would talk to her, she would say, "So you're coming, right? I'll see you in a few days?" For the next two months as her health declined, she moved to hospice. Her last night, she had been moved into a nursing home. They had one

phone for a ward. I spent hours trying to get to talk to my mom. Every time, I'd have to explain to her that we're not allowed to travel, and even if we were there, we wouldn't be allowed to see her. I always asked if she was afraid or scared, and she never was. That helped my conscience a little bit.

VERA: My sister was medevaced here to Nome. Her doctor was kind enough to get us tested right away and made sure that we were there for her critical time. So at least I was able to see her and talk to her before she passed away. The hardest part was not going home to Savoonga, because of safety issues and not having a good place to stay, since every place was filled with people quarantining from hospital trips to Nome.

There was some spread of COVID for a bit out on St. Lawrence Island, but leadership took action and completely shut the community down, which was hard to do for them, but it worked. Our health aides have been just amazing.

BOB: Whole families would be quarantined in their own home due to one family member testing positive or traveling. There are still people in the community who have not seen newborns in their family. So they are being really careful about mixing people together.

This is like a lost year in a lot of ways, of lost opportunities. I miss sitting on the deck and drinking beer with friends. I'm way more conscious of the moment. That was one of the things I had wanted to do in my retirement: be more present for Vera and family than I had been for a long time. We sure managed this year to stay in the moment with each other. If there is a silver lining, that's mine: we've been able to spend all this time together.

VERA: Lessons learned: Take care of ourselves, and follow the mandates. Having wonderful neighbors and friends is essential. Value what you have and appreciate it.

BOB: And for posterity's sake: masks are not a big deal. If it just takes a mask to increase the percentage of safety for everyone, do it.

VERA: It's simple!

FIGURE 3.2. Vera and Bob Metcalf stand on their deck in Icy View, north of Nome. Vera worked from home for over a year with Bob's support. 2021. Photograph by Carol Gales.

FIGURE 3.3. Bob and Vera Metcalf paid a visit to their granddaughter Grace and grandson Gunnar in Anchorage during Christmas 2020. The Metcalfs took many precautions during their travels so they would not inadvertently expose family members to COVID-19. Photograph courtesy of Bob and Vera Metcalf.

SHERRI ANDERSON

Sherri Anderson was born and raised in Shishmaref. She moved to Nome in 2000 to search for work and have her own place to live. She now serves as the Native Connections project director at Norton Sound Health Corporation and develops support activities for at-risk youth (figure 3.4). This conversation was held between Sherri Anderson and Carol Gales via Zoom on March 24, 2021.

My family and I were in Anchorage to cheer on the boys' and girls' basketball and cheer teams when COVID started reaching Alaska. Before then, I had heard of COVID happening down in the states and how it was impacting communities and spreading like wildfire. Then COVID slowly moved its way up north. While we were in Anchorage, they started canceling tournaments at Anchorage schools. It felt kind of eerie because we didn't know what was going to happen. We thought we had to go home without playing in the tournament. Luckily, Lumen Christi High School said that we could utilize their gym for our tournament. We completed our tournament in one day.

Before coming back to Nome, I remember we were out shopping for food at Walmart, and we could see through an entire aisle to the other aisle because there were no more tissues, paper towels, hand sanitizer, Clorox or Lysol wipes, or housecleaning wipes.

Before COVID started, I had been experiencing some invasive back pain and was going through a bunch of back procedures. I was traveling a lot going to my appointments. Then we had to mask up and lock down. We couldn't have visitors at patient housing. We had to quarantine for fourteen days after coming back from Anchorage. I remember our first quarantine. It felt like jail. Our kids had to quarantine with us. They couldn't do anything. Their friends couldn't come over, and they couldn't go out.

Once we started getting cases of COVID here in our region, our hospital departments kind of shut down. We would receive updates from our supervisors saying, "Okay, we're going to stay home for this week, and you will still get paid. Just stay home—don't go out." But I am kind of a homebody. I really enjoy arts and crafts. So I did a lot of sewing when the hospital allowed us to stay home.

Norton Sound Hospital was really awesome about providing meals for those who worked at their office on certain days. As time went on, we started working more and more in the office (figure 3.5). Clientele-wise, it was by telephone or by Zoom, like we're doing now. We really had to get creative.

My son, who is a senior in high school, was really frustrated with how the school and the pandemic was affecting his social life. This year he joined cheerleading and basketball. He's student council president, so he has to attend school board meetings. He's in band and plays the tuba. He was really

FIGURE 3.5. Sherri Anderson stretched out on the floor of her office to relieve back pain during her interview with Carol Gales via Zoom in March 2021. She also made the most of her time by sewing a baby bootie. Screenshot by Carol Gales.

FIGURE 3.4. Sherri Anderson stands outside her workplace at Liitfik, a new wellness and training center operated by Norton Sound Health Corporation that opened in Nome during the COVID-19 pandemic. Photograph courtesy of Sherri Anderson.

frustrated with the homework packets. My seventh grader fell behind in her school too. I think COVID has had a really big impact on her.

I really want to have our activities back and community gatherings like Eskimo dancing and arts and crafts fairs like the Nome Preschool bazaar. I miss going to church. I miss my Elders that go to church. I know our Elders have been really self-conscious about going out, maybe because they're scared about what they've seen, or what they were told growing up.

My grandma Katherine Olanna was one of the last remaining survivors of the 1918 influenza epidemic. She passed away in 1995. When they found out what was going on with the epidemic, the men of Shishmaref would take turns standing post and

they would not let anybody leave Shishmaref and they wouldn't let anybody enter. My grandpa was one of those people that would have to go stand at a post. He recalled that some of his friends actually had to shoot people for trying to come in. I don't think the influenza epidemic actually did get to Shishmaref.

This past fall I did some berry picking. I invited a couple of my friends to go, and I felt safe with them in my vehicle. I did make sure before going out that we had negative COVID results, which seems kind of funny now. I did a lot of solo time too, where I went out berry picking by myself. A lot of Facebook time or telephone calls. A lot of FaceTime with my daughter, who was away at University of Alaska Anchorage. I call my mom every day just to make sure they are healthy and okay back home in Shishmaref. I walk my dog and do a lot of baking and cooking instead of ordering out. I remember when Milano's first reopened and I had a cheeseburger from them, and I was just like, "Ah, this tastes so good!"

37 JOHN LANE

John Lane was born and raised in Fairbanks until age twelve, when his family moved to Nome. He works for the State of Alaska Department of Facilities Services, where his responsibilities include maintaining buildings, clearing roads in winter, and repairing runway lights at village airports (figure 3.6). This conversation was held between John Lane and Carol Gales in John's home at Lester Bench just north of Nome on March 25, 2021.

I knew COVID was coming. I was worried to death about the parents of some of my best friends. But their children, my friends, protected them very well. My girlfriend, Amy, and I were buckled down together in Nome the whole time. It worked for us.

I love my job in Nome, but I do it all so I can spend time at Council. That's where the fishing, the hunting, the try-to-relax activities happen (figure 3.7). The hardest part of COVID was social gatherings. I love a big barbecue at the cabin for birthdays and anniversaries or special events. Everybody in Council comes over. Those gatherings slowed down pretty much to near zero. We still socialized, but we were leery of other people and careful. We have some really good friends at Council, Ron and Matilda Davena. Ron is eighty-two, and Matilda is seventy-nine. We didn't visit them as much, and when we did visit we would sit out in the driveways or lawns or out on the decks, and we'd talk at a good distance. We tried to take care of them the best we could.

We have thirty-seven village runways that we maintain for my work. I travel on Bering Air sometimes twice a week. Bering Air requires a negative COVID test result within seventy-two hours before you fly. After my seventeenth test, as I was trying to get on Bering Air to head back up to Kotzebue, they said, "Hey, you're positive." I said, "I kinda doubt it, but okay." I hadn't seen anybody who had COVID. The people that I was around for the prior two weeks, including my close contacts and my girlfriend that I have lived with for eleven years, were all negative. I had a cold. I had a runny nose for one day. A day and a half later, and I was 100 percent fine. I never had any hardcore symptoms. The doctors were calling me every day. "How do you feel? Do you have any symptoms?" And I said, "Doc, I don't have it, I swear to God." Best-case scenario, that rapid test machine was 64 percent accurate. That's why I believe that I was a false positive and I just had a cold.

Quarantine was boring. Amy and I had a plan. I was going to just stay in the master bedroom. We got a TV, we got internet, and I had my phone. Still, to just sit there for ten days, I started getting really upset. Amy cleaned constantly. She's a nurse, and she was scared to death of this pandemic when it hit New York back in the spring of 2020. She would leave a tray of food at my doorway, and then we would wait about two or three minutes. She would walk away, and then she would text me, "Okay,

FIGURE 3.6. John Lane tested frequently for COVID-19 as part of his runway maintenance work for the State of Alaska. His job also involves snow removal on state roads around Nome. Photograph courtesy of John Lane.

FIGURE 3.7. John Lane kneels on the ice with a catch of Dolly Varden to share with Elders in Nome. Photograph courtesy of John Lane.

your dinner's on the tray by your door," and I would sneak out and get it.

I thought the City of Nome kind of overstepped their boundaries. You have the city manager in people's faces down at Alaska Airlines. They herd you right down the hallway, and they have policemen there. You got the hospital cramming a hundred people into that little testing tent at the airport. When we got back from Christmas, it was four below zero and the winds were probably twenty-five knots. You had to walk outside before you got into the tent. You were sheltered from the wind, but there was no heat in there. You're standing in that tent for up to half an hour, shoulder to shoulder. There is no social distancing in there. I think they should have made people test but get a better facility.

The Nome hospital did a wonderful job for travelers from outside the region and people traveling back into the region. Amy was in charge of COVID housing. If somebody travels to Nome and quarantines, she sets up the house and does the shopping; they had a drop-off process. The hospital really took care of a lot of people passing through to get home. Amy was very, very busy. Too busy. They were scrambling for housing.

COVID is going to linger, I think, because you cannot tell every single person to quarantine. What's the outcome going to be? How is this going to affect our lives two years from now? We don't know yet. Could it get worse? Yeah. Medical science is striving hard to prevent that. They're trying to learn from past history, like the Spanish flu. I don't know how many strains of that there was, but boy, it sure wiped out a lot of people from Alaska.

BRANDON AHMASUK

Brandon Ahmasuk serves as vice president of natural resources for Kawerak, Inc. He was born in Anchorage, raised in Nome, and later attended school in Oklahoma and Arizona before returning to Nome to work. He has three sons, who are ten, thirteen, and sixteen years old (figure 3.8). This conversation was held between Brandon Ahmasuk and Carol Gales via Zoom on March 30, 2021.

Watching the news and seeing how fast COVID spread, learning how fast people got sick, and that people were dying from it was my concern. I didn't know if the hospital in Nome was going to be prepared for it. I wasn't alive during the Spanish flu epidemic, but that is what COVID reminded me of. I was hearing the stories of what had happened, and even my old man was talking about how things used to be when people were dying left and right. I feel that the City of Nome and our state officials took COVID very, very seriously. There were travel bans put in place and quarantine requirements. I feel our region did pretty good trying to control the pandemic and keeping the spread of the virus down in Nome and across our region.

Our administration at Kawerak really looked out for all our employees. Kawerak allowed people to work from home because they didn't want to be the cause of spreading COVID. They were able to help where they could by providing us with laptops and internet. I feel really fortunate. Now we are allowed to go into our offices, but we still have to wear masks, social distance, and whatever we touch, we're supposed to sanitize. Kawerak has sanitizing wipes staged throughout the building.

I am one of those high-risk individuals because of my low immune system. It's been kind of hard, not being able to see friends and family, especially early on in the pandemic. You are able to text, or email, or call them, so that helped. I don't go out much. I share custody of my three sons. When they are here, we keep to ourselves for the most part.

I don't know how it is at school for social distancing. I know they are supposed to be wearing masks. To get away from all that, we decided to homeschool our boys. We thought they would shut school down if there was an uptick in people testing positive, and that happened. We just continued to homeschool. It's worked out great. There was such a high demand for homeschool products that it took maybe two and a half months to get all the supplies. But once we got them, my boys dove right in. Raven Homeschool provided us with instruction manuals, so we have something to reference.

I think my oldest son missed sports more than hanging out with his friends. Both my other sons want to continue to homeschool this next year. They like it more. They can sleep in until 11 a.m., do their homework for a few hours, and then be done

and go play or do whatever. My oldest son wants to go back to Nome-Beltz High School.

I am okay with wearing a mask. I used to be a pipe welder, and any time we had to do stainless steel we had to wear a respirator for basically twelve hours. Obviously, I wish I didn't have to wear a mask, but anytime I go anywhere, I have a mask in my pocket.

I was still able to do all my hunting and fishing during the pandemic. Subsistence activities fall right in with social distancing: getting out and getting away from everybody. We could be up at camp for weeks and not see anybody. I think this was a subsistence user's time to shine. I purchased a pressure cooker. I started jarring my own salmon.

Early on during COVID, especially when I was just by myself, I was playing a lot of video games in my off time. I did take up a hobby making knife sheaths (figure 3.9). I looked everywhere to find a leather sheath to fit this one particular knife I had. At one point I happened to do a Google search for knife sheaths and found this material called KYDEX. It's a plastic, but you can heat it up and it will form to whatever you need it to and hold its shape. I can hold this knife by the sheath itself, and the knife doesn't fall out. So I ordered a whole bunch more KYDEX. I actually have a press for it and a heat gun, so the sky's the limit on what I can make. That's one thing I took up.

COVID has been trying for everybody all over the world. When I watch the news, other places don't seem to take COVID seriously. To those people I would say, "Go visit the hospitals, where they are overloaded with sick people in beds and where they've had to move people out into tents in the parking lot. Go visit those places before you treat COVID like a joke, before taking everybody else's life in your hands."

FIGURE 3.8. Brandon Ahmasuk and son Wyatt boating near the mouth of the Sinuk River, where their family has a subsistence camp. Photograph courtesy of Brandon Ahmasuk.

FIGURE 3.9. Brandon Ahmasuk holds two of the knife sheaths he made from a special plastic while spending time at home during the pandemic in Nome. 2021. Photograph by Carol Gales.

39 MELISSA FORD

Melissa Ford moved to Nome from West Virginia in 1995 for a summer job and never left. She owns a local real estate business, operates a bed-and-breakfast, coaches the Nome Northstar Swim Team, and is on the board of the Nome Chamber of Commerce (figure 3.10). This conversation was held between Melissa Ford and Carol Gales via Zoom on April 2, 2021.

COVID became real to me in March 2020, when I realized we were going to be dealing with it here in Nome. I pretty much locked everybody down pretty tight in our house. I had two of my own children at home as well as my two grandchildren and two foster children. They are all between the ages of six and eleven, so we had a really full house through the pandemic. My oldest daughter, Jennifer, was our link to the outside world. Anything that needed to be picked up, she took care of because she was already being exposed to the public as an essential worker. She was not living with us.

It was a pretty scary time. We say bedtime prayers at night, and every single one of the kids have added to their prayer, "Please protect people from COVID," or, "We hope we don't get COVID," or some kind of COVID addendum. It is definitely something that affected everybody psychologically.

I was doing most of my work remotely because I am a realtor. I would open up a house for sale, then I would come outside and say, "Go in, have a look. Walk around." Around August 2020, I started having more normal interactions with my clients. We saw about a 25 percent reduction in moving. People typically move in the summer, when kids are out

of school. March through July, we saw absolutely nothing happening. But then in August and September, we saw a big flurry.

I am also a landlord. One of my big concerns was maintaining these houses and keeping my workers safe. I had to purchase a lot of extra equipment for my maintenance guys. We developed special procedures where the maintenance workers asked the people who lived in the house to please vacate the house or at least to gather in one room. We asked them to open windows. A lot of less-urgent maintenance things were let go.

I was really advocating for homeowners and for landlords to receive some of the City of Nome's COVID funding. We did get some extra funding for folks who are landlords. A couple people lost revenue immediately in March 2020 because they had some turnover happening at that time. Tenants that were supposed to move in couldn't come because of COVID.

Our swim team is at about forty kids. We do one big swim meet a year that usually happens in April. Almost the whole team goes because it's a really big deal. All of us had our tickets for 2020 and then, March 13, boom. Everything stopped in Nome. That

FIGURE 3.10. Melissa Ford's real estate business slowed dramatically during the first summer of the pandemic as travel restrictions limited people's desire and ability to move. Photograph by Carol Gales.

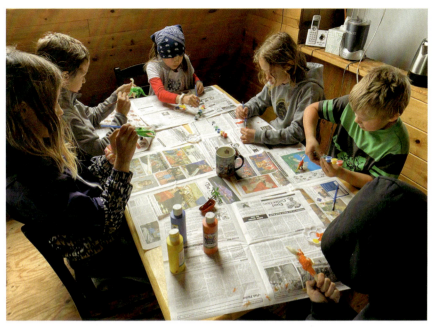

FIGURE 3.11. Melissa Ford's children, grandchildren, and foster children work on an art project together at home. Melissa decided to homeschool during the 2020–2021 school year as a COVID-19 precaution. Photography courtesy of Melissa Ford.

was a heartbreaker. The pool had to be closed and didn't reopen until February 2021. The first thing we did after we got our staff trained was reinstate the swim team. Just about every practice, somebody says, "When are we going to a meet?"

When COVID first happened, the school sent home boxes and boxes of paperwork. It was very user-unfriendly in my opinion. When August 2020 came and it was time to decide what we were going to do for school, I was really concerned about the potential to open, close, open, close. I didn't want boxes and boxes of random worksheets. We decided instead to go with Extensions Homeschooling out of Nome. I thought there would be a little more guidance than there was; it pretty much all fell on the parents. It really made me appreciate what teachers do. One of the cool things about homeschooling was we were able to create classes (figure 3.11). The boys decided they were interested

in gold mining. So we created a class where they got to explore different aspects of being gold miners. My daughter picked up a paintbrush and became quite the artist.

A lot of people are disturbed with the city's mask and travel mandates. Yes, it's inconvenient, and it's a pain in the butt. But in March of last year, we were staring down the barrel of some pretty devastating numbers if we didn't get control of what was going to happen. We buttoned up the town really well.

Even though we may not have been able to be face-to-face with each other during this time, we were still very much engaged with one another. Through the phone, through meetings, through just a general feeling of solidarity with each other. It sounds like it was a lonely, cold time, but there was a very lovely sense of community and fellowship that came from all this. I am just so proud of my community. I love this place.

40 ANNE MARIE OZENNA

Anne Marie Ozenna is originally from Little Diomede, where she worked for many years as a health aide. She moved to Nome in 2009 and took a position in the lab at Norton Sound Hospital before joining the Tribal Healer Program (figure 3.12). This conversation was held between Anne Marie Ozenna and Carol Gales in the Tribal Healer Program office at Norton Sound Hospital on April 6, 2021.

I first heard about COVID-19 on the news. I was keeping track of it, and then I got scared of it coming here. I thought, "Oh, no, it's time to go live at camp." I was imagining people dying left and right or getting sick. I started reading a little about the epidemics we had in this area during the early 1900s. I started wiping down doorknobs and light switches and keeping the kids at home. I was scared of getting COVID.

When COVID-19 came to Nome and the number of cases increased, our department stopped seeing patients. I went to the lab and helped them while they were short staffed. I would run over to the COVID "cave" to run the analyzers—the testing units. The COVID cave is in the operations building at the hospital where testing is done. Each patient had a swab, and we would run them.

In August 2020, I went to go shopping in Anchorage for my kids' school supplies. I tried to be safe; I don't know what happened. I drove all the way to Hope, Alaska, stayed there, and then went to Anchorage, shopped, and then came back to Nome. I had my COVID test, and it was negative. Then we went into quarantine. Maybe on the sixth or seventh day, my family went and had our second test, and that came back positive. I started feeling sick

maybe two days before I went and had the test. I had a runny nose, headache, and fatigue. Then maybe on the third day I was sick. Real sick. I had this shallow breathing, right here in my throat. I felt dizzy, light-headed, and was not eating.

I got scared. I became more scared when I realized that my daughter and my grandson had caught COVID too. Oh, my God. A couple of my other grandkids that came over to visit got it too. I was blaming myself, wondering, "What did I do to them? Why did I give them this? What are they going to think of me? What's going to happen?"

It was pretty tough. As I got worse, my body felt like I wasn't getting air. I had fever and sweats. When I couldn't handle my breathing and became more scared from it, I was admitted into the hospital for a couple of days. I just slept and slept. After I was discharged from the hospital, the difficulty breathing and fatigue lasted about maybe six or seven months. This is my second month not feeling sick and I'm like "Ooh, that feels good!" I am getting my energy back.

My girls were in eleventh grade this past year. They missed their teachers and friends. I didn't have internet, but now we do because we need it for

FIGURE 3.12. Anne Marie Ozenna sits at her desk in the Tribal Healer Program office at Norton Sound Hospital in Nome. 2021. Photograph by Carol Gales.

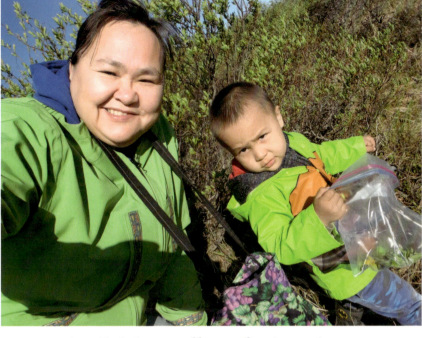

FIGURE 3.13. Anne Marie Ozenna and her grandson Avery enjoy some socially distant *sura* (willow leaves) picking during spring 2020 along the Teller Road. Photograph courtesy of Anne Marie Ozenna.

school. I try to keep my kids off that equipment and play outside, but this COVID really got kids stuck on doing things inside. They are doing stuff in the house instead of getting up like a regular teenager and wanting to be outside all the time. Things are clean, laundry folded, dishes done, lots of cooking. Lots of baking. I think COVID got them lazy; they are on their bed, on their phone, or watching TV. I got the girls started on sewing. That was good.

This summer, I spent a lot of time out on the Teller Road, berry picking, or looking for berries (figure 3.13). We were fishing, picnicking, and going to Teller. Every weekend. It was good. We realized how much we missed our Eskimo dancing and our Eskimo foods. I see a lot of people getting depressed from COVID. I fell into depression; I became a couch potato. Lazy. Depression is a quiet, quiet thing. I got real quiet.

We've been seeing patients at the hospital a little over a month now, since COVID numbers dropped. We have to wear a mask. We wipe everything down. I make sure the patient has had a COVID test before they come in or check to see if they are vaccinated. We didn't see very many people this year, but we're seeing them now and it feels good to be hands-on again.

I don't know if COVID's going to be over or if there's another strain coming. I'm worried about that. That's why I'm trying to move to a village maybe. I'm going to be more cautious. They say you will get it no matter where you are, but maybe I will go be at home in Diomede or over in Teller, with less people. I would be out in the country more, out boating, and doing that stuff. I don't know if it's over yet. I hope so.

41

JOSIE STILES

Josie Stiles lived in Anchorage until age ten, when her family moved to Unalakleet (figure 3.14). She moved to Nome in 1981 after high school. She has served as president of the Nome Arts Council and works for the State of Alaska's Legislative Information Office in Nome. This conversation was held between Josie Stiles and Carol Gales in Josie's office on April 8, 2021.

I had a roommate who was working for Alaska Airlines when everything started happening with COVID. She tried to come home one day and said, "I'm going to quarantine here for two weeks." I said, "No, you're not. You could have it. I could get it." She ended up going somewhere else and quarantining.

My boss shut us down right away in March 2020. I continued to come to work every day. I don't want to be home 24–7. I need that routine. I was glad the City of Nome scaled down Iditarod. I had a few friends who came to Nome and wanted to see me. I said, "I'm sorry. I'm not interacting with anybody. I just want to be home and be safe and not go where there are tons of people." That's when I started my own little bubble of people (figure 3.15). We all would take turns making dinner.

I got COVID in November 2020. I went outside of my bubble. It was my first time being invited over to this family's house for dinner. A few days later I got a call: "Somebody tested positive here; you need to go get tested." I had already started feeling sick. A few days later, I got really sick. It started with fifteen hours of throwing up. All I could do was to try and drink water so I would have something to throw up and not get dehydrated. The next day I felt a little

better. Then I started throwing up again the third day. Then I lost my sense of smell, my sense of taste. I had fever. I had chills. I had sweats. It ended with diarrhea. I was scheduled to go to the hospital and get a COVID test, but I was just so sick, I couldn't go anywhere. So they came to my house and swabbed me and brought me Tylenol and ibuprofen to take every three hours. After that I just rode it out. I was by myself this whole time.

I had fatigue really bad. I had no energy. I just stayed in bed. Friends would shop for me and drop off Gatorade and juice and Jell-O. I got so sick of soup! I spent Thanksgiving by myself. My daughter brought me a plate of food with turkey, and a friend brought me a pie. I really wasn't hungry. I forced myself to eat. I forced myself to drink water.

There were a few times when I found myself bawling. I was just not feeling very good. I think the worst part for me was being alone. I wish I would have had a companion or even a family member with me, but it didn't turn out that way. You don't want to infect anybody. You're quarantining. I felt really sick for about a week and a half. Then I just started feeling better. But even now I still have fatigue. I don't have as much energy. It's really

FIGURE 3.14. Josie Stiles is looking forward to traveling again and seeing her father after two years. Photograph courtesy of Josie Stiles.

weird. There's just so many unknowns. That's the spooky part.

I wish people would get vaccinated. I am floored that they could think they are so invincible, especially after what I went through. We are very fortunate in our region that a lot of people didn't die.

I think the city's response has been really good. I have been pleased with Norton Sound Health Corporation and their response, their vaccinations, and stopping everybody who comes in at the airport and testing them. Whether people like it or not, it's good for us because we catch it and treat it.

I want to go see my dad. He lives in Thailand. He's eighty-six years old now and has one lung. If he got COVID, he would probably die. He can't travel over here, and he hasn't been here for two years now.

FIGURE 3.15. Josie Stiles (left) at Airport Pizza in Nome with friends who were part of her COVID-19 bubble. Clockwise from upper left: Stephanie Ryan (who grew up with Josie in Unalakleet), Chandre Szafran, and Luisa Machuca. Photograph courtesy of Josie Stiles.

Usually, he comes every year. So I'm looking forward to seeing him.

I got vaccinated in January 2021. I have moved on. I'm not going to live in fear. I've lived in fear enough. The pandemic has been horrible. It's been long. It's been crazy. It's something I hope we never have to go through in our lifetime again.

42 MIKE HOYT

Mike Hoyt taught history, government, and philosophy at Nome-Beltz High School and served as assistant coach for the boys' high school basketball team during the pandemic. Mike was born and raised in Portland, Oregon, but most of his family is from Wrangell, Alaska, while his maternal grandfather is from Diomede. He moved to Nome with his wife, Meghan Topkok, in 2018 (figure 3.16). This conversation was held between Mike Hoyt and Carol Gales via Zoom on April 11, 2021.

Students were kind of skeptical of COVID at first. I was hearing this frustration of "It's only a couple of people in the hospital. Why is this impacting us?" I tried to explain to them, "Well, these things have happened in the past and they have had hugely devastating impacts." When things first shut down, I think the sense was "Okay, this is just kind of an extension of spring break and we'll be back soon." But as it dragged on, students started to realize, "This is serious. This is a lot harder than we were expecting it to be."

There were a lot of questions about what we were going to do as a school. To try to do everything online doesn't really work in Nome, because internet is so spotty. So we started working with paper packets, scanning the material, as well as assignments. Every Monday you would get thirty or forty packets ready, drive out, and deliver them to students. The route I was mostly doing was out toward Dexter. Seeing students really helped remind you why you were doing all of these precautions. The students were kind of starving for social interaction. If a certain student wasn't doing a whole lot of their schoolwork, the person dropping off the packet might do a check-in with that student. There

was a lot of calling home, calling parents, emailing, trying to see what we could do to bridge that gap.

We set up schedules where classes would meet virtually a couple times a week during what was usually our first-period class, second-period class, and so forth. Some students would call in, some would be online, and some would turn in paper packets without doing either one. Probably a third to half of the students were consistently getting their work done. The rest more or less kind of dropped off and didn't have a lot of contact or communication with the school in terms of getting work back to us.

For the 2020–2021 school year, we had a three-stage plan: red, yellow, and green. Green was essentially in-person classes, but there were a lot of modifications involved: temperature checks at the door, masks or some kind of face covering had to be worn, hand sanitizer everywhere, and wiping things down between classes. Yellow was sort of in-between, some online and some in-person classes. Going red was no in-person meetings at the school. We had an incident where we switched to red for the first week of school and then went back to green and stayed like that for the majority of the year.

We spaced the desks out as far as we could, more or less six feet apart. So much of educational philosophy today emphasizes cooperative learning and working as groups. Going from that to everybody sitting in a line, in their own desk, with no interaction, and everybody facing forward, it just felt so backward to all of us.

I remember at one point almost a month into the school year, one of my eighth graders took off their mask to take a drink of water. When they put their mask back on, I thought, "That's the first time I've seen that student's face." It's such a weird idea because it's such a human thing, to see somebody's face.

It was frustrating to constantly have to work all these extra things into teaching. You're trying to focus on whether they understand the topics we are covering, and then there's this other stuff in the back of your mind like "Oh, hey, wear your mask properly" (figure 3.17). You make a mental note of whatever the students touch to wipe it down—tables, chairs, pencils. We have five minutes between periods and having to wipe everything down, while trying to make sure you have enough printed material and all of these other things going on—it was a very exhausting teaching year.

I teach government, so I ask my students a lot of questions about "What is the government's response to the pandemic? What is the school's response? What are we supposed to expect from other people in our society? Is the vaccine an infringement on people's rights? Or do we accept that we have some responsibilities to each other if we live in a society together?" As someone that teaches history, and especially Alaska history, I've placed a big emphasis on epidemics in the past. This is definitely going to be in the history books. So then we started asking questions: "How do we tell that story? Who gets to tell that story? What do we include in that story?" It makes the idea of studying history a little more engaging for students.

FIGURE 3.16. Mike Hoyt stands in the historic home he shares with his wife, Meghan Topkok. The two were able to tackle some home renovation projects during the pandemic. 2021. Photograph by Carol Gales.

FIGURE 3.17. Mike Hoyt (wearing a tie) looks forward to a time when he won't have to remind the high school basketball team to properly wear their masks. 2021. Photograph courtesy of Mike Hoyt.

43

MARY RUUD-POMRENKE

Mary Ruud-Pomrenke was born and raised in Nome. She earned a two-year nursing degree through the University of Alaska Anchorage School of Nursing distance program and works at Norton Sound Regional Hospital. She and her husband, Dylan, welcomed their first child, son Otto, on March 29, 2021 (figure 3.18). This conversation was held between Mary Ruud-Pomrenke and Carol Gales at the home of Mary's father, Marty Ruud, on the side of Anvil Mountain, on April 13, 2021.

When I first heard about COVID, I didn't think it would hit Nome or Alaska that bad. I work in the emergency room as a nurse, and around Iditarod last year we started talking about "Do we need to start taking precautions?" We started wearing masks full-time with patient care. Everyone was worried about what would happen if COVID got to the villages.

If you work in a hospital, you're within six feet of patients all the time. Just getting ready to do patient care and taking care of your patients was a big challenge. It was a challenge to get patients to wear masks, and then get them to wear them properly over their mouth and their nose; that's still a struggle.

We had a separate room at the hospital—we called it our COVID room—for patients who had symptoms like coughs, fevers, chills, diarrhea, and loss of smell or taste. Only nurses had access to the room. We would go in wearing full PPE [personal protective equipment], a gown, a mask, a face shield. That's where we would perform rapid COVID tests. If they had a negative test, we could move them into the ER and continue our routine with patient care.

I was going with the flow at first, but then I got pregnant. Pregnant ladies have a compromised immune system, so I was a little more cautious. I tried not to take high-risk patients. I tried to work the desk as much as I could and limit patient interaction, but I was always there if needed. I always wore a face shield and a face mask.

We traveled to Anchorage on March 9, 2021, to have our baby. Usually, you can have as many people as you want to help coach you through delivery. But with COVID, it was strictly just one person. So Dylan and I toughed it out by ourselves. Dylan was on the phone probably at least once an hour calling his mom, calling my mom, calling my sister Teri. Just giving updates and then asking what to do. "She's screaming in pain. Is this normal? What do I do? What do I say? How do I talk to the doctor? How do I talk to the nurses?"

Dylan was a great support person. It was hard to do it alone, just him and me. But we made it through. We had a difficult labor and had to stay in the hospital three days; usually it's a day or two. We weren't allowed in the hallway to walk around, and family members couldn't come in either. It's made our relationship a lot more tight-knit, and I think we learned a lot about each other. I'm just really thankful that I had him.

FIGURE 3.18. Dylan and Mary Ruud-Pomrenke cradle their new son Otto. Because of COVID-19 restrictions at the hospital, Mary was allowed just one coach in the delivery room, and Dylan filled the role. 2021. Photograph by Frose Photography.

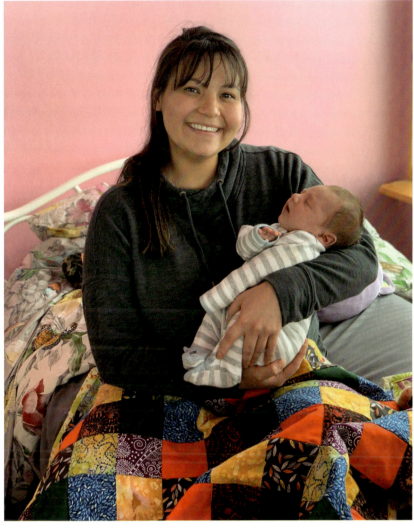

FIGURE 3.19. Mary Ruud-Pomrenke smiles with her son Otto and the baby quilt she learned to make by consulting internet videos during the pandemic. 2021. Photograph by Carol Gales.

We were supposed to have a big outdoor wedding on the Kuzitrin River in August 2020. That July we decided to postpone the wedding because it would have been impossible for family members to fly all the way up to Nome. Quarantine was in effect, and we didn't want to risk anyone traveling, contracting COVID, and then also bringing it to Nome. We got married on January 21, 2021, out here on our property, on Anvil Mountain, with our parents and siblings who could make it and a couple of friends. Fifteen people total. It was very intimate.

Nome is rural and small and isolated. I think the pandemic made it feel more that way. It was hard for people to be unable to do activities like sports events and school functions and all the craft fairs. I've talked to some people who have developed depression or a lot of sadness and just a lot more isolation from being stuck at home.

I did a lot more sewing. Even though it's a hobby, it became less fun during this time because it's all I could do. I made my parka and ruff and a sea otter headband for my wedding. I made Dylan a white hunting jacket for springtime. And I made a baby quilt (figure 3.19). I'm not a quilter, but I did that, and it was hard, and I'm never going to do it again!

I look forward to traveling more again and being able to introduce my baby to all my friends and family who are so eager to meet him. But I'm still on the fence about bringing him around. We're staying home for now and waiting for more people to be vaccinated or for it to be over so we can introduce him to the world.

44 HOWARD AND JULIE FARLEY

Howard Farley spent two years in Nome with the US Coast Guard in the early 1950s, then made a permanent move from Detroit, Michigan, to Nome in 1959. Soon after, he met and married Julie Kunnuk, a skilled sealskin sewer, who was born on King Island and relocated to Nome with her family when she was eight (figure 3.20). The Farley family are commercial fishermen and operate Farley Marine, a pilot boat for large vessels coming into the Port of Nome. This conversation was held between Howard and Julie Farley and Carol Gales at the Carrie M. McLain Memorial Museum on April 15, 2021.

HOWARD: The director of the World Health Organization came out and named this a pandemic. I think if he hadn't named it a pandemic, it might've had a different outcome. He told the whole world: we have a pandemic, and it's going to affect everybody. The flu, which is common, is probably more of a problem. I think it just got out of hand. We all received information, and it just kept flowing. Now I have got to the point where I am absolutely confused about what they are getting at. Confusion is the thing that I have found depressing.

JULIE: We had a couple of people over for lunch, and that weekend they came over again for dinner. Then our son Harvey had an appointment at the hospital, and he came back and he says, "They told me I had the virus." He said, "You should go get tested." So we went to the hospital, and we both tested positive. Howard had mild symptoms. I had it bad. It started with a dry cough. Then I started getting cold; I was so cold. I couldn't eat anything except ice water. The phlegm in my mouth was always there. It got to a point where I didn't eat anything. Just water, just ice. I didn't like the taste of coffee or wine. I went through a whole month without those drinks because they tasted horrible.

While I had the virus, I lost fifteen pounds. I had diarrhea really bad. I don't know if I was scared or not, because I didn't believe in the pandemic. I didn't believe in the virus. I kept telling Howard, "It's a hoax, Howard." Because nobody died in our immediate area. To me, it was a hoax, until I got it. If you hear of an epidemic, you think, "Oh, they're going to die. Some of our friends are going to die."

HOWARD: We didn't lose any friends. If you compare the total population to the amount of deaths, it's still very, very minor. But the problem is they went down that road. The only thing good about the virus is it led to a vaccine. Now we've got a debate on the vaccine. There's people that don't want to get the vaccine. We chose to have it. We didn't have any reason not to.

JULIE: When they said that you had to have the vaccination in order to travel, we went and got vaccinated. I said to Howard, "What number did you get?"

HOWARD: There are people that believe they have been vaccinated with a number. Julie believes that. I don't believe it for a minute.

JULIE: I think city officials did the right thing at the time, when it started. But they kept on and on and on. I think they went a little overboard with precautions. But I think people got used to it. It's a propaganda thing. It's a way of life now, what we have gone through. But I hope we get out more and see other people without masks, and have family gatherings.

HOWARD: It has gone way, way beyond where it should have gone. There has to be an end to it. It has affected the economy. It has put people out of business. And it's put people out of work. I think it could have been over a long time ago.

JULIE: More and more people are coming out. Feeling better and looking better. They are happy to be returning to semi-normal lives. I am just amazed at how people came through with their little activities and festivities here in Nome. Like their basketball games—we couldn't go over and watch them, but they had games with their masks on. There were snowmachine races and dog races in between the storms (figure 3.21). I think that was good. It gave you hope for the future.

HOWARD: People still talk about the 1918 flu. This is the way they will be looking at this when the same time goes by. It will go one of two ways: those people were fools, or they did the right thing. Time will be the test.

FIGURE 3.20. Howard and Julie Farley hold their 2021 Historic Preservation Award from the Alaska Preservation Society for their lifetime dedication to the Iditarod Trail Sled Dog Race and preservation of their historic home in Nome. Photograph by Jessie Lynn Campbell. *Courtesy of Howard and Julie Farley.*

FIGURE 3.21. Young mushers gather on the snow for sled dog races as part of the 2021 Nome Winterfest, which took place in lieu of traditional Iditarod activities not held due to the pandemic. Photograph by Amy Phillips-Chan.

PART 4
Poems

Historic amounts of rain fell over Nome during the summer of 2021, but the rough weather did not dampen enthusiasm for *Stronger Together: Bering Strait Communities Respond to the COVID-19 Pandemic*. Focus turned to editing interview stories, gathering photographs and permissions, and reviewing materials with contributors. As the manuscript began to take shape, a noticeable absence of written artistic expression appeared within the conversation. The Bering Strait region is recognized for its traditional crafts and visual arts, but there are also skilled masters of the literary arts, including children's authors, journalists, and poets. In November 2021, museum director Amy Phillips-Chan reached out to several accomplished poets with ties to the Bering Strait region. Each writer was invited to create a commissioned piece of work that expressed ideas related to the pandemic.

Part 4 features the poetry of three Alaska Native female authors who currently make their homes in Nome, Alaska; Maple Valley, Washington; and Cambridge, Massachusetts. Each author is introduced by a short biography that includes references to their published works. Portrait photographs submitted by the authors accompany each poem. Poems are presented in their original structure and rhythm. The written works speak to constructive responses to social stresses, the timelessness of personal loss, and Indigenous knowledge lessons.

(*opposite*) A bucket of late-season blueberries and lowbush cranberries rests on a blanket of crowberries outside Nome in September 2022. Photograph by Amy Phillips-Chan.

45

CARRIE AYAGADUK OJANEN

Carrie Ayagaduk Ojanen (Inupiaq) is a writer from the Ugiuvamiut (King Island) tribe (figure 4.1). She is the author of Roughly for the North *(2018), a collection of poems that weave a moving portrait of grief, of resilience in the face of adversity, and of respect for the Alaska Native traditions in which she grew up. Ojanen received her MFA from the University of Montana and currently resides with her family in Maple Valley, Washington. "Pandemic within" speaks to personal loss during the COVID-19 pandemic and was submitted by Carrie Ayagaduk Ojanen on December 20, 2021.*

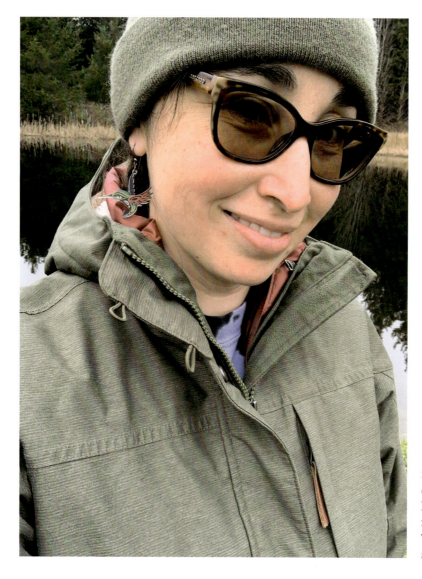

FIGURE 4.1. Carrie Ayagaduk Ojanen enjoys connecting with the lush lakes and meandering rivers surrounding her home in western Washington. Photograph courtesy of Carrie Ayagaduk Ojanen.

Pandemic within

there exists a concurrence,
simultaneity, parallel catastrophe
I create an edifice
word by word to protect you
from the brunt of it

time becomes relentless

it goes out from us forever
a barrenness
our ancestors spoke of it
the great catastrophe—
the year without summer—
has come again. forever

unfolding
time becomes relentless
she was the future—
the green branch growing—
the comfort of our collective family feeling—
hope—

where is the coming of summer
where does the bright green
syrah[1] fill
the dark
willow bud and burst
against the brown red
landscape
instead there is desolation

footsteps lead out on the ice
there is the end
we wait now, forever, for her to bloom
to show us our way forward

how do we make our way
time becomes relentless

we begin to understand this new catastrophe

life without summer
time becomes relentless

the sun shines and holds no warmth
the wind scours the earth
the bare branches shiver against the endless
 snow

I am waiting for the right words
I am waiting for my cousin to come

you can tell me how blunt I should be
somebody take the lyric from me

I thought I could write this
but my heart is broken

time becomes relentless

we experience this simultaneously
locked away in our respective boxes
unable to reach each other
unable to reach her

this is a poem I didn't ever want to write
this is a fight I didn't ever want to fight

where is our summer
where is our summer
our beautiful, beautiful girl

time becomes relentless

1 *Syrah* or *sura* refers to new willow leaves harvested during
 spring in the Bering Strait region.

MARIE TOZIER

Marie Tozier (Iñupiaq) has devoted much of her life to passing down traditional skills and ways of knowing (figure 4.2). She can show you how to butcher a seal. She leads classes in sewing, quilting, knitting, qiviut processing, and writing at the University of Alaska Fairbanks Northwest Campus. She is the author of the rich poetry collection Open the Dark *(2020). In her poem "Qiniiluataqtuna Ilipsiiniinun!," Tozier pushes back against systemic attempts to obliterate all things Native, making room for cultural traditions of health and healing. She lives in Nome with her beloved husband, Tok, and their children. This poem was submitted by Marie Tozier on December 17, 2021.*

FIGURE 4.2. Marie Tozier composes poems of subsistence, hardship, and celebration that spring from the tundra, from rural life, and family life. Photograph courtesy of Marie Tozier.

Qiniiluataqtuna Ilipsiiniinun![1]

My grandfather shared a story from his youth.
As a boy, he lived in a sod house with his
 parents,
Siblings, and his grandmother. He grew up
Wearing cotton pants and sealskin mukluks.

His cloudy eyes would wander, when he
 recalled
Falling from his bunk one night. He swore
That his life was saved by his mother, Nellie,
And her love. "My mama nursed me," he said.

"Stayed beside me and fed me broth." He would
 tell us
Many times, that a soup made from boiled
 Ptarmigan
Could nurse anyone to health. I wonder
What he would make of Covid.

What would a man, who grew up
Without his natural, first language—silenced
By the intimidation of not succeeding—what
 would he think
Of today's mask mandate?

Of a cloth that covers up who you are? A mask
That makes us all the same. Takes us from
 individual
To homogenized mass. Strips us of our natural,
 first instincts
To make contact, to smile.
I suppose, as a people known
For non-verbal communication, it might be
 easier.
Inupiaq: using our eyes
To find humanity.

1 *Qiniiluataqtuna Ilipsiiniinun* means "I'm happy to see you!"
 Translation by Josie Tatauq Bourdon

47 JOAN NAVIYUK KANE

Joan Naviyuk Kane (Inupiaq) is from Ugiuvak and Qawiaraq (figure 4.3). The author of nine collections of poetry and prose, she was selected as a Fulbright Specialist for 2023–2026 and recently received the 2023 Paul Engle Prize. Forthcoming in 2024 is her edited anthology Circumpolar Connections: Creative Indigenous Geographies of the Arctic, *as well as an essay collection,* Passing through Danger. *Kane served as a Harvard Radcliffe Institute Fellow and a Mellon Fellow at Brown University in the early part of the pandemic. She has since held teaching positions with Scripps College, Tufts, Harvard, and the Institute of American Indian Arts. She currently raises her children in Oregon, where she is a visiting associate professor at Reed College. This poem, titled "Turning Back," was shared by Joan Kane on April 22, 2022.*

Turning Back

I wished to be closer to my mother
to think of displacement in a different way.

To part the bright green new growth
of a plant she has asked me to gather.

We never imagined so many years apart.
I have no way to make amends.

Set adrift, I wanted to stay near the shore
of something familiar but instead I trace

the memory of *tuqqayuk*, sea lovage,
with something other than my tongue.

I wish for my family to be its own refuge,
for the sorrow to become something islandic.

Someplace we can travel back to together
if we have to, if we make it through these days.

FIGURE 4.3. Joan Kane speaks to absence and reunion in *Turning Back*, written after having returned to Alaska for the first time in three years to see her mother during the spring of 2022. Photograph courtesy of Joan Kane.

SPANISH INFLUENZA TIMELINE, 1918–1919

A note on sources: Information presented below was primarily culled from the Nome Tri-Weekly Nugget *from 1918 to 1919. Additional information was located in the Annual Reports from Wales, Council, and Shishmaref submitted to the United States Bureau of Education in 1919.*

SPANISH INFLUENZA 1918

Sept. 13	Dr. Daniel Neuman advises mail from the *SS Victoria* be fumigated before distribution in Nome.
Oct. 9	Dr. Neuman telegraphs Seattle to inspect passengers and crew of *Victoria* for exposure to influenza before sailing to Nome. Three passengers removed.
Oct. 20	*Victoria* arrives in Nome roadstead slightly delayed from having to let off a crew member with influenza at Port Townsend. Dr. Neuman marches *Victoria* passengers from the Nome beach to Holy Cross Hospital to be quarantined. All mail brought ashore and fumigated.
Oct. 21	As a precaution against influenza, schools in Nome close for 2 weeks, Dream Theater closes for 5 days, Fort Davis put under strict quarantine, and public gatherings banned until all danger has passed.
Oct. 25	*Victoria* passengers released from Holy Cross Hospital due to absence of influenza symptoms. A sick crew member identified as suffering only from tonsillitis. Quarantine lifted from Fort Davis, and Dream Theater reopened.
Oct. 28	*Victoria* leaves Nome for Seattle with close to 700 passengers. Crew member George Lablian reported very ill onboard with a "bad cold." Mrs. Leonhard Seppala reported ill with "pneumonia" in Nome and taken to Maynard-Columbus hospital.
Oct. 29	William Bailey, enlisted man at Fort Davis, named as first Nomeite to contract Spanish influenza. Bailey thought to contract disease from tending to heating plant at Holy Cross Hospital when *Victoria* passengers were in quarantine. Precautions reinstated: Fort Davis put under quarantine, Dream Theater closed, church services and other public gatherings prohibited.
Nov. 1	Influenza begins to rage through Nome, with some of the ill comprising the Nome Coast Guard crew and captain, an Alaska Native family of 11 living on the Sandspit, and *Nugget* newspaper staff.

Nov. 4	200 cases of influenza reported in Nome and Fort Davis. 21 patients with influenza in Holy Cross Hospital. Dr. Neuman taken ill with influenza leaving Dr. Henry Burson, surgeon at Fort Davis, to look after everyone. Dr. Burson coaxes Dr. A. N. Kittleson out of retirement to assist him during the emergency.
Nov. 11	*Victoria* arrives in Seattle after a harrowing journey from Nome in which influenza spread to over 90% of those onboard. Thirteen people died en route. The death list of passengers who traveled aboard the ship reaches 34 by the end of November.
Nov. 12	Influenza reported at Cape Woolley, Sinrock, Cape Nome, Council, and Candle. Death list of white residents at Nome and Fort Davis climbs to 17. An estimated 150 Alaska Native peoples in the Nome area are reported dead from influenza. Sons of the North turn their building over to the care of Alaska Native orphans and families. Holy Cross and Maynard-Columbus Hospitals are full.
Nov. 14	Announcements in the *Nugget* prematurely assert that the worst of the epidemic is over.
Nov. 15	First influenza cases appear at Wales, but residents are unable to send a message to Nome or Teller, due to the absence of a wireless telegraph system. Almost all of Wales becomes sick within a week, and 170 people perish out of a population of 312.
Nov. 18	Influenza reported at Solomon and Bluff. Pioneer Mining Company manager Louis Stevenson and his crew are digging a trench 200 feet long set 300 yards back from the Snake River for the burial of 175 Alaska Natives who succumbed to influenza.
Nov. 20	Influenza reported at St. Michael. Nome residents form a Citizens Health Committee to enforce sanitary measures across town.
Nov. 22	Influenza reported at Mary's Igloo. William Webb's automobile put into service transporting medicines, supplies, and people from surrounding villages.
Nov. 25	Citizens Health Committee tasked with rounding up stray dogs that belonged to deceased Alaska Native families and put down 90 dogs in Nome. Kotzebue Sound reports men with guns guarding the outer section of every camp to enforce the strict quarantine.
Nov. 27	Influenza reported at Penny and Cripple Rivers, Chinik, and Golovin.
Dec. 2	Joe McArthur and Thomas Jensen arrive in Teller and report the town is in "death grip" of influenza. Jensen hurries on to Wales with gravest fears that influenza struck the village. Additional Nome volunteers travel to Teller with clothing and medical supplies.
Dec. 4	Mining is suspended in Nome district due to lack of workers in a healthy physical state. Incoming and outgoing mail for Nome and Second District halted. Three Alaska Native mail carriers have died from influenza while making deliveries. First relief party reaches Wales.
Dec. 6	Nome fur traders worry there will be no winter catch due to death of Alaska Native hunters. Additional volunteers travel to Wales with supplies in case village has been overtaken by influenza.
Dec. 13	Alaska Native deaths in Nome and the surrounding district rise to 630.

Dec. 16	Death toll at Mary's Igloo reaches 68, and the government school is converted into a temporary orphanage.
Dec. 20	First report reaches Nome of influenza striking Wales and decimating the community. Bureau of Education reports they are caring for 250 orphaned children between Nome and Wales.
Dec. 25	On Christmas Day, the howl of huskies on the tundra rings like a steam siren across barren Front Street.

SPANISH INFLUENZA 1919

Jan. 1	A quiet New Year's Day in Nome is marked by a short blast of the fire whistle at midnight.
Jan. 3	Bureau of Education transfers care of 90 orphans at Holy Cross Hospital over to the Lavina Wallace Young Native Mission and the Catholic Church.
Jan. 6	Quarantine lifted at Nome. Mushers and mail permitted to move between all points where epidemic has visited. Elementary and high school classes resume at Nome Public Schools. All students examined by Dr. Neuman.
Jan. 10	Strict quarantine at Shishmaref has kept the influenza out, but Alaska Native hunters have not been able to secure furs with which to purchase food. Nome makes plans to send emergency supplies to Shishmaref.
Jan. 13	Two public school teachers in Nome sick with influenza. Parents raise fears about mixed-race students attending public school.
Jan. 27	The winter of 1918–1919 is reported the coldest on record for Nome with temperatures below −50°F.
Feb. 10	Mail can now be moved along all routes of the Seward Peninsula. Mail carriers required to wear masks made of eight folds of cheesecloth upon approaching anyone within twenty feet.
Feb. 24	Dream Theater offers a special moving picture show for almost 90 Alaska Native orphans in Nome.
Mar. 3	National Red Cross appropriates $10,000 for the relief of Alaska Native influenza victims.
Mar. 10	Dora Kudlucy (Inupiaq) dies by suicide in Nome from what appears to be post-traumatic stress after seeing so many people die from influenza in Wales.
Mar. 12	Report reveals the western coast from Nome to Port Clarence almost absent of Alaska Native peoples. Old villages deserted and only a handful of people living in communal groups.
Mar. 21	Community members in Wales insist to government officials that orphans belong to their village and should not be taken away. Orphans in Wales remain and are cared for by survivors.
Apr. 4	Alaska Native families from Wales and villages east of Solomon begin to return to Nome to buy supplies and sell meat and fish for the summer.

COVID-19 PANDEMIC TIMELINE, 2020-2021

*A note on sources: Information shared below was disseminated through the
Nome Nugget newspaper, City of Nome public service announcements,
Nome City Council meeting minutes, and Norton Sound Health Corporation
press releases. Additional information was located on social media pages
hosted by local organizations and schools in the Bering Strait region.*

COVID-19 PANDEMIC 2020

Jan. 30	Nome agencies begin to plan for potential arrival of the coronavirus, a novel virus that originated in the Chinese city of Wuhan in December 2019.
Mar. 12	First active case of COVID-19 is reported in Alaska. Nome City Council holds a three-hour special emergency meeting to discuss the COVID-19 threat in relation to incoming visitors for the Iditarod Trail Sled Dog Race and the Lonnie O'Connor Basketball Tournament. Council determines to close the Nome Recreation Center, Richard Foster Building, swimming pool, Nome Visitor Center, and Old St. Joe's Hall. The basketball tournament is postponed, and the Iditarod Arts & Crafts Show is cancelled.
Mar. 17	Nome City Council approves an emergency ordinance to address the COVID-19 pandemic. City manager authorized to direct use of city resources, close facilities, regulate public accommodations, and institute travel restrictions.
Mar. 18	Norwegian musher Thomas Waerner is the first to cross the finish line in Nome and wins the 48th Iditarod Trail Sled Dog Race. Due to COVID-19 precautions, few spectators gather on Front Street to welcome sled dog teams. Mushers and their support crew are quickly transported out of Nome.
Mar. 23	Nome city manager Glenn Steckman and mayor Richard Beneville announce a series of emergency orders due to rising COVID-19 case numbers in Alaska. Air travel to Nome is limited to critical infrastructure personnel, mandatory travel permits are issued, and Alaska Airlines drops passenger flights to Nome to once a day. Trips to Nome grocery stores are limited to two visits a day, and hours are reduced for alcohol and marijuana establishments.
Mar. 30	Nome Public Schools transition to distance learning due to the COVID-19 pandemic.
Apr. 14	The first positive case of COVID-19 is confirmed in Nome.
May 11	Business owners push back against travel restrictions and extension of the COVID-19 emergency ordinance as tempers flare during a Nome City Council meeting.

May 15	Nome City Council votes to extend the local emergency authorization order. Limited visits to the grocery stores and reduced alcohol and marijuana hours are lifted. A penalty of $500 is instituted for violation of any emergency order, including refusal to follow a quarantine period after travel through Anchorage.
May 21	Nome-Beltz High School recognizes its graduates with a parade through town and a socially distant outdoor ceremony in the high school parking lot. Graduates walk single file across a stage and receive their diplomas from the end of a fishing pole.
May 22	After more than a month without any cases, Nome sees its second and third cases of COVID-19. Two employees of Norton Sound Health Corporation test positive for COVID-19, and NSHC shuts down all Nome facilities for four days of cleaning and testing staff.
June 4	Alaska governor Mike Dunleavy proclaims all businesses can reopen to the public on May 22. Nome businesses gradually open up with face mask requirements and a range of in-person and take-out order options.

| **July** | **11 COVID-19 cases in Bering Strait region: 3 in Nome, 3 in Teller, 4 in unidentified villages, and 1 of a resident traveling outside the region.** |

| July 2 | The City of Nome receives $5.68 million in federal CARES Act funds aimed to provide financial relief for individuals, businesses, and governments negatively impacted by the COVID-19 pandemic. The Nome City Council votes to distribute the first installment of CARES Act funds through a utilities credit, artisan grant, and upgrades to city infrastructure. |
| July 4 | Nome celebrates a subdued Fourth of July with a parade, patriotic program, and street games with a smaller crowd and shorter series of events. |

| **Aug.** | **20 COVID-19 cases in the Bering Strait region: 9 in Nome, 3 in Diomede, 2 in Unalakleet, 1 in Stebbins, 1 in White Mountain, 1 in Savoonga, 1 in Gambell, 1 in an unidentified village, and 1 of a resident traveling outside the region.** |

Aug. 6	The Nome City Council votes to distribute a second round of CARES Act funds through grants to businesses and nonprofit organizations that suffered financial losses due to the COVID-19 shutdown.
Aug. 18	Alaska holds its primary elections with the option to vote either absentee by mail or in person. A record number of absentee ballots are issued for the Bering Strait region, and more people vote in person at Old St. Joe's Hall in Nome than in past primary elections.
Aug. 25	Nome Public Schools open in the "green" zone, with a minimal number of COVID-19 cases that allow students to attend in-person classes. Bering Strait School District schools open in the "red" zone, with student instruction delivered through a distance learning program.

| Sept. | **22 COVID-19 cases in Bering Strait region: 3 in Nome, 6 in Gambell, 4 in Stebbins, 2 in Unalakleet, 3 in unidentified villages, and 4 of residents traveling outside the region.** |

Sept. 17 — The *Nome Nugget* reports on tribal organization responses to the COVID-19 pandemic. Nome Eskimo Community receives $1 million in CARES Act funds to extend existing programs and create the Coronavirus Emergency Financial Assistance Program for tribal members. Kawerak, Inc. receives close to $6 million in CARES funding for tribal members and launches the AK Can Do program and COVID-19 Income Loss Support Program.

Oct. — **80 COVID-19 cases in Bering Strait region: 6 in Nome, 25 in Gambell, 42 in Stebbins, 1 in Savoonga, 1 in St. Michael, 1 in an unidentified village, and 4 of residents traveling outside the region.**

Oct. 8 — Over 30 positive cases of COVID-19 are confirmed in Gambell, making it the first site of a COVID-19 outbreak in the Bering Strait region. A strict curfew is instituted, and food and water are delivered to affected households so they can remain in isolation. All positive cases are eventually able to recover leaving the community COVID-free.

Oct. 13 — Stebbins see another outbreak of COVID-19, with 18 confirmed cases. Stebbins leadership issues an order to "hunker down" requesting that people stay inside their homes and refrain from visiting other households.

Nov. — **84 COVID-19 cases in Bering Strait region: 50 in Nome, 22 in Stebbins, 3 in Golovin, 2 in Shaktoolik, 1 in Unalakleet, 1 in Elim, 1 in Savoonga, 1 in St. Michael, 1 in an unidentified village, and 2 of residents traveling outside the region.**

Nov. 26 — Nome experiences its first major outbreak of COVID-19 after a case at a bar leads to a surge of 50 active cases in just a few weeks. The Nome City Council votes to shut down bars and restaurants, other businesses, and organizations across the city close, and community Christmas celebrations are cancelled.

Dec. — **55 COVID-19 cases in Bering Strait region: 55 in Nome.**

Dec. 15 — The Nome City Council extends an emergency ordinance effectively closing all bars and restaurants to in-person service. Taxicabs are limited to transporting one household at a time, and gatherings in public spaces are limited to 10 or fewer people with the exception of grocery stores.

Dec. 16 — Nome receives its first doses of the COVID-19 Pfizer vaccine, and Norton Sound Health Corporation begins to administer doses to residents and staff of Quyanna Care Center. The Moderna vaccine arrives a week later, and NSHC begins sending vaccination teams to regional villages to vaccinate clinic staff and Elders.

Dec. 18 — The Iditarod Trail Committee announces the 49th Iditarod Trail Sled Dog race will follow an alternative course due to the COVID-19 pandemic and will not come to Nome for the first time in race history.

Jan. 4	Most schools in the Bering Strait region return to in-person classes after the Christmas break. Nome opens in the "green zone," with mask wearing and regular testing in place.
Feb. 19	The week closes without any new cases of COVID-19 in the Bering Strait region for the first time since June 2020.
Mar. 6–20	The Iditarod Trail Sled Dog Race does not end in Nome for the first time since the race's inception in 1973. In lieu of Iditarod events, Nome hosts a Winterfest, with two weeks of family-friendly activities that include fat bike and cross-country ski races, dog mushing races, a virtual art show, and a snow sculpting contest.
Apr. 30	Alaska's lieutenant governor Kevin Meyer and Bill Thomas, the governor's special assistant for Southeast Alaska, travel to Nome to learn how the cruise ship–related tourism industry fared during the pandemic.
May 21	The first appearance of the COVID-19 Gamma (P.1) variant is identified in three closed cases in Nome.
May 24	Norton Sound Health Corporation makes official COVID-19 vaccine record cards available to prove full vaccination.
May 26	The Nome-Beltz High School graduating class of 40 students parade in decorated trucks through town and then participate in a COVID-19 safe outdoor graduation ceremony for the second year in a row.
Aug. 9	Norton Sound Health Corporation medical providers and state epidemiologists assert that most, if not all, recent cases of COVID-19 in the Bering Strait region are the Delta variant, first identified in Alaska on May 30, 2021.
Aug. 19	Cases of COVID-19 surge across the Bering Strait region. Stebbins and St. Michael experience community outbreaks and go into lockdown mode until no new cases are identified for 14 days.
Aug. 23	The US Food and Drug Administration gives full approval to the Pfizer BioNTech COVID-19 vaccine for individuals ages 16 and older.
Sept. 27	Nome City Council votes for the fifth time to extend a COVID-19 emergency ordinance that gives the city manager authority to utilize city staff and buildings as needed and control movements of people in and out of Nome.
Oct. 13	More than a year and a half into the pandemic, the Bering Strait region experiences its first COVID-19–related death.
Oct. 27	Norton Sound Health Corporation confirms the second COVID-19 death in the Bering Strait region.
Nov. 1	Active cases of COVID-19 reach over 200 across the Bering Strait region. Savoonga experiences an outbreak of over 100 community-spread cases, and the local school transitions to distance learning for two weeks.
Nov. 4	Pediatric COVID-19 vaccine supplies arrive in Nome, and children ages 5–11 are eligible to receive the pediatric version of the Pfizer vaccine, which contains one-third of the adult dosage.
Nov. 29	The third COVID-19 death in the Bering Strait region occurs.
Dec. 30	Cases of COVID-19 continue to decline across Alaska. The year ends with only 9 active cases of COVID-19 in the Bering Strait region.

REFERENCES

BOOKS AND ARTICLES

Ailak, Sam. 1979. "Teller Mission." In *I remember III . . .*, edited by Noralee Itchoak, 1–6. Village Library Project, ESAA Title VII. Nome, AK: Kegoayah Kozga Public Library.

Alaska Airlines. 2020. "Alaska Airlines Expands Next-Level Care Safety Measures." *PRNewswire*, June 9. https://newsroom.alaskaair.com/2020-06-09-Alaska -Airlines-expands-Next-Level-Care-safety-measures.

Alaska Department of Health and Social Services. 2022. "Resources for the General Public." Accessed March 15, 2022. https://dhss.alaska.gov/dph/Epi/id /Pages/COVID-19/general.aspx.

Alaska Native Tribal Health Consortium. 2021. "COVID-19 Vaccine Materials Now Available in Alaska Native Languages." https://anthc.org/news/covid-19-vaccine -materials-now-available-in-alaska-native-languages/.

Alvanna-Stimpfle, Yaayuk. 2019. *Bering Strait Region Languages Map*. Nome, AK: Kawerak Eskimo Heritage Program.

Arrajj, Shawn. 2021. "Commemorative COVID-19 Exhibit Opens at the Health Museum." *Community Impact Newspaper*, October 21. https://communityimpact .com/houston/heights-river-oaks-montrose/arts -entertainment/2021/10/21/commemorative-covid -19-exhibit-opens-at-the-health-museum/.

Bahnke, Melanie. 2021. "Alaska Native Tribes and Tribal Organizations Support Inclusion in Federal Fisheries Management." *Native American Rights Fund*, July 26. https://narf.org/bering-sea/.

Bockstoce, John R. 1979. *The Archaeology of Cape Nome, Alaska*. Philadelphia: University of Pennsylvania Museum of Archaeology and Anthropology.

Bockstoce, John R. 1986. *Whales, Ice, and Men: The History of Whaling in the Western Arctic*. Seattle: University of Washington Press.

Bockstoce, John R. 2018. *White Fox and Icy Seas in the Western Arctic: The Fur Trade, Transportation, and Change in the Early Twentieth Century*. New Haven, CT: Yale University Press.

Burch, Ernest S., Jr. 2012. *Caribou Herds of Northwest Alaska, 1850–2000*. Edited by Igor Krupnik and Jim Dau. Fairbanks: University of Alaska Press.

Chambers, Hayley. 2021. *Collecting NOW*. Presentation, 48th Annual Meeting of the Alaska Anthropological Association, March 3. YouTube video. https://www .youtube.com/watch?v=Zx1NL0BS1ds.

City of Nome. 2020a. Nome City Council Special Meeting Minutes. March 12. https://www.nomealaska.org /sites/default/files/fileattachments/meeting/3431/20 -03-12_emergency_special_meeting_minutes.pdf.

City of Nome. 2020b. Nome City Council Meeting Minutes. March 30. https://www.nomealaska.org/sites /default/files/fileattachments/meeting/3411/20-03 -30_reshed_reg_mtg_minutes.pdf.

Cole, Terrence. 1984. *Nome: City of the Golden Beaches.* Anchorage: Alaska Geographic Society.

Cooper Hewitt, Smithsonian Design Museum. 2021. "Design and Healing: Creative Responses to Epidemics." Exhibition to Open in December at Cooper Hewitt. News Release, November 9. https://www.si.edu/newsdesk/releases/design-and-healing-creative-responses-epidemics-exhibition-open-december-cooper.

Coppock, Mike. 2006. "The Race to Save Nome." *American History Magazine* 41(3):55–63.

DuBrock, Francesca, and Hollis Mickey. 2021. *Alaska Museums and Artists Respond to the Covid-19 Pandemic at the Anchorage Museum.* Presentation, 48th Annual Meeting of the Alaska Anthropological Association, March 3. YouTube video. https://www.youtube.com/watch?v=ZX_u1U6oLgM.

Eldridge, Kelly. 2014. "The Snake River Sandspit (NOM-146): A Late Western Thule Site in Nome, Alaska." *Alaska Journal of Anthropology* 12(1):53–69.

Errico, Olivia. 2020. "National Museum of American History to Collect Objects Related to COVID-19." Rutgers University–Camden, April 9. https://march.rutgers.edu/national-museum-of-american-history-to-collect-objects-related-to-covid-19/.

Filene, Benjamin. 2021. *Curating in Crisis: Seeking Opportunities within Pandemic Restraints.* Presentation, 2021 Museums Alaska Annual Meeting, September 13. YouTube video. https://www.youtube.com/watch?v=5jPXUajmaqE&list=PL4IL3yENm-g7-k_62yHN9wY2r1Z30sx4Q.

Haecker, Diana. 2020a. "Nome Musher Hit by Snowmachine." *The Nome Nugget*, March 5.

Haecker, Diana. 2020b. "Nome Shuts Down Public Places, Discourages Crowd Gathering As Steps to Curb Covid-19 Outbreak." *The Nome Nugget*, March 12.

Haecker, Diana. 2020c. "Nome Common Council Passes Emergency Ordinance to Reduce Impact of COVID-19." *The Nome Nugget*, March 19.

Haecker, Diana. 2020d. "COVID-19: City Council Hears Citizen Concerns." *The Nome Nugget*, April 2.

Haecker, Diana. 2020e. "First COVID-19 Case Confirmed in Region." *The Nome Nugget*, April 16.

Haecker, Diana. 2020f. "Fourth Nome Patient Tests Positive for COVID-19." *The Nome Nugget*, June 11.

Harrison, Edward S. 1905. *Nome and Seward Peninsula.* Seattle: Metropolitan Press.

Haycox, Steve. 2020. "Alaska's Forgotten Epidemic Dwarfed the Spanish Flu and COVID-19." *Anchorage Daily News*, November 21. https://www.adn.com/opinions/2020/11/21/alaskas-forgotten-epidemic-dwarfed-the-spanish-flu-and-covid-19.

Jarvis, D. H., H. A. Taylor, J. H. Jarvis, and Wyman. 1900. "Smallpox at Cape Nome." *Public Health Reports* 15 (28): 1757–1760.

Johnson, Stephanie. 2020. "2020 Serum Run Expedition: Traveling Home from Nenana to Nome." *Mushing Magazine*, July 11.

Jones, John P. 1919. *Annual Report of J. P. Jones, Government Teacher at Shishmaref on the Arctic Ocean for the Year Ended June 30th, 1919.* Department of the Interior, Bureau of Education, Alaska Division, Alaska Native School, Medical and Reindeer Service. Archives of the Carrie M. McLain Memorial Museum.

Kaloke, Jerry. 1979. "Flu Epidemic." In *I remember III . . .*, edited by Noralee Itchoak, 7–14. Village Library Project, ESAA Title VII. Nome, AK: Kegoayah Kozga Public Library.

Kawerak, Inc. 2021. "Walrus Ivory: Protecting and Sustaining Indigenous Cultures." https://walrusivory.org.

Kelliher-Combs, Sonya. 2021. *Body/Land/Sea/Air—Maureen Gruben & Sonya Kelliher-Combs Distance Artist Residency.* Presentation, 48th Annual Meeting of the Alaska Anthropological Association, March 3. YouTube video. https://www.youtube.com/watch?v=Zx1NLoBS1ds.

Krauss, Michael E. 1995. *Inuit Nanait Naunagit Yuget Map.* Fairbanks: University of Alaska Fairbanks.

Krupnik, Igor. 2020. "Pacific Walrus, People, and Sea Ice: Relations at Subpopulation Scale, 1825–2015." In *Arctic Crashes: People and Animals in the Changing North*, edited by Igor Krupnik, Aron L. Crowell, 351–374. Washington, DC: Smithsonian Scholarly Press.

Lean, Reba. 2021. "New Shishmaref Clinic Opens." *The Nome Nugget*, September 16.

Lerner, Julia. 2021a. "COVID Cases Rise to 181 in Region." *The Nome Nugget*, August 19.

Lerner, Julia. 2021b. "COVID Case Numbers Rise, DHHS Activates Crisis Standards of Care." *The Nome Nugget*, October 7.

Lerner, Julia. 2021c. "Nome Mourns First COVID-19 Death, Case Numbers Continue to Rise." *The Nome Nugget*, October 21.

Loewi, Peter. 2022. "Active COVID Cases Rise to 142 in Region." *The Nome Nugget*, January 20.

Mason, James. 2018. "100 Years Ago the Flu Pandemic Ravaged Regional Communities." *The Nome Nugget*, October 17.

Mason, James. 2020. "No School but Students Are Getting Their Education." *The Nome Nugget*, April 2.

Mason, James. 2021. "Winterfest Kicks Off with Mushing and Skijoring." *The Nome Nugget*, March 11.

McDowell Group. 2020. "Arts of the Bering Strait Region: The Economic, Social and Cultural Role of Traditional Arts and Crafts." Nome, AK: Kawerak, Inc.

Nagozruk, Arthur. 1919. *Bureau of Education Annual Report, 1918–1919, United States Public School, Wales, Alaska*. Archives of the Carrie M. McLain Memorial Museum.

New York Public Library. 2020. "The New York Public Library Launches History Now: The Pandemic Diaries Project to Collect and Preserve the Stories of the COVID-19 Crisis." *Press Release*, August 20. https://www.nypl.org/press/press-release/august-19-2020/new-york-public-library-launches-history-now-pandemic-diaries.

Norton Sound Health Corporation (NSHC). 2020a. "Patient and Employee Safety Remains Number One Priority." *Press Release*, May 13. www.nortonsoundhealth.org/psa-nshc-slowly-reopens-outpatient-services/.

Norton Sound Health Corporation (NSHC). 2020b. "Close Contact Case Identified: Vaccinations Begin." *Press Release*, December 21. www.nortonsoundhealth.org/press-release-close-contact-case-identified-vaccinations-begin/.

Norton Sound Health Corporation (NSHC). 2021a. "Pediatric Vaccine in Nome as Regional Active Case Count Reaches over 280." *Press Release*, November 4. www.nortonsoundhealth.org/press-release-pediatric-vaccine-in-nome-as-regional-active-case-count-reaches-over-280/.

Norton Sound Health Corporation (NSHC). 2021b. "Four COVID-19 Cases Identified in Nome." *Press Release*, December 30. www.nortonsoundhealth.org/press-release-four-covid-19-cases-identified-in-nome/.

Norton Sound Health Corporation (NSHC). 2021c. "COVID-19 Pfizer Vaccine Now Available to 12–15 Year Olds." 2021. *Press Release*, May 12. www.nortonsoundhealth.org/press-release-covid-19-pfizer-vaccine-now-available-to-12-15-year-olds.

Norton Sound Health Corporation (NSHC). 2022. "Weekend Review for Regional COVID-19 Cases." *Press Release*, January 10.

Office of Governor Mike Dunleavy. 2020a. "Governor Issues Second COVID-19 Health Mandate; Signs COVID-19 Legislation." *Press Release*, March 16. Accessed August 23, 2020. https://gov.alaska.gov/newsroom/2020/03/16/governor-issues-second-covid-19-health-mandate-signs-covid-19-legislation/.

Office of Governor Mike Dunleavy. 2020b. "Governor Announces Phase Three of Reopen Alaska Responsibly Plan." *Press Release*, May 19. Accessed May 21, 2020. https://gov.alaska.gov/newsroom/2020/05/19/governor-announces-phase-three-of-reopen-alaska-responsibly-plan/.

Ojanen, Carrie Ayagaduk. 2018. *Roughly for the North*. Fairbanks: University of Alaska Press.

Oquilluk, William A. 1973. *People of Kauwerak: Legends of the Northern Eskimo*. Anchorage: Alaska Pacific University Press.

Phillips-Chan, Amy. 2019. *Nome*. Charleston, SC: Arcadia Publishing.

Phillips-Chan, Amy. 2020. "Bering Strait Narratives and Collaborative Processes of Exhibit Development in Nome, Alaska." *Alaska Journal of Anthropology* 18(1):23–50.

Pratt, Kenneth L., Joan C. Stevenson, and Phillip M. Everson. 2013. "Demographic Adversities and Indigenous Resilience in Western Alaska." *Études Inuit Studies* 37(1):35–56.

Ramsey, William. 1919. *A Brief History of the Spanish Influenza in so far as the Undersigned Was Concerned in the Defense of those Places Mentioned, in Preventing Contamination, and the Relief of Places after Infection*. Written especially

for the Bureau of Education. Alaska School Service. Archives of the Carrie M. McLain Memorial Museum.

Ray, Dorothy Jean. 1971. "Eskimo Place-Names in Bering Strait and Vicinity." *Names* 19(1):1–33.

Ray, Dorothy Jean. 1984. "Happy Jack: King of the Eskimo Ivory Carvers." *American Indian Art* 15(Winter):32–47.

Ray, Dorothy Jean. 1996. *A Legacy of Arctic Art*. Seattle: University of Washington Press.

Ray, Dorothy Jean. 2003. "Happy Jack and Guy Kakarook: Their Art and Their Heritage." In *Eskimo Drawings*, edited by Suzi Jones, 18–33. Anchorage, AK: Anchorage Museum.

Ricker, Elizabeth. 1928. "Togo's Fireside Reflections." Lewiston, ME: Lewiston Journal Printshop.

Salisbury, Gay, and Laney Salisbury. 2005. *The Cruelest Miles: The Heroic Story of Dogs and Men in a Race against an Epidemic*. New York: W. W. Norton & Company.

Senungetuk, Willie. 1979. "Willie Senungetuk Remembers: Story by Ray Angnabooguk." In *Surah*, edited by Anne Will, 10–14. Nome, AK: Nome-Beltz High School.

Shields, Philip. 2017. Personal communication with the author. Nome, AK. July 24.

Smith, Kathleen Lopp, and Verbeck Smith, eds. 2001. *Ice Window: Letters from a Bering Strait Village, 1892–1902*. Fairbanks: University of Alaska Press.

Smith, RB. 2020a. "One More Regional Resident Tests Positive for COVID-19, Nome Stores Require Masks." *The Nome Nugget*, July 23.

Smith, RB. 2020b. "COVID-19 Pandemic Evokes Stories of the 1918 Influenza." *The Nome Nugget*, September 3.

Smith, RB. 2020c. "Gambell Suffers Largest COVID-19 Outbreak in Region to Date." *The Nome Nugget*, October 8.

Smith, RB. 2020d. "COVID-19: 43 New Cases in Region, 37 in Nome." *The Nome Nugget*, November 26.

Smith, RB. 2020e. "COVID-19 Surge in Nome Prompts Citywide Closures." *The Nome Nugget*, November 26.

Smith, RB. 2020f. "31 New Cases of COVID-19, All in Nome." *The Nome Nugget*, December 3.

Sutton, Anne, and Sue Steinacher. 2012. *Alaska's Nome Area Wildlife Viewing Guide: Exploring the Nome Roadways*. Juneau: Alaska Department of Fish and Game.

Thomas, Bob, and Pam Thomas. 2015. *Leonhard Seppala: The Siberian Dog and the Golden Age of Sleddog Racing 1908–1941*. Missoula, MT: Pictorial Histories Publishing Co.

Thomas, Maisie. 2020. "COVID-19: The Function and Fashion of Masks." *The Nome Nugget*, July 30.

Thomas, Maisie. 2021. "NBHS Student Examines Efficiency of Protective Mask Types." *The Nome Nugget*, March 18.

Tozier, Marie. 2020. *Open the Dark*. Fairbanks, AK: Boreal Books.

Willoya, Emma. 1979. "The Long Way Back: A Visit with Emma Willoya by Mona Ozenna." In *Surah*, edited by Anne Will, 63–73. Nome, AK: Nome-Beltz High School.

Wolfe, Robert J. 1982. "Alaska's Great Sickness, 1900: An Epidemic of Measles and Influenza in a Virgin Soil Population." *Proceedings of the American Philosophical Society* 126(2):91–121.

Zagoskin, Lavrentiy A. 1967. *Lieutenant Zagoskin's Travels in Russian America 1842–1844: The First Ethnographic and Geographic Investigations in the Yukon and Kuskokwim Valleys of Alaska*. Edited by Henry N. Michael. Toronto: University of Toronto Press.

NEWSPAPERS

The Nome Nugget (Nome, Alaska) 1897–current.

Nome Gold Digger (Nome, Alaska) 1899–1905.

Nome Tri-Weekly Nugget (Nome, Alaska) 1918–1919.

Kusko Times (McGrath, Alaska) 1921–1937.

INDEX